# RUSSIAN IMPERIAL STYLE

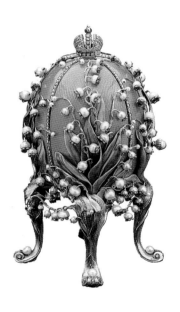

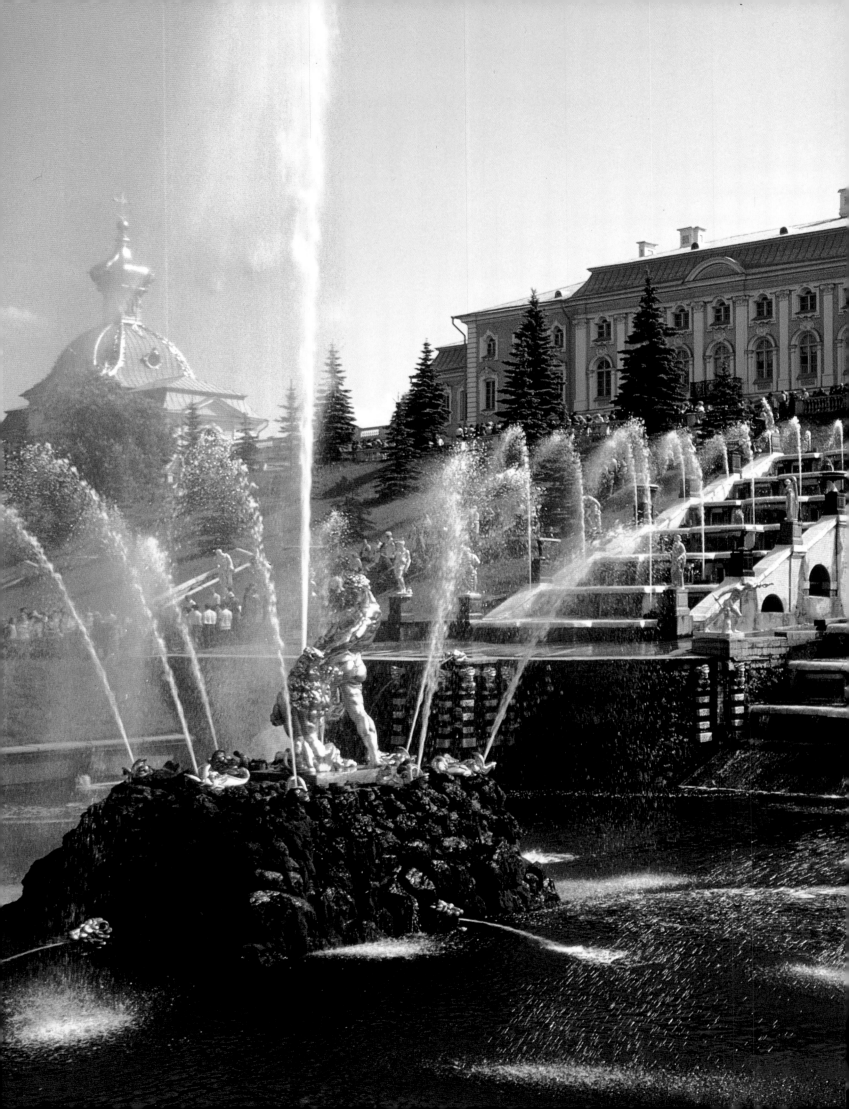

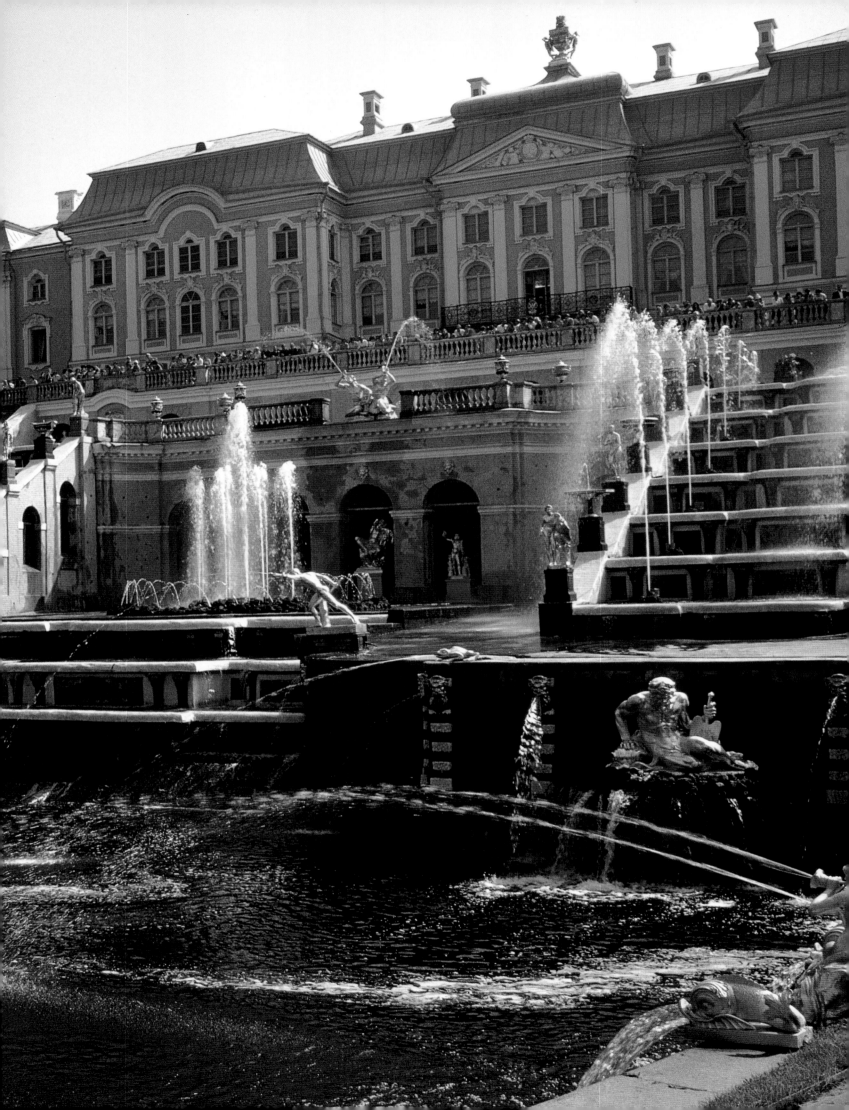

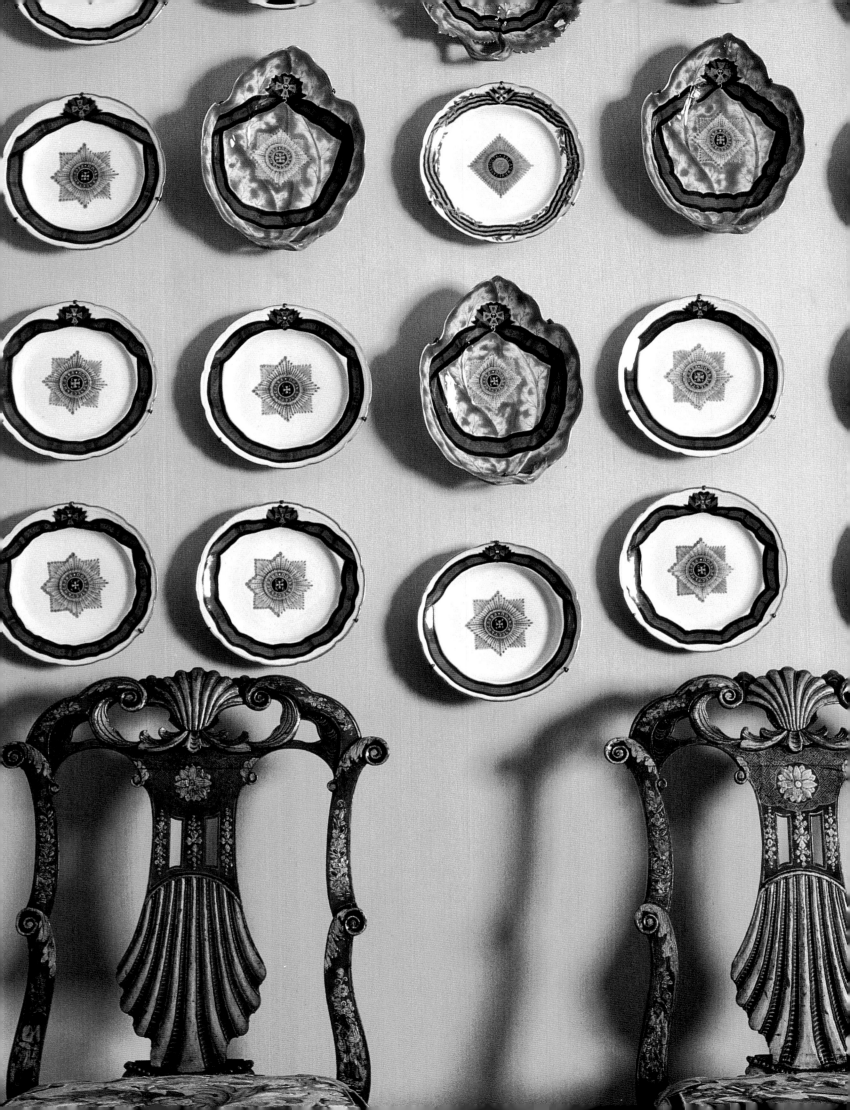

# RUSSIAN IMPERIAL
## STYLE

*Laura Cerwinske*

WITH THE COOPERATION OF
*A La Vieille Russie*

WITH PHOTOGRAPHY BY
*Anthony Johnson*

PRENTICE
H A L L
EDITIONS

NEW YORK     LONDON     TORONTO     SYDNEY     TOKYO     SINGAPORE

*PRENTICE HALL PRESS*
*15 Columbus Circle*
*New York, NY 10023*

*Text copyright © 1990 by Laura Cerwinske*
*Foreword copyright © 1990 by Ray, Paul, and Peter Schaffer*
*Photography credits appear on page 219.*

*PRENTICE HALL PRESS and colophon are registered trademarks of Simon & Schuster, Inc.*

*PRENTICE HALL EDITIONS is an imprint of Simon & Schuster, Inc.*

*Library of Congress Cataloging-in-Publication Data*

*Cerwinske, Laura.*
    *Russian imperial style / Laura Cerwinske: photographs by Anthony Johnson.*
        *p.    cm.*
    *Includes bibliographical references.*
    *ISBN 0-13-784810-2 :*
    *1. Decorative arts—Russian S.F.S.R.   2. Art patronage—Russian S.F.S.R.   3. Russian S.F.S.R.—Social life and customs.*
    *I. Johnson, Anthony, II. Title.*
    *NK975.C45   1990*
    *745'.0947—dc20   89-48365*
                    *CIP*

*Designed by J. C. Suarès*
*Design Coordination by Gates Studio*

*Manufactured in Japan*
*10 9 8 7 6 5 4 3 2 1*
*First Edition*

PAGE 1: The Lily-of-the-Valley Egg (seen closed on page 1 and open on page 11), presented by Nicholas II to his mother, the Dowager Empress Maria Fyodorovna, in 1898, by Fabergé in gold and rose enamel, with leaves veined with rose diamonds. The blossoms are made of rose diamonds and pearls, and the Imperial Crown is made of rose diamonds and a cabochon ruby.

PAGES 2 AND 3: Peterhof, Peter the Great's summer palace on the Gulf of Finland, now known as Petrodvorets and as the Versailles of the North.

PAGE 4: A collection of wall-mounted St. Vladimir Order plates, commissioned by Catherine the Great in 1777 and made by the Gardner Porcelain Factory.

PAGE 7: Two red-bordered military plates commissioned by Alexander I in the early nineteenth century from the Russian Imperial Porcelain Factory, along with two gold and enamel presentation boxes by Keibel, the top with a miniature of Czar Nicholas I (1825–1855) and the bottom with one of Czar Alexander I (1801–1825), both great patrons of the Russian Imperial Porcelain Factory.

PAGE 11: The opened Lily-of-the-Valley Egg. The surprises —three diamond-surrounded miniatures—emerge and retreat at the touch of the gold-mounted pearl button.

ACKNOWLEDGMENTS

I would like to express my profound gratitude to my parents whose devotion to my son made the work possible; my thanks to Peter and Paul Schaffer and Mrs. Schaffer for so generously sharing their time, knowledge, and library with me.

My appreciation to Dino Milinovic, for the knowledge he lent to the writing of this book.

Finally, a salute of admiration and appreciation to J. C. Suarès for conceiving this project, maintaining the vision, and inviting me to be a part of it.

—Laura Cerwinske

I would personally like to thank my mother, Ray Schaffer, and my brother, Paul Schaffer, for taking over many of my responsibilities to allow me the time needed to work with Laura Cerwinske, Anthony Johnson, Prentice Hall Editions, and, of course, J. C. Suarès. Not least, thanks go to our staff for their time and assistance.

—Peter L. Schaffer

On behalf of A La Vieille Russie, we would like to acknowledge with much gratitude those who have graciously assisted in the preparation of this book: Morris Bornstein, Mrs. Bing Crosby, Ralph Esmerian, the late Malcolm S. Forbes and the Forbes Magazine Collection, Mrs. Yolande B. Fox, the Brooklyn Museum and the Guennol Collection, Mr. and Mrs. A. Herenroth, the Vaughn Foundation, the Virginia Museum of Fine Arts, the Lillian Thomas Pratt Collection, as well as others who have opened their homes and collections to us.

*For Russia, land of destiny*

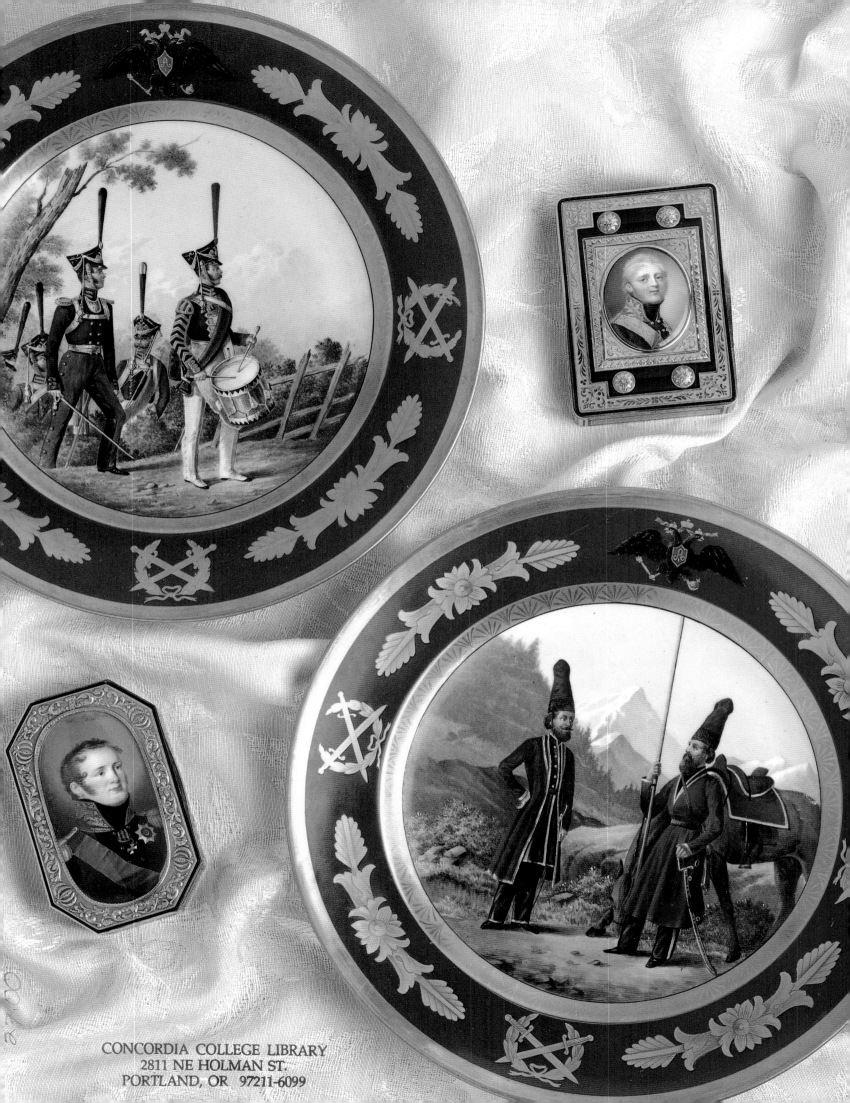

# 1

# 2

"A La Vieille Russie, Then and Now—Russian Imperial Style, Then and Now" by Ray, Paul, and Peter Schaffer

"Submission in Russia makes you believe there is uniformity. Correct this idea. Nowhere is there a country where there is such diversity of races, of customs, of religion or [of] mentality as in Russia."
—Czar Nicholas I

"Freshwater pearls, plentiful in Russia's riverbeds, became a favored jewel."
—Audrey Kennett

"The fury to build is a diabolical thing, it devours money and the more one builds, the more one wants to build. It is as intoxicating as drink."
—Catherine the Great

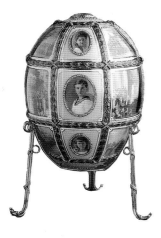

# 3

## OBJETS D'ART
137

"Clearly, if you compare my things with those of such firms as Tiffany, Boucheron, and Cartier, of course you will find that the value of theirs is greater than [that] of mine. But of course these people are merchants and not artist-jewelers. Expensive things interest me little if the value is merely in so many diamonds or pearls."
—Peter Carl Fabergé

# 4

## TABLE SETTINGS
165

"Dinner services were made of glass as well as of porcelain, and there were periods when nothing but silver was good enough for plates and goblets."
—Audrey Kennett

# 5

## PAINTING
189

"Russian art . . . reflected the craving for the heroic, the widespread romantic impulse of the time, the desire for vivid impressions born of the world's beauty, and wealth of color."
—Anna Sokolova

# RUSSIAN IMPERIAL STYLE

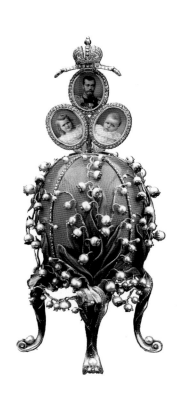

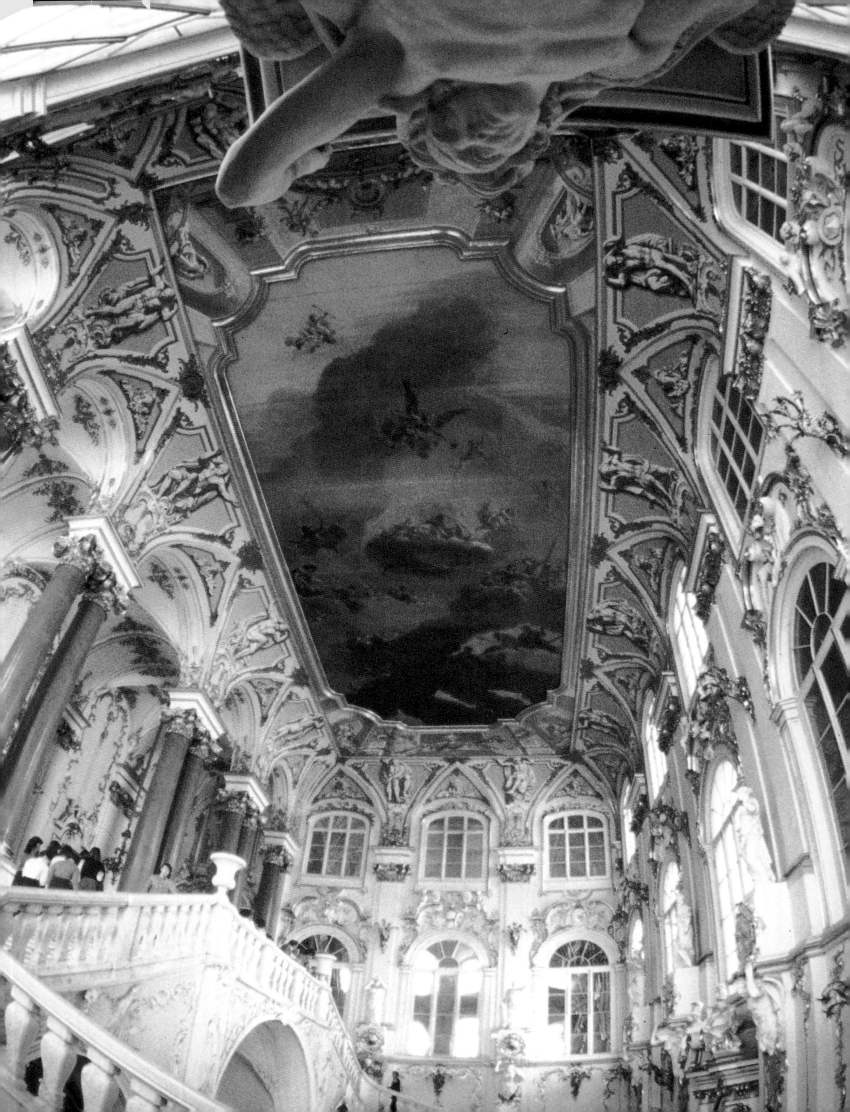

# FOREWORD

## A La Vieille Russie, Then and Now— Russian Imperial Style, Then and Now

The Fabergé family originated in France, settled (as Huguenots) in Russia, in the late seventeenth century and, for the most part, returned to France or left for Switzerland after the Russian Revolution. Similarly the history and location of A La Vieille Russie have been affected by religious persecution and political change. The firm, a family affair since its founding in 1851 in Kiev, left the turmoil of the Revolution and was reestablished around 1921 in Paris by Jacques Zolotnitsky, a son of the founder, and his nephew, Léon Grinberg. They went on to help organize major exhibitions of Russian art in Brussels in 1928 and 1931 and in London in 1935. Their shop, with premises on the fashionable rue du Faubourg St. Honoré, became an intellectual and trading center for the large Russian colony in Paris, and earned an international reputation, including appointments as jeweler to the courts of Sweden and Egypt.

In Russia, the original firm dealt in antiques and works of art. Peter Carl Fabergé, who had one of his shops in Kiev and who was himself a well-known collector, was a client. The store was given a French name because in nineteenth-century Russia, in "civilized" company, one spoke only French—Russian was reserved for servants, naughty children, and animals.

Parallel to the flight of Zolotnitsky and Grinberg, one Alexander Schaffer, a former professional soccer player, fled the Hungarian dictatorship of Béla Kun, and

A ceiling in the Hermitage, part of the Winter Palace in St. Petersburg (Leningrad).

finally arrived in Paris around 1923. He eventually settled in New York in 1926, after having spent most of the time shuttling between Russia and Western Europe, trading in merchandise acquired, in large part, in the Soviet Union. Schaffer was in fact one of the first—and last—businessmen to purchase extensively from the Soviets during the Stalin era.

One of Schaffer's first jobs was working for L'Ermitage Gallery in New York, which was set up by three brothers named Hammer, one of whom is in America the well-known industrialist, Armand Hammer. According to Victor Hammer, Armand's brother, "Alex started out as the pupil and ended as the teacher." So thoroughly did he learn the history of Russian art and so accomplished did he become at trading in it, that when the Hammers decided to divest their gallery of their Russian collection, they sold everything to him.

Alexander Schaffer married his wife, Ray, in 1932 and together they were a formidable team. They opened the Schaffer Collection of Russian Imperial Treasures in Rockefeller Center in 1933, at 36 West 50th Street. The establishment took their European name of A La Vieille Russie in 1941 when the Schaffers moved to 785 Fifth Avenue, a few doors north of 781 Fifth, where their shop has been since 1961.

Working in alliance with the Paris firm, the Schaffers in New York—and Zolotnitsky and Grinberg in Paris—helped develop the international market for Russian jewelry, icons, silver, porcelain, furniture, and Fabergé's exquisite eggs, delicate flowers, animals, and enameled boxes and cases. Schaffer's trips to Russia did not stop when he founded his shop; in fact, they became more frequent, bringing him often to Paris, where the association with his Russian counterparts deepened. With the

outbreak of World War II in Europe and the imminent occupation of France, Schaffer provided the affidavits of support necessary for their immigration to the United States.

In the Soviet Union, Schaffer was fortunate enough to have been able to acquire Russian art in quantity from places like the Anitchkov Palace in Leningrad. On such trips he would tour such a site, pointing to objects and saying, "I'll take this and that and that." Getting the Russians to *agree* to sell anything was always difficult, but what he found consistently remarkable was that once they reached an agreement, they always shipped the goods, never requiring any delivery papers, and accepting payment upon receipt. If ever he told them something had arrived broken, they never questioned it, inspected it, or asked for it back—they simply sent another or comparable piece. This pattern held true through the 1950s—whenever they made a business agreement, they stuck to it.

What the young dealer acquired during his trips to the Soviet Union was not limited to Russian works of art, although these predominated. Items included quantities of porcelain, icons, brocades, memorabilia, and a few items in precious materials, such as Fabergé objects, gold boxes, and antique jewelry, his main area of interest. He did not travel to Russia as a collector with the means of Ambassador Joseph E. Davies and his wife, Marjorie Merriweather Post, but as a dealer and trader. With 800 dollars of capital borrowed from his wife, he could hardly do otherwise. But his limited means forced him to choose carefully. Furthermore, the difficulty and length of time needed to travel at that time (by boat, train, and planes with limited range, a New York–Moscow trip took several weeks) dictated a busi-

OVERLEAF: The St. Petersburg studio of artist and stage designer Alexandre Benois re-created at Petrodvorets.

nesslike attitude, which fitted well with the needs of the young Soviet government.

The prewar period in Soviet Russia was difficult and confused, with the economy in shambles, starvation widespread, and the State in organizational and economic ruin. The need for hard currency was paramount, and sales of works of arts were effected by various governmental agencies staffed with inexperienced ministers that paid less attention to conserving the national heritage than to raising cash by selling the spoils of the aristocracy and the Church to Western buyers.

Whatever the collateral reasons for selling, the officials involved earnestly attempted to carry out their tasks as part of the rebuilding of the country, and the result was a relatively steady supply of merchandise ready to be purchased in businesslike fashion, but laced with memorable experiences. Despite the burning of antique Russian brocades to recover their precious metal content or the occasional selling of valuable eighteenth-century French silver and gold for its intrinsic value, other aspects of the Soviet government's dealings were more straightforward. Negotiations were often protracted and characterized by psychological one-upmanship, but when a bargain was struck, the deal was honored, and the goods were always sent as agreed. Once credit was established—usually with no more than a small deposit—the merchandise was either delivered or shipped, with payment being completed later.

To cite one example, Schaffer once received a communication from the Soviets that there was a lot for him to see in Russia, and so he went. He was shown a quantity of objects, all of which were of a lesser quality than had been promised. Finally, they showed him a magnificent lot but asked for an amount that was, in his opinion, three times its value. He was furious, but he did offer them half of what it

was worth. They refused. Realizing that a deal was impossible, he requested the return of his passport so he could go home. After days of waiting in his hotel room or reading at the U.S. Embassy and being told that he could not leave unless he agreed to the government's terms, he was suddenly told to leave for the airport where his passport would be returned to him. On arrival, he was surprised to find not only his passport but also his parcel of goods, given to him as he was running to catch his plane, and given without a receipt, which was refused as being unnecessary. Needless to say, he got the goods at his price.

Objects by Fabergé were only a small part of what Schaffer was able to purchase during his first trips, but his facination with the technical skill of this artist was linked to his interest in eighteenth-century French gold boxes, and he began to buy more and more. He sought out works by Fabergé not only because of A La Vieille Russie's long acquaintance with his work but also they fulfilled so well the three basic principles upon which any successful business operates: quantity, quality, and price. During the 1930s and 1940s, Fabergé was available in abundance—most people regarded it, despite its brilliance and beauty, as "second-hand," and out of fashion. Therefore, of course, prices were relatively reasonable. Being at that time a half century newer than now, such items could be bought for a modest sum; in fact one could have a whole garden of his flowers or a menagerie of his animals to choose from, and then be able to sell them reasonably. The silver was purchased by weight, and that too could be offered at affordable prices. Items like cane handles, frames, clocks, and other smaller pieces including the miniature eggs likewise sold for less than fifty dollars. (Miniature eggs made by Fabergé and those by other Russian

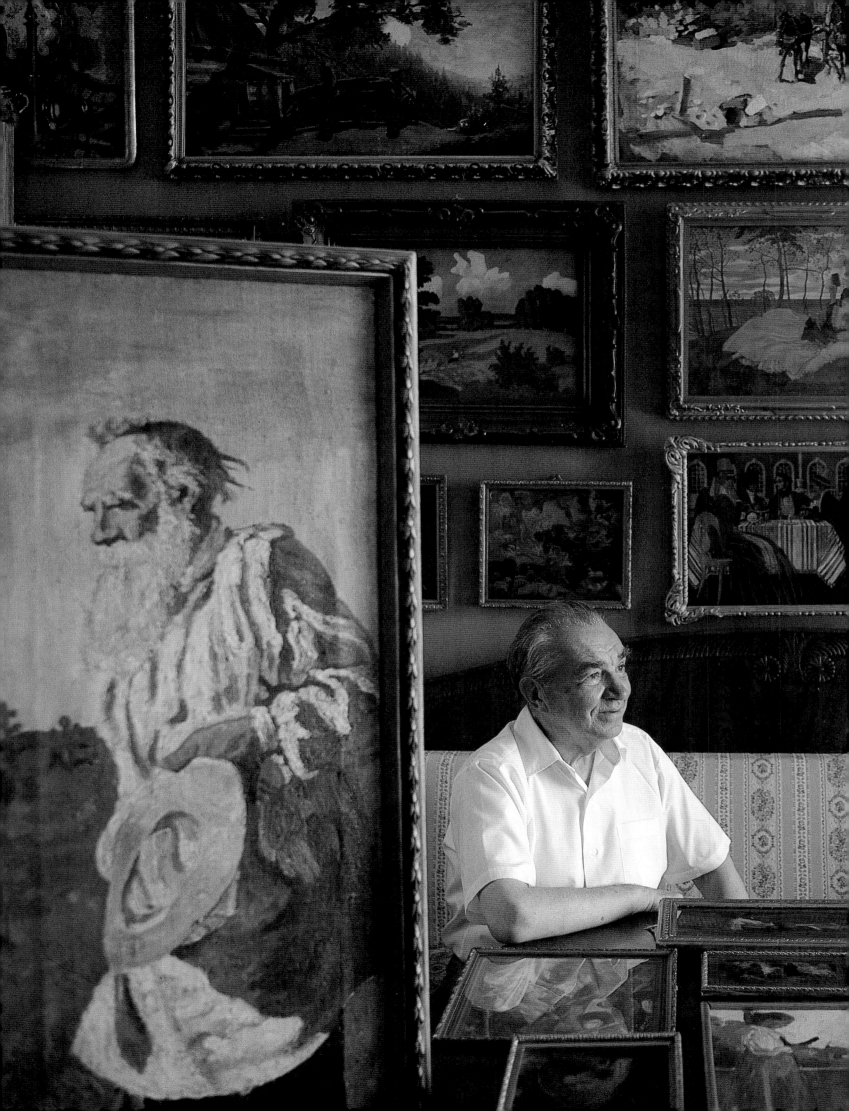

jewelers were regarded more or less as equal and were priced according to their quality, rather than according to their authorship, as is done today.) Also on display at the gallery were many more modestly priced items, such as a seventeenth-century icon for twelve dollars, Gardner plates of the Order of St. Vladimir at thirty-five dollars each, and a dozen cloisonné enamel spoons for sixty dollars, to mention only a few. Porcelain eggs with the monogram of Alexandra Fyodorovna were abundant enough to be boxed and offered as gifts to favored clients at Easter time, as were Fabergé World War I–era brass and copper ashtrays. In short, there was a large variety of merchandise to choose from, and the noble origins of many of the pieces, bearing labels from Imperial palaces and aristocratic estates, added to their interest. Most desirable, then as now, were the Fabergé items, whose extraordinary detail and exquisite charm gained the gallery many clients, including Mrs. John L. (Lillian Thomas) Pratt, Mrs. India E. Minshall among others, whose Fabergé collections form the nucleus of the Russian collections at the Virginia Museum of Fine Arts, Hillwood, and the Cleveland Museum of Art, and the aforementioned Marjorie Merriweather Post (Mrs. Joseph E. Davies). By 1936, when The Schaffer Collection, including much Fabergé, was exhibited in Rockefeller Center to celebrate its move across town to larger quarters, the increased demand for Fabergé was such that a presentation box now commanded as much as 2,500 dollars, and an Imperial egg retailed for more than 10,000 dollars, which, by Depression standards, were strong prices indeed. As the gallery's clientele grew and as the Schaffers' fascination with Fabergé increased, trips to the Soviet Union became more frequent and included longer stays in Western Europe, where the Russian aristocracy in exile had

Professor Nikolai Blokhin in his Moscow apartment with examples from his collection of nineteenth-century paintings.

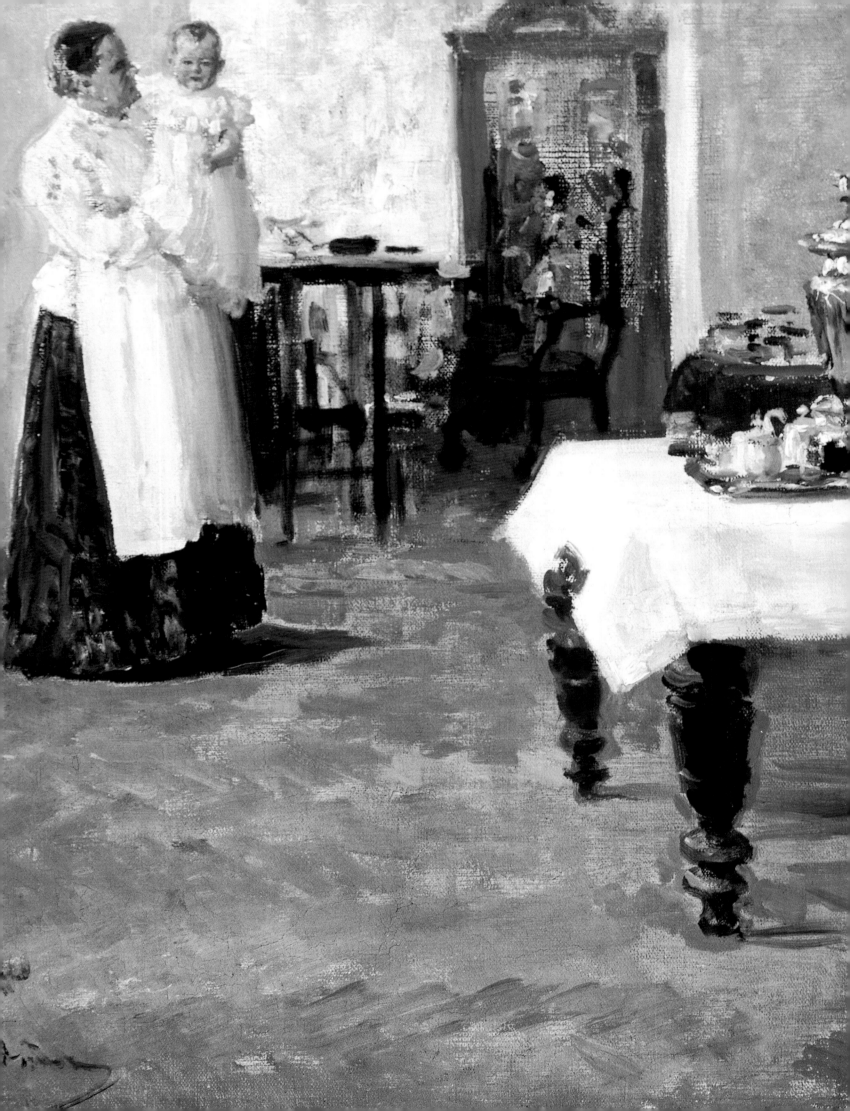

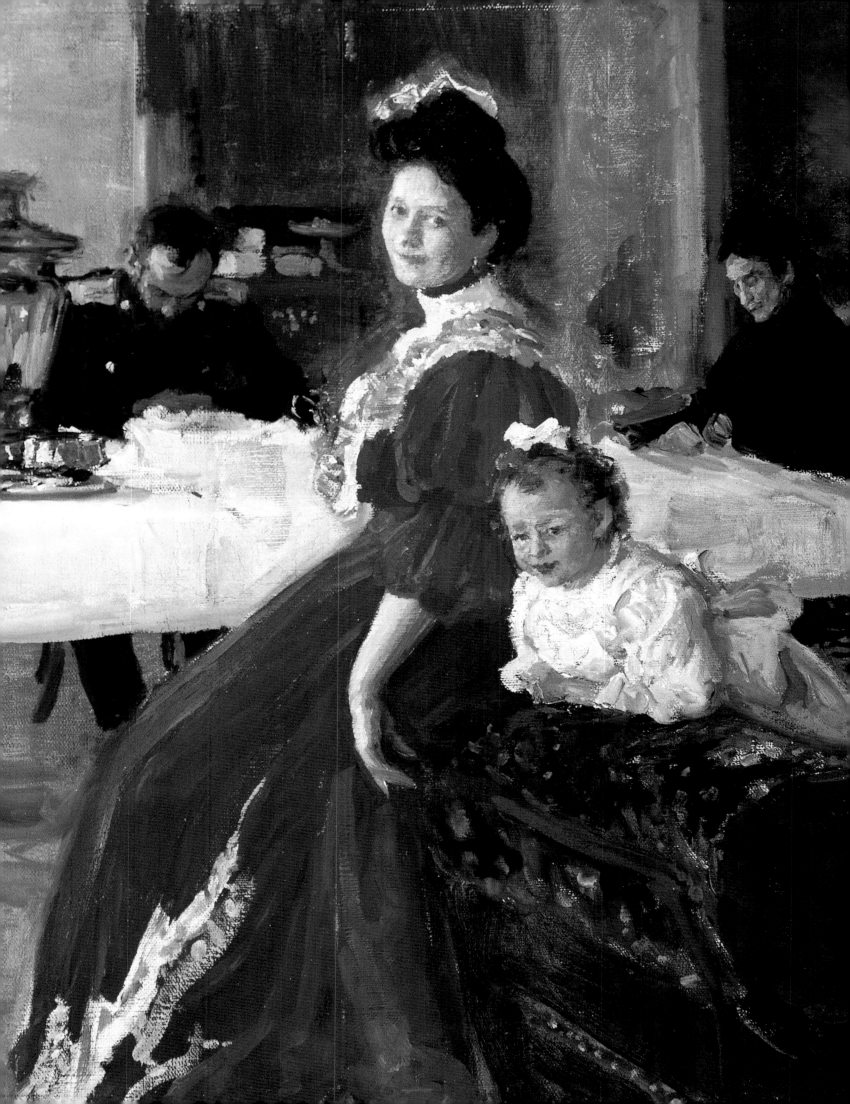

brought much of interest. The majority of the stock, however, was acquired in Russia.

Records of this prewar period are sketchy, but it is of interest to note a few transactions, which are cited merely as indicative of the period. The attempt at exactitude is further complicated by the brevity of many descriptions, making the positive identification of pieces still known today the exception. This is not surprising given the modest cost of many pieces, for elaborate descriptions were not warranted. A gold and enamel clock, for instance, cost 65 dollars, a gold and enamel frame, 95 dollars, a buckle, 15 dollars, and a stone animal, 135 dollars. A few exceptions: The circular blue-enamel presentation box with the monogram of Nicholas II (exhibited at A La Vieille Russie in 1983) was purchased in 1923 for 250 dollars, sold in 1930 for about 700 dollars and resold in 1979 for 42,800 dollars; the twelve-panel pink-enamel Easter egg now in the collection of Her Majesty Elizabeth II of England was sold in 1933 for about 850 dollars; the coronation snuffbox (Forbes Magazine Collection) was sold in 1937 for about 1,700 dollars, with a profit of about 350 dollars; the rich *mujik* (exhibited at the Victoria and Albert Museum in 1977) was sold in 1937 for 950 dollars, with a 200 dollar profit; and a red-enamel cigarette case (exhibited at A La Vieille Russie in 1983) was purchased in the mid-1930s for 54 dollars and sold in 1975 for about 8,000 dollars.

Also illustrative were the deals not done: The smoky topaz vase (exhibited at A La Vieille Russie in 1983) was turned down in 1938 when offered for 1,350 dollars; and the cloisonné enamel tea set (by H. C. Bainbridge) was turned down in 1940 when offered by Fabergé's son in Paris for 1,500 dollars. Although such original

PRECEDING PAGES: *Family Portrait: The Artist's Daughter, Tatyana, and Her Family* by Ilya Yefimovich Repin, 1905.

prices seem low today, they were only relatively so, and if proof is needed, one might observe of a lorgnette in its original case priced at 67.50 dollars that a dollar was indeed worth halving! After all, A La Vieille Russie in New York was operating throughout the Great Depression.

Since its New York opening the gallery has handled more than twenty-six of the known Imperial eggs, among other great Fabergé treasures, and in 1989 it was one of eleven foreign lenders (and the only American) to the first-ever exhibit of Fabergé items in Russia. Called "The Great Fabergé," this exhibition at the Elagin Palace in Leningrad not only rehabilitated the artist's name in the USSR but indirectly, because some of the Fabergé photo frames exhibited contained photographs of Nicholas and Alexandra identifying them as the last Czar and Czarina, it has apparently also resulted in their rehabilitation.

———

But the history of a firm is only partly the merchandise it deals in. It is also its clients, who, after all, are the *raison d'être* of any business, and, more importantly to this history, who have had the courage to act on their instincts and become the tastemakers of their generation. During the early years of our business, starting as it did with limited capital at the bottom of a depression and with largely unknown merchandise, the relationship between client and dealer became exceptionally close, as both explored virgin territory together. Particularly important to this stage was Alex's wife, Ray, who did not accompany him on his early buying trips, but worked closely in New York with clients to help form their collections.

It was in this period that the Peter the Great egg came on the market and was offered to numerous dealers here and abroad, most of whom branded Schaffer insane

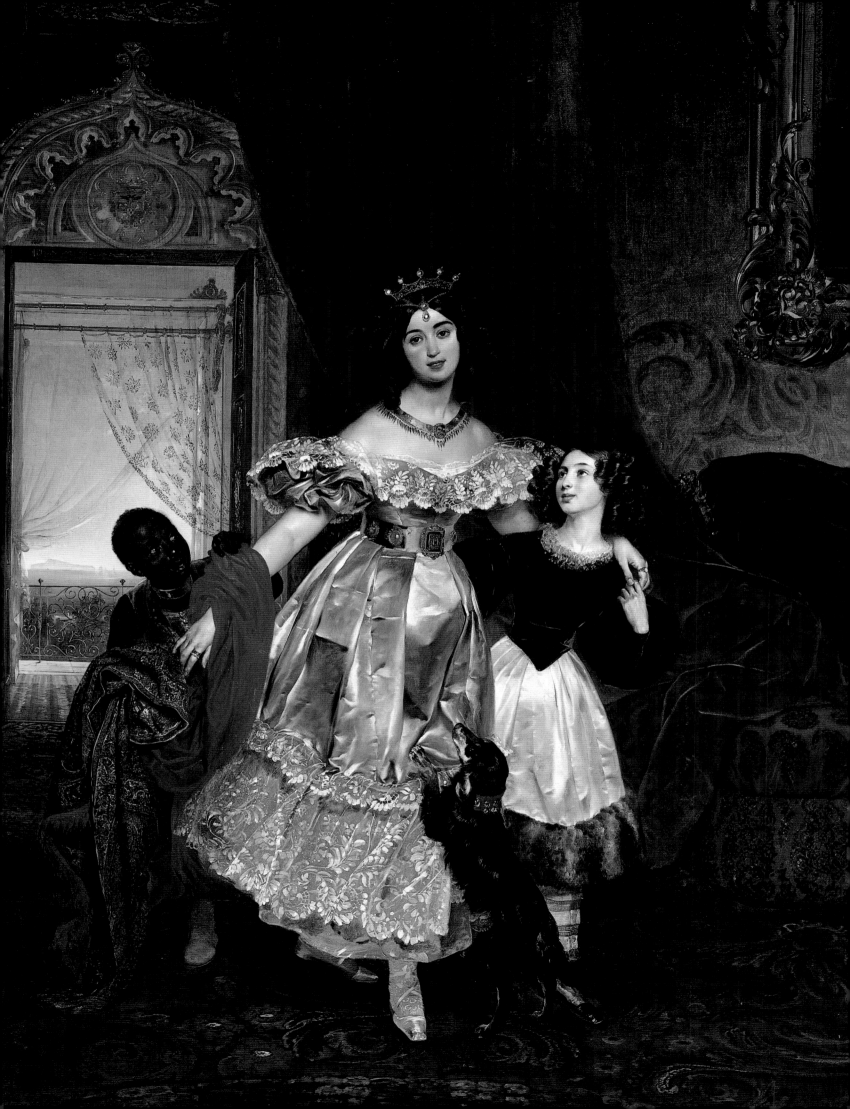

for handling such a "modern" piece. But it was always his opinion that it was the most important piece of Fabergé he had ever sold, and the description of it uttered by an English friend, "modun," remained with him the rest of his life. Lillian Thomas Pratt, of course, would fall in love with it and add it to her collection. As with most of the more important pieces of Fabergé, it was expensive and beyond the reach of the average buyer, but being a true collector, she stretched her purse a little and paid for it in monthly installments. What a pleasure to have been able to exhibit this marvel of craftsmanship and historical commemoration recently (1983) and once again to hold in our hands a work now universally recognized as a priceless masterpiece.

The war years brought numerous changes. A La Vieille Russie, Paris, was turned over to a relative to run as long as necessary; the Zolotnitsky family immigrated to the United States; A La Vieille Russie, New York, was opened on Fifth Avenue as Schaffer closed his shop in Rockefeller Center; Mrs. Schaffer concentrated on raising her two children; and Alex became very involved in searching for relatives and friends left behind in Europe and, as the war ended, in supplying countless affidavits of support for those who survived. As for the gallery, interest in Fabergé remained, and Schaffer managed to buy pieces from important collections during this period, and business operated more or less as usual.

After the war, travel to the Soviet Union resumed, although trips were not as frequent, as successful, or as easily organized: An invitation had to be extended by the Soviet government; permission from the United States Passport Agency had to

*The Countess Samoilova and Her Foster Daughter* by Karl Briullov, 1832–1834, painted in Italy where the Countess, who had fallen in disfavor with Czar Nicholas I for entertaining too lavishly, had moved to enjoy a freer society of artists and musicians. Documents record a romantic interest between the Countess and the artist.

be requested, stating the purpose of the visit and asking if there were any objections; and, finally, the Allied High Command had to be petitioned for travel through Poland and Austria en route. But if these postwar trips to the Soviet Union were less successful, Europe still had much to offer and in 1949 our first postwar exhibition of Fabergé was held, in conjunction with the publication of H. C. Bainbridge's *Peter Carl Fabergé*, with 291 pieces on view. By 1954, when King Farouk of Egypt's collection, which we had helped form, was dispersed, an adventure in itself, the world was recovering economically, and prices had begun to advance significantly from the relatively steady period of the 1930s and 1940s. New collectors were entering the market.

Chief among these were Mr. and Mrs. Jack Linsky and Mr. and Mrs. Lansdell K. Christie. The Linskys' Fabergé was denigrated as being too "new" by the then-director of the Metropolitan Museum of Art, and it was sold, but the Museum's judgment was corrected when the Museum later displayed the Christie collection on semipermanent loan in a specially decorated gallery. Unfortunately, Christie died before he was able to make plans for its permanent display, and its subsequent sale was handled by A La Vieille Russie (most of his collection was exhibited anonymously in our second major postwar Fabergé exhibition in 1961). Many of the important pieces, including the Imperial eggs, were purchased by the Forbes Magazine Collection, now the most important in the world.

It should be noted that A La Vieille Russie is actually two shops in one: a gallery that deals in major pieces and a store that sells jewelry and smaller objects. As such, we have developed two distinct, though not mutually exclusive, clienteles: one that acquires museum-quality art through us and another that exchanges gifts through the

gallery, much like a wedding registry. A perfect example occurred many years ago, when the late Malcolm Forbes came in to buy a gift and ended up, in addition, buying himself a Fabergé miniature egg. Over the next few years we continued to show him Fabergé pieces, and his interest grew. He credits A La Vieille Russie as the source for the great majority of his collection, although, at one point, he stopped buying because he thought the prices were too high. As he reported at the time in his magazine, Mrs. Schaffer chastised him, saying "Just because you didn't buy IBM at 200 doesn't mean you can't buy it at 500," and he found her words so sage that he started buying again. There is never a bad time to buy quality.

In recent times the gallery's dealings with the Soviets have continued. In 1963 they published a book on the Russian painter Karl Briullov, whose portrait of the Countess Samoilova they proclaimed to be the best Briullov in the world. They lamented in print, however, that not only did they not own the painting but they had no knowledge of where it was, saying only that it was in the U.S.A. In fact, A La Vieille Russie had bought the portrait privately and brought it to New York. At that time another longtime patron of the gallery and passionate collector of Russian art was Marjorie Merriweather Post, who at one time was married to Joseph E. Davies, the American Ambassador to the USSR in the early 1940s. Mrs. Post saw the Briullov, fell in love with it, but felt she had no place to hang it (it is extraordinarily large). Thus, we offered it to the Soviets, who sent team after team of their experts to examine it. At length, after reaching an agreement on a price, we sent the portrait to the Soviet Union, where it was put on view at the Tretyakov Museum. It identified A La Vieille Russie, New York, as the gallery from which it

had been loaned—the first time such an exhibit had ever acknowledged a foreign source.

Unfortunately, however, the Soviets never got around to paying for the painting! After months of fruitless conversations, mountains of correspondence, unsatisfactory meetings, and mounting frustration, Alexander Schaffer went to the Soviet Union to negotiate some sort of exchange. He suggested they keep the Briullov and give us a Chagall or a Kandinsky, or another of their "decadents" (of whom they had plenty but refused to show). Unfortunately they had decided that these artists were *so* decadent that they wouldn't even show them to him. (Of course, five years later, they were hanging in the Hermitage.) Eventually, we did manage to get the Briullov back, and Mrs. Post, delighted at its return, made room for it in her house, and bought it. Years later, we learned that the director of the Tretyakov used to carry in his wallet the newspaper article announcing the arrival of the "Portrait of the Countess Samoilova" in Russia. Keeping the painting in the USSR had become a *cause célèbre*, and whenever he pulled the clipping from his pocket, tears reportedly came to his eyes: "We couldn't buy it," he'd explained to a colleague. "It was a question of guns or butter."

———

At the present time, A La Vieille Russie continues to be the leader in the field, having recently been invited by the Kremlin Museums to attend the opening of their special exhibit of the Imperial Easter Eggs, which included banquets and concerts within the Kremlin walls. Scheduled are two important loan exhibitions from Soviet museums and palaces. We therefore continue a close working relationship with those in the Soviet Union responsible for maintaining their collections, with resultant

exchanges of ideas, information, and loans. Also scheduled is an exhibition of an important Royal collection, including Fabergé and other Russian works of art which have both artistic and historic interest. And we still purchase great pieces, many from the continuous stream of *objets* that have passed and continue to pass through our hands, even as we make new discoveries.

The diversity, color, style, and quality of Russian art have fascinated collectors the world over for centuries. This book, *Russian Imperial Style*, joins the past with the present in a way not seen before. Its publication is part of our ongoing involvement with the dissemination of classic Russian art. So let it be this thought, that we at A La Vieille Russie have successfully combined our duties of conservatorship with a desire to educate, that inspires us to continue into our second century of operation, not forgetting the help of those farseeing and imaginative clients, who have turned out to be our good friends and best students.

Ray, Paul, and Peter Schaffer
New York City

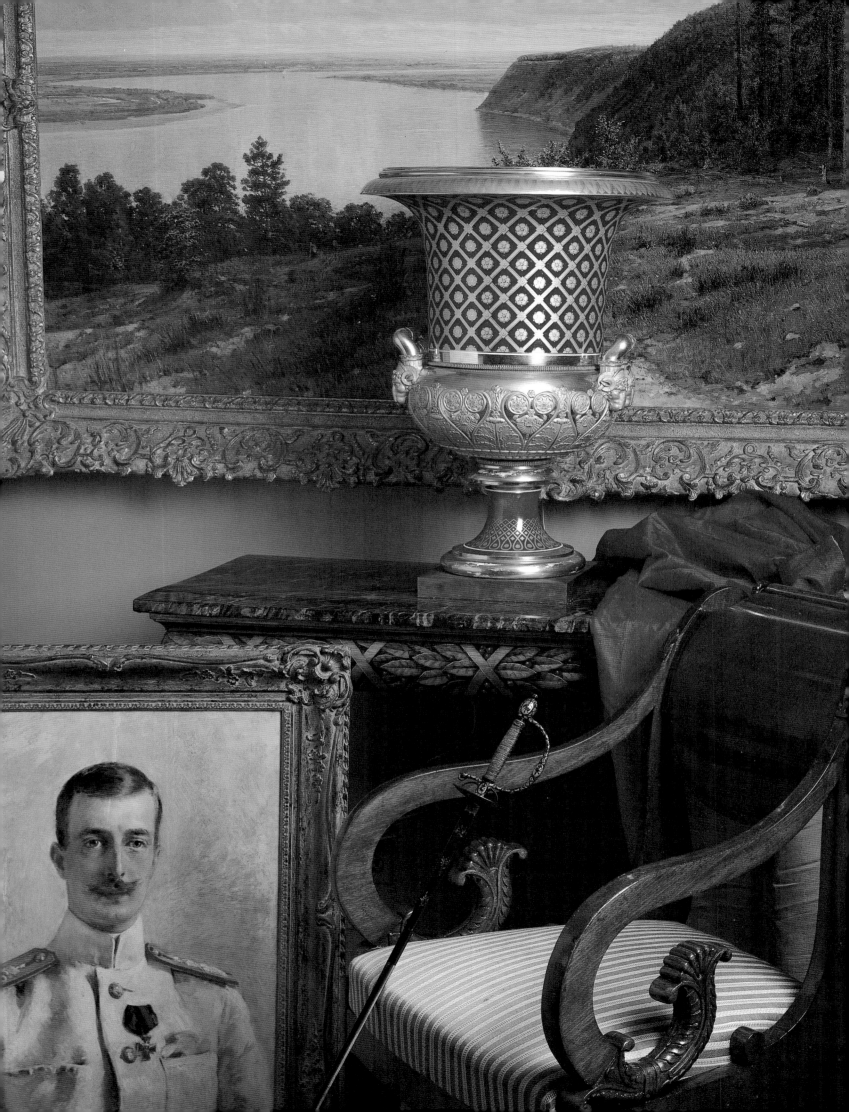

# PREFACE

Between the years 1762, when Catherine the Great was crowned Empress and Autocrat of all the Russias, and 1917, when the Revolution brought the Romanov dynasty to its violent end, the Russian aristocracy luxuriated in a style of living nearly unparalleled in history. The costumes, jewelry, palaces, churches, furniture, objets d'art, and table settings produced for the nobility were more magnificent, more elaborate, more intricately crafted, and more valuable than even those created for the French and British thrones. Although lavish ostentation was the hallmark of courts throughout Europe, it tended to be reserved for grand occasions. In Russia, opulence was the signifying character of every aspect of Imperial life, and it was manifest on a scale and with a frequency that were noticeably distinct from those of all of its European counterparts. In fact, with the possible exception of the Pharaohs of Egypt, no other rulers in history so consistently fueled an insatiable thirst, a constant search for *more* as did the Russian aristocracy.

---

Fifteen years ago, long before the faintest thought of *glasnost,* New York artist and designer J. C. Suarès became aware, in the course of researching another project, of how great a quantity of Russian Imperial art had survived the Revolution. Much, he learned, had been preserved in Russia, and more still was in circulation abroad.

A smallsword from the Tula Factory from the period of Catherine the Great, circa 1785; a portrait of the Grand Duke Cyril Vladimirovich by Constantin Makovsky; a Russian chair from the early nineteenth century; a green faux marbre table from the late eighteenth century, from the Hermitage; a Russian Imperial Factory vase from the period of Nicholas I; a painting of *The Banks of the Kama*, by Ivan Shishkin, 1882. OVERLEAF: *The Boyar Wedding* by Constantin Makovsky, 1883.

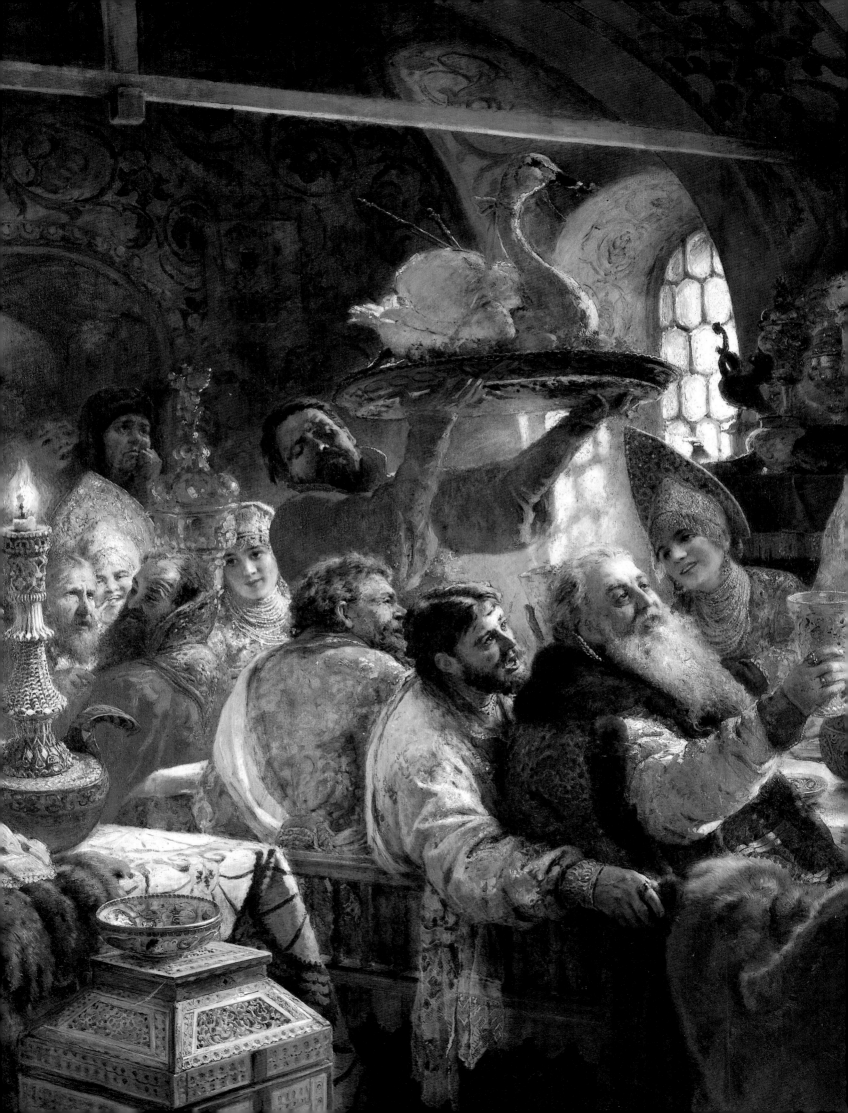

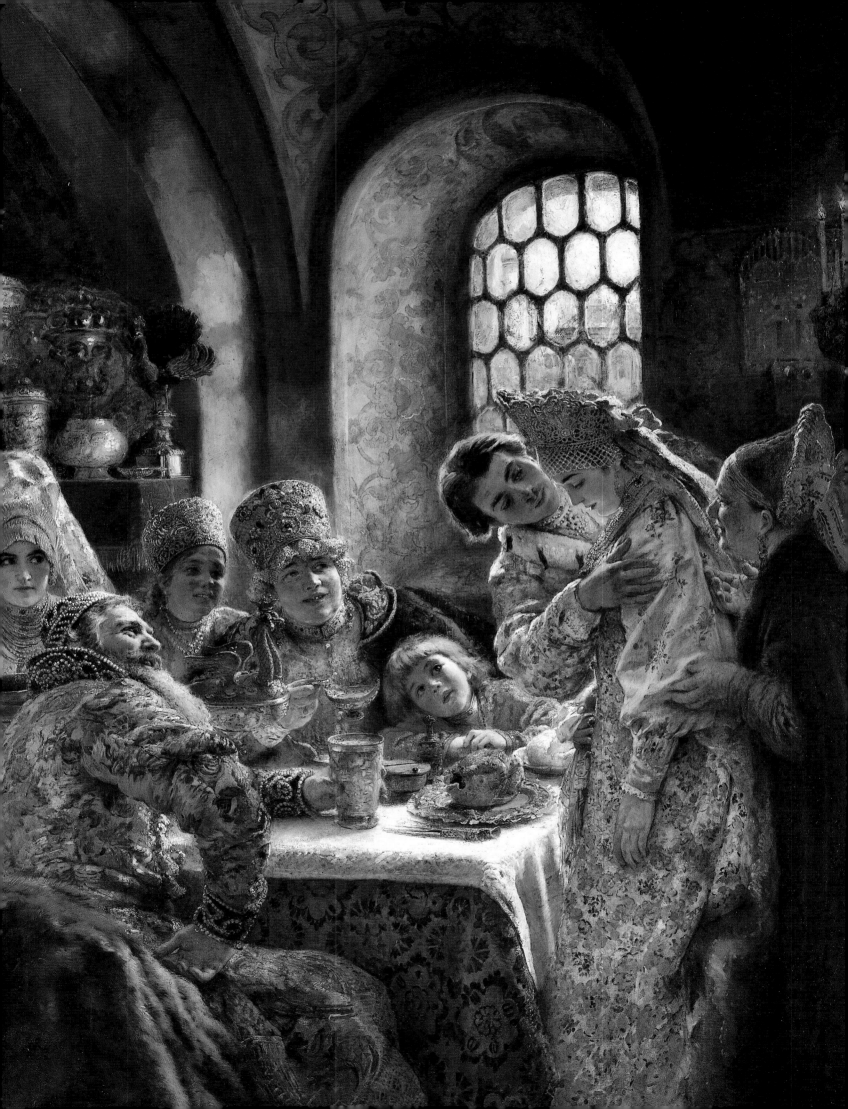

Thoroughly engrossed, he began nurturing the idea for a book on the subject. At length, he approached Ray, Paul, and Peter Schaffer, owners of the New York gallery, A La Vieille Russie. He looked specifically to the Schaffers both because they are among the world's leading experts on the Russian arts and furniture and because they have been living in the midst of it all their lives. The Schaffers not only agreed on the significance of such a book but also felt that rather than showcase the vast collections of European treasures imported by the Czars, it should focus on works created by Italian, German, English, Scottish, French, and Russian artists *in* Russia.

This astonishing range of styles and assimilation of craft traditions is most dramatically illustrated in the Russian Imperial palaces, three of which—Pavlovsk, the Catherine Palace at Tsarskoye Selo (now known as Pushkin), and Peterhof, (now known as Petrodvorets)—were reopened during the late 1970s. Virtually demolished during the German invasion of World War II, these Imperial residences underwent thirty years of intensive restoration. At Pavlovsk, the country residence built by Catherine the Great for her son, Czar Paul I, and his wife, Maria Fyodorovna, experts had to reconstruct bas-reliefs, tempera-painted silks, large grisaille friezes, frescoes, and ceilings. Fortunately, many original lamps, draperies, and art objects had been saved, as were bronzes by Gouthière and Thomire and furniture by the French master Henri Jacob and the brilliant German designer David Roentgen.

Using original architects' drawings and prewar photos, the walls, moldings, and ornaments of the baroque, thousand-room Catherine Palace have been painstakingly pieced back together. The resurfacing of the *boiserie* in the Great Hall alone required

twenty pounds of feather-light gold leaf. A portrait of Peter the Great, found in fragments scattered in the snow, had to be reconstructed. Here, however, as at Pavlovsk and Peterhof, much of the furniture, art, and canvas-painted murals, which were hidden in fields and secret vaults, were recovered and used to refurnish the palace. Nevertheless, its chief restorer foresees twenty more years of work ahead. In light of all that is involved, it is to the great credit of the Soviet government that out of veneration for the art produced during the Imperial era, and a recognition of the urgency of restoring it while Russia's knowledgeable craftspeople were still alive, the country has insisted, at great cost, on the most careful and consistent preservation of these treasures possible.

Public access to the Imperial palaces, and the increased circulation of Russian objects abroad have reinvigorated interest in Russian art. Contrary to popular thought, most Russian art and furniture was not smuggled out by émigrés during and after the Revolution. Rather, much of it was brought to Europe before 1917 to furnish French, British, and even American (particularly Californian) pieds-à-terre of the highly international Russian aristocracy. These monied Russians traveled widely, purchased avidly, and commissioned amply. Some of the finest pieces of Russian Imperial art, like the Karl Briullov portrait of Countess Samoilova (page 26), now at the Hillwood Museum in Washington, D.C., were actually painted in Italy. In addition, the Soviet government sold a great amount of work both privately and at public auction.

Broadened interest in the Russian arts has, naturally, brought about an escalation in their value. Russian painting has been increasing in worth geometrically as have

the Russian decorative arts, the most obvious example of which is the work of Peter Carl Fabergé, goldsmith to the Crown. Icons, which were once the exclusive form of painting in Russia (with the exception of frescoes), have rarely been sold for lofty sums. Nonetheless, collectors who acquire art for its spiritual value continue to seek icons enthusiastically. What's more, these antique examples are also sought by collectors who have been unable to obtain the Russian icon's close cousins—extremely rare Italian primitives (religious paintings made between the fifth and fourteenth centuries). Russian furniture, unlike that made in most of the rest of the world, which is intended to stand alone, was designed as an integral part of the architecture. It is prized today, in part, as a tribute to the Russian artists whose designs exhibit the strength to work successfully outside their original contexts.

As bold as they were at visual endeavor, the Russians were equally quick at absorbing entire artistic traditions. (Remember, while the West was experiencing its Renaissance, Russia was still in the midst of the Tartar wars.) Once they assimilated the principles of spatial perspective and portrait painting, they quickly found ways of adapting them to Russian taste and temperament. This forthrightness accounted for their being not only adept creators but also keen collectors. For example, Catherine the Great dauntlessly acquired numerous superior European art collections, and the Russian merchants, Serge Shchukin and Ivan Morozov, who were traveling to Paris in the late nineteenth century, dared to purchase hundreds of paintings by the then-uncelebrated French painters Renoir, Degas, and Matisse.

Ten years ago, Russian art and furniture were purchased primarily to be used as accents. Even then, many who acquired Russian pieces were less aware of their

provenance than of their power to tie together a French- or English-style room. Today, with the ever-growing changes in the East and the revived taste for its exoticism, the Russian Imperial style has grown from an accent to a dominant theme, prompting people to compose not merely with Russian objects but also with the Russian spirit.

L.C.

New York City

# INTRODUCTION

*In Russia all must follow the Imperial whirlwind, smiling unto death.*

—Marquis de Custine, who traveled in Russia in 1839

Empress Catherine II of Russia arose from her bed in St. Petersburg's thousand-room Winter Palace on the morning of September 1, 1762, in a mood of eager anticipation. Having deposed her feckless husband, Czar Peter III, in a bloodless coup two months earlier, she was about to embark on her coronation journey to Moscow, the old capital where Russia's monarchs traditionally were crowned. Although the trip through the forested hills, sprawling countryside, and winding riverbanks would require thirteen days, Catherine did not fear for her comfort. Her sleigh, built for the occasion, was designed like a miniature palace on runners, complete with a salon, library, and bedroom. It had six windows, was heated by porcelain stoves, and was wide enough to allow eight people to pass abreast. Behind this conveyance—in a procession that included 19,000 horses—would follow 14 large sleighs and 184 smaller ones carrying the Empress's court. Along the journey, 600,000 silver coins would be tossed to the crowds lining the roads.

A German-born princess, Catherine had grasped quickly upon her arrival in Russia eighteen years earlier that color and grandiosity were keys to the Russian heart. Now, having at last secured the Crown, she was determined to burnish her image as a true Muscovite: She had planned a coronation so extravagant it would

A group of decorative objects that could have been in a Russian noble's home, romanticizing pastoral life, including a porcelain floral Easter egg, lacquered objects, pieces from the Tenitsheva Workshops, and embroidered headdresses.

glow forever in Russian memory. She would wear a silver brocade gown on which the Imperial eagles were embroidered in gold and with sleeves sewn with five rows of Belgian lace. The train of the gown would be carried by eight gentlemen-in-waiting, and an ermine mantle crafted from 4,000 pelts would fall from her shoulders. Her crown, shaped like a bishop's miter, was made of 5,000 diamonds, hundreds of pearls, and a 415-carat ruby purchased a century earlier by Czar Alexis I from a Chinese emperor. At the top of the crown, surmounting the ruby, stood a cross of diamonds, and in the band surrounding the head were set diamonds, each an inch wide, encircled by solid masses of smaller diamonds. Seventy-six perfect, large rose-colored pearls bordered the central arch. With characteristic boldness, Catherine herself would place the crown on her head.

Moscow was frantic with activity. Tall Siberians in fur-lined coats, Caucasians in red costume, Turks in tasseled fezzes, cavalry generals in gold-trimmed red tunics, and bands of high-booted Cossacks filled the streets. Heralds in medieval costumes proclaimed the event throughout the city. Residents whitewashed their wooden houses, hung strings of evergreen across their doorways, and draped the white, blue, and red Russian flag from their windows. At the entrance to the city they erected four triumphal gates and hung a new bell in the tower named for Ivan the Great to ring in Catherine's arrival.

Before reaching Moscow, Catherine transferred from her sleigh to a velvet-lined, gold and white carriage decorated with scenes from classical mythology and topped with a replica of the Imperial Crown. Four white Neapolitan horses drew it down the four-mile approach to the city, which was lined with a ribbon of troops to hold back the throngs gathered to hail the new Empress. First came the gold-helmeted

Imperial Guard cavalry on horseback, followed by the Cossacks of the Guard in long red and purple coats, black boots, and curved sabers. Behind them rode Moscow's nobility, dressed in gold and crimson with jeweled medals pinned to their chests. Next, on foot, came the Court Orchestra, the Imperial Hunt, and the court footmen in red knee breeches and white silk stockings. Finally, the officials of the Court, dressed in brilliantly embroidered uniforms, appeared, signaling the coming of the Imperial carriage. As it reached the first triumphal gate, waiting trumpeters and kettle drummers struck up a musical salute.

The carriage clattered through the streets of Moscow to the Kremlin where, at last, Catherine alighted. Striding to her place behind the long-bearded, golden-robed priests who would perform the coronation Mass, she proceeded to the Assumption Cathedral. Inside, frescoes illuminated with candles enlivened the walls and ceilings. Before the altar stood the iconostasis, a golden screen covered with jeweled icons, and at the front of the Cathedral the seventeenth-century Diamond Throne of Czar Alexis (in which were embedded 870 diamonds—one armrest alone was set with 85 diamonds, 144 rubies, and 129 pearls).

Among the invited guests who filled the church were Circassian princes, Mongol officers, Greek-Orthodox noblewomen, Mohammedan princes, as well as kings, queens, and potentates from the many lands of the Empire, all of them subjects of the new Czarina. Anthems of the Orthodox Church, sung by fifty choruses, resounded through the domes of the church as the priests and the Archbishop of

OVERLEAF: Arranged on a carved and polychromed oak table with petrified wood made in the Talachkino Workshops around 1900 are a group of hardstone objects. Clockwise, from top right, an Imperial jewel chest (1864) made of lapis lazuli mounted in silver, by Samuel Arndt, a Court jeweler, from the personal boudoir of Maria Alexandrovna; a gold-mounted purpurin clock and floral basket by Fabergé; a nephrite monkey bell push, the enameled cigar used as the push, by Fabergé; an apple-form gum pot by Fabergé; a nephrite and pearl flower by Fabergé; a malachite gilt bronze sled with rock crystal ice.

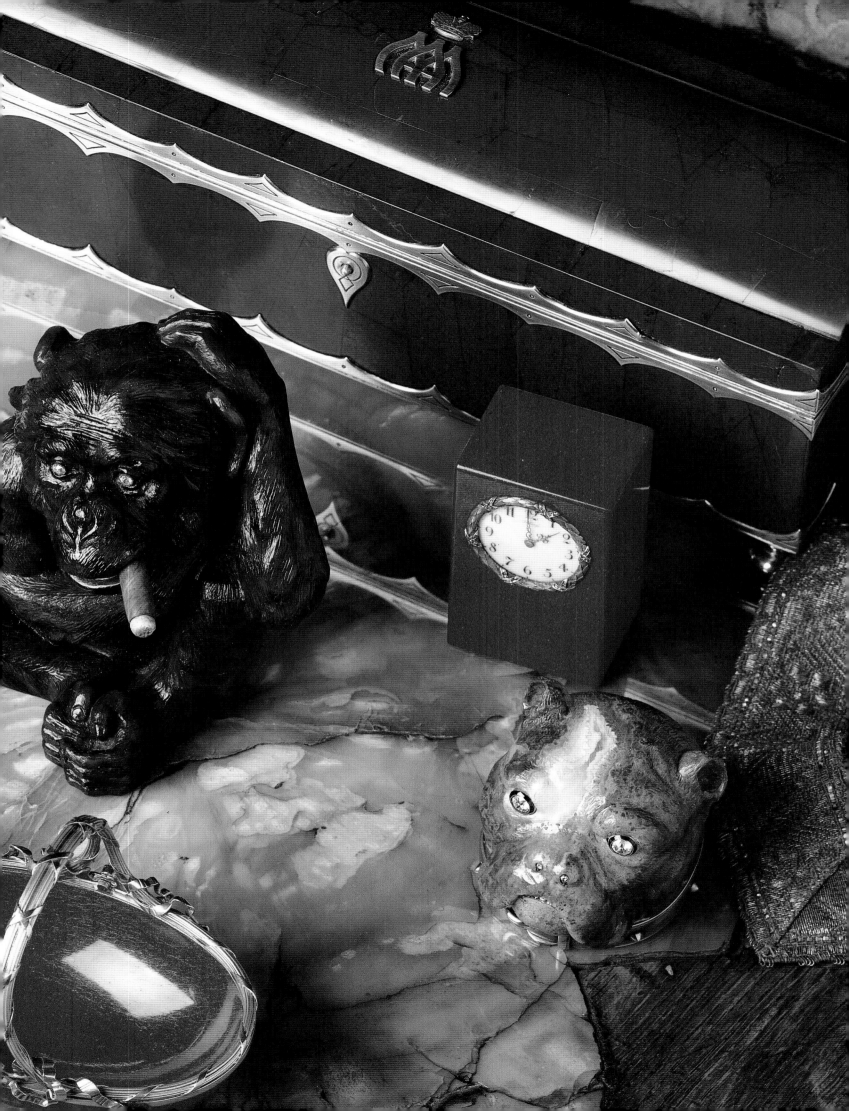

Novgorod gathered at the altar to anoint the new Empress. The ceremony lasted five hours and culminated with the oath and coronation: Catherine first swore "to rule the Empire and preserve autocracy as Empress and Autocrat of all the Russias," then crowned herself and turned to walk back through Ivanov Square, her procession flinging coins to the cheering crowds. A cannon salute thundered through the sky and the bells of thousands of churches rang across the countryside.

Catherine's coronation succeeded in proving her the most regal, the most Russian of monarchs. But, as if this event were not spectacular enough, the new Empress added to it a week of public feasts, receptions, celebrations, and fireworks displays. These were followed by weeks more of private festivities, which continued into the usual winter social season—a constant round of balls and masquerades, operas and plays, festivals and feasts, weddings, games, and excursions, all of which culminated in a three-day public masquerade in January 1763, involving 4,000 actors and musicians.

Although the coronation of Catherine II was, without question, the most extravagant event of the century, it established a standard of style and ceremony by which the Russian aristocracy would measure itself throughout the Imperial era. It was impossible for foreign travelers in eighteenth- or nineteenth-century Russia not to be struck by the lavishness of aristocratic hospitality, the size of noble households, and the richness of everything they touched. From palaces to manor houses even the simplest objects were made of costly materials. "The discovery of quantities of semiprecious stones in the Ural Mountains [in the nineteenth century] made everyone who could afford them long to use them," explains the writer Audrey Kennett, author of *The Palaces of Leningrad.*

Walls were ornamented with porphyry, amethyst, jade, jasper, and agate; furniture was decorated with gilded bronze; vases and dinner services were made of glass as well as of porcelain—and there were periods when nothing but silver was good enough for plates and goblets. . . . Servants were clothed in purple velvet laced with silver or crimson and gold, and for galas, the gentry had liveries made expressly for each occasion.

The Russian rapture with Western taste was initiated in the early eighteenth century by Peter the Great who imported the European style as a means to reassert the idea of power in this land where, ever since the sixteenth century, the czars had either shown too much madness or had behaved as either tyrants or sacrificial lambs. Peterhof, Peter's summer palace on the Gulf of Finland, for which he recruited architects from the court of Louis XV, became known as "the Versailles of the North," and was, like his capital, the fruit of Peter's stubbornness and ideas of "grandeur."

Russian culture, however, did not attain the level of refinement to which Peter ultimately aspired until Catherine II assumed the throne. Under her predecessor, Peter's daughter, the Empress Elizabeth Petrovna, the court had been subjected to the supercilious amusements of dwarf acts, jesters, and nightly gambling and card playing. In her diary, Catherine lamented how "these entertainments were essential at a Court where there was no conversation, where everybody cordially hated everybody else, where slander took the place of wit. . . . Intricate intrigues were mistaken for shrewdness, Science and art were never touched on, as everybody was ignorant of those subjects; one could lay a wager that half the court could hardly read and I would be surprised if more than one third could write." Catherine, a woman of vast cultural curiosity, changed all of that.

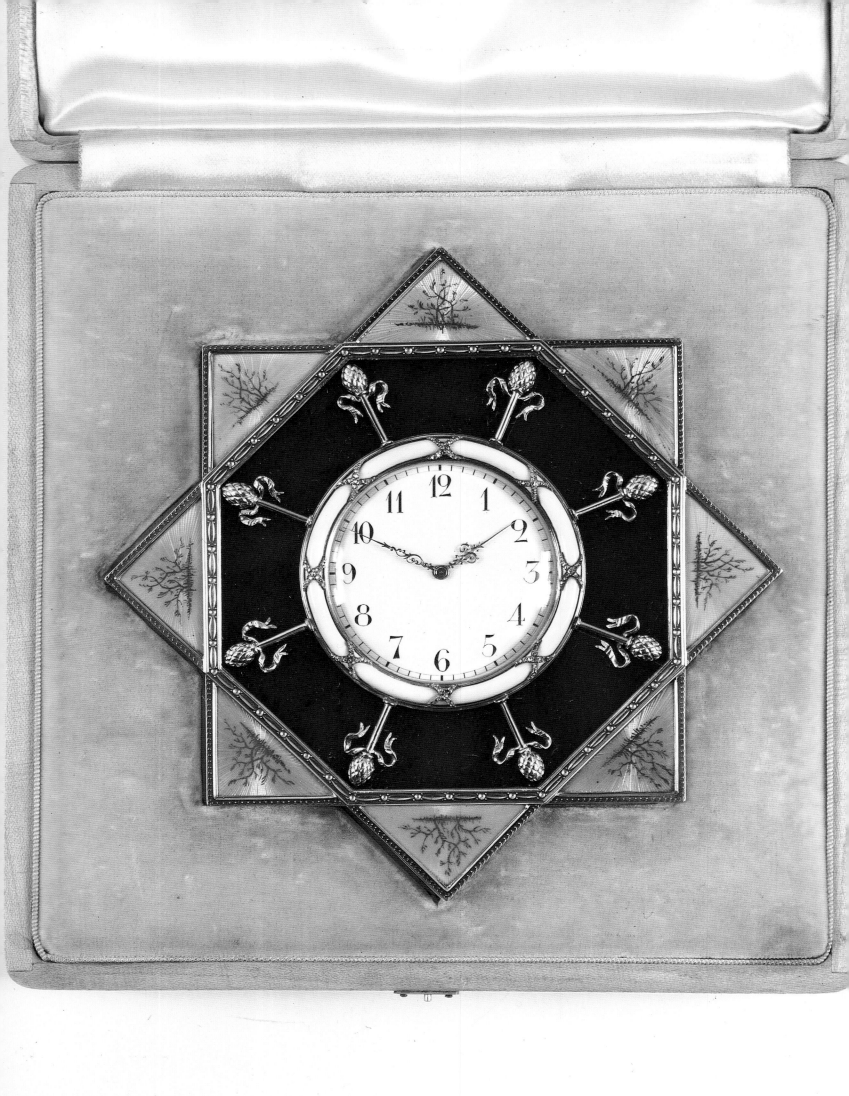

In 1912, the Russian writer U. Shamurin wrote, "Studying art, reading memoirs and diaries, one would think that there was never in the history of Russia a time so cultured, beautiful and noble [as Imperial Russia]. With its

> beautiful buildings, love of literature and cruel pastimes; the exquisite French used in letters and memoirs, alongside Russian signatures, garments of the latest London style, and rudeness of manners. Studying the manners and social customs of the period, one comes to the conclusion that the eighteenth century in Russia was a dark, hypocritical period of feudalism. . . . The truth is neither here nor there. In the realm of material culture the aristocracy fully succeeded in rising to the Western European level; they managed to develop a fine appreciation of aesthetic treasures, to acquire the words of Western thought and literature. But only to *acquire* it; they could add nothing. Those who wished only to make merry had nothing of their own to contribute. The mind of an enlightened aristocrat reflected the shape of Russia in those days: There stood the manor-house with its architectural wonders, its exquisite colonnades, its library of intellectual books, its imported pictures, marble, splendid wrought-iron fences, and colors. But if one were to go out beyond the front gate, he would see an empty, uninviting Russia—straw huts, swamps, heavy grey clouds over the fields and everywhere a black, dead land, waiting for its worker!

For, in truth, despite the extraordinary cultural accomplishments of the Russian landowning gentry—that minuscule proportion of the population in which the nation's wealth was concentrated—Russia remained a cultural wasteland. Its villages were inhabited by peasants whose fathers had been serfs and who themselves clung

The Polar Star Clock by Fabergé, in eight-pointed pink enamel and nephrite, suggesting a compass rose. The white enamel border is in the form of a life preserver with rose diamond ties. It was probably designed for use aboard the Imperial yacht, the *Polar Star*.

to traditional patterns of life. Those patterns were the result of millennia of struggle toward civilization, and represented deeply rooted forces from the East as well as those newly introduced from the West, which, together, combined to shape the country's diverse culture.

Until Peter I, Russia had been a nation without a modernizing influence. And until the tenth century, it had been little more than an uncivilized amalgam of nomadic tribes of Slavs. Since the thirteenth century, it had been ravaged by invaders—rolling through the Russian steppes from the east, and from Scandinavia in the north: The Slavs and Scythians dominated Russian territories in the centuries before Christ and were followed throughout the next several centuries by the Huns, Avars, and later the Vikings. As late as the thirteenth century, the Russian capital—then Kiev—was besieged by Tartars and its population enslaved for 200 years.

Determined to civilize "Rus" (the earliest name known to designate the peoples living in what is now European Russia), Prince Vladimir of Kiev turned, in A.D. 988, to the one power he felt could impose an ethical foundation on this long-vanquished land—religion. He sought a mystical order visual and sensual enough to compel his nation of peasants, and he found it in Eastern Orthodox Christianity. After sending emissaries to investigate each of the four principal faiths of the time (Roman Catholicism, Judaism, and Islam being the other three), his envoys returned from Constantinople with descriptions of gold-domed churches filled with fantastic jeweled images, and religious services conducted in a sensuous atmosphere of candlelight, burning incense, and celestial music, an atmosphere "so wondrous we knew not whether we were in heaven or earth."

Christianity not only provided the ethical foundation Prince Vladimir sought and

united Russia spiritually but also generated the development of handcraft and the creation of sacred art, a form fundamentally imported from Byzantium. In one swift stroke, Russia became a land of artists and artisans: Thousands of countrymen took up glassmaking and enameling to produce the wealth of religious objects called for by the Church. Thousands of others devoted themselves to the making of icons, holy paintings that served as "windows on eternity," symbols of the threshold between the secular world and the divine. As rugged young converts, the uncritical Russians were far more intent on beautifying their new churches and worship services than on analyzing dogma. Their theology was one of pictures rather than words. Within decades, every Russian home and hut, even that of the poorest peasant, displayed a vividly colored, precisely constructed, divinely inspired icon.

Churches, too, proliferated throughout every city, town, and village. The vast forests of the Russian north made wood abundant and cheap, and enabled wooden architecture to take precedence over stone. Accustomed to working with wood—and in prescribed methods set over centuries of peasant life—the Russians were carpenters rather than architects, and, as such, applied their traditional techniques of wood construction to their churches. Most churches were designed with snow-shedding onion domes and tent roofs, different in style from the hemispheric domes of the Mediterranean world to the south and the spires of Baltic Europe to the west. They often displayed ridged *kokochnik* gables, named after the headdress worn by unmarried girls, which were used because their steep slopes also easily shed snow.

OVERLEAF: A mahogany and gilt wood canape from the early nineteenth century with a portrait of a young lady by Tyranov, and a piece of Imperial brocaded silk. FOLLOWING PAGES (*front row, left to right:*) the Hen Egg (the first Imperial egg), the Spring Flowers Egg, the Rose Bud Egg, the Coronation Egg, the Lily-of-the-Valley Egg, the Cuckoo Egg, the Chanticleer Egg, the Orange Tree Egg, the Fifteenth-Anniversary Egg, the Cross of St. George Egg (the last Imperial egg); (*back row, left to right*) the Resurrection Egg (the second Imperial egg), and the Renaissance Egg.

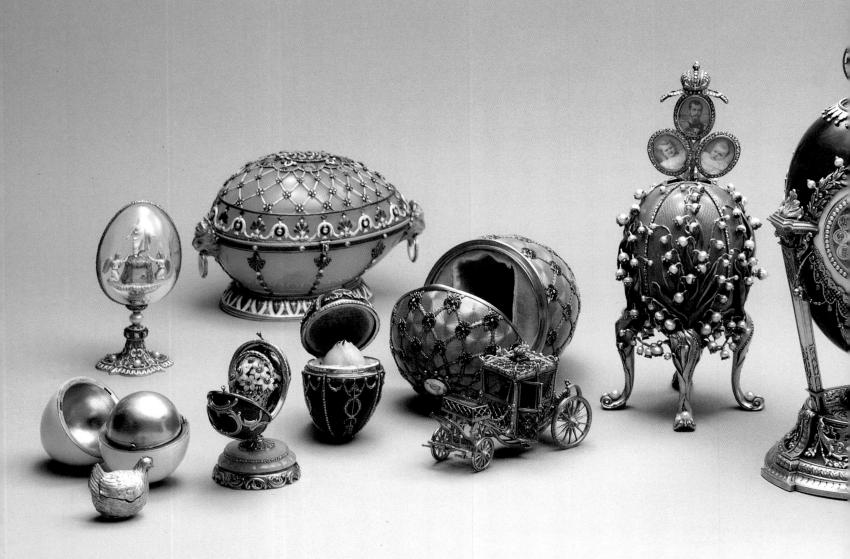

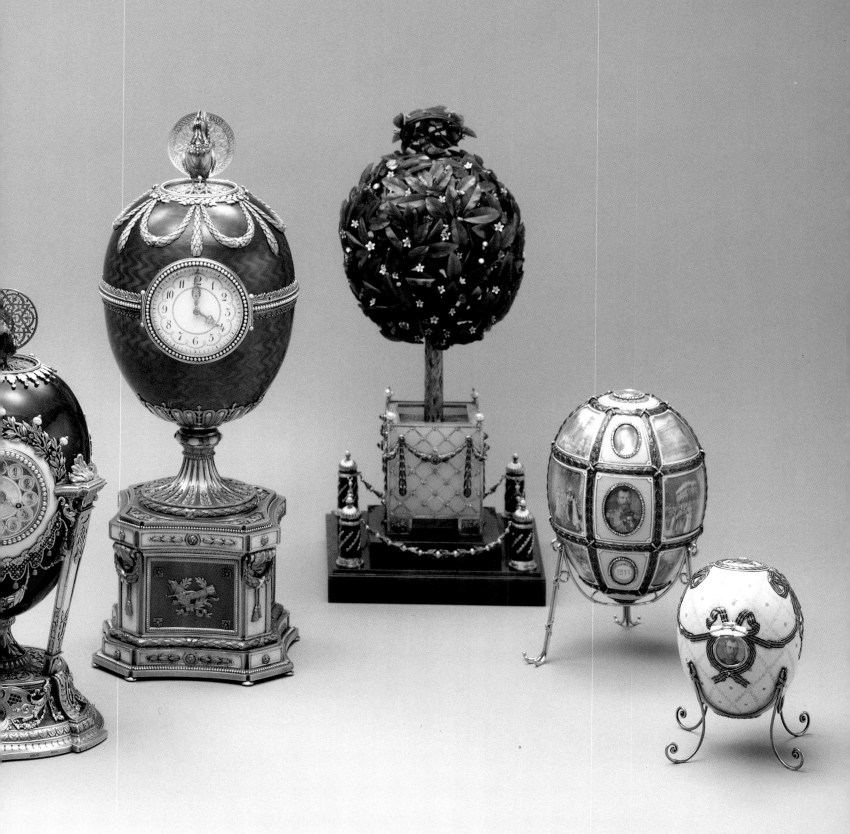

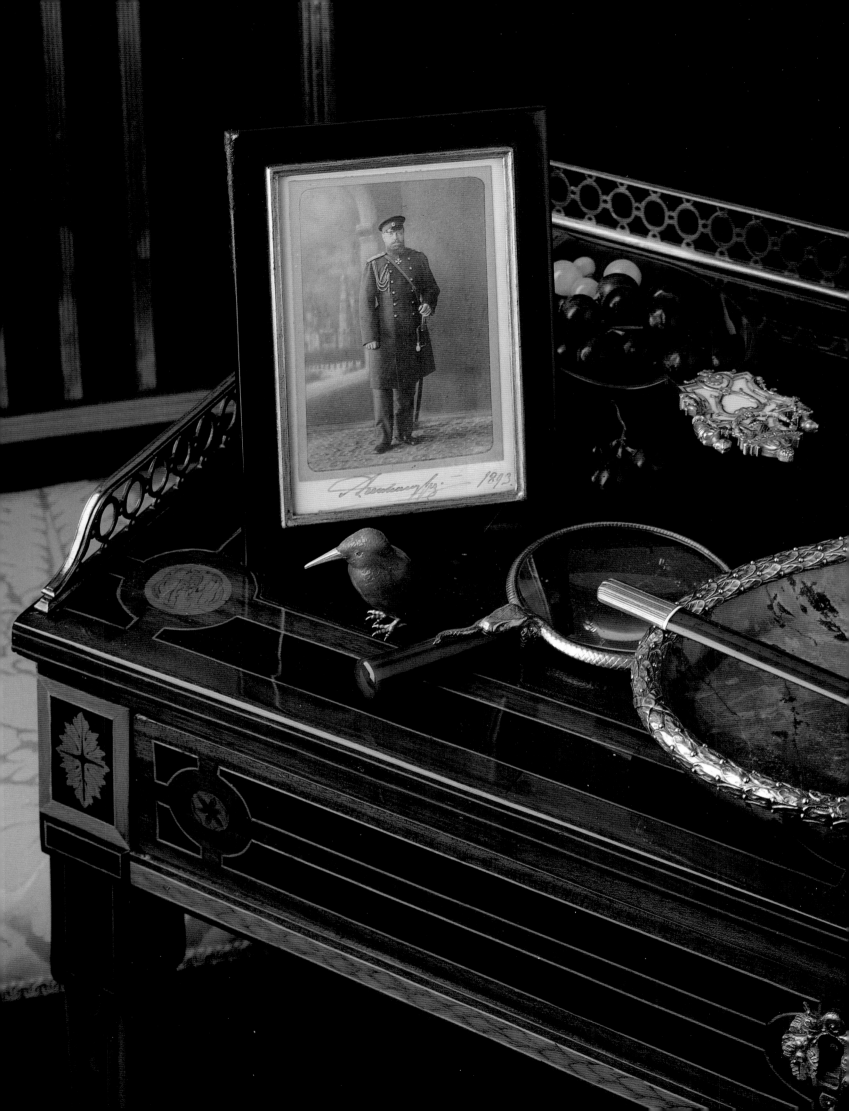

Evolved from the vaults of Byzantine architecture, these exotic gables added to the churches' intricate appearance.

As religion became an ever-deepening source of solace and strength, church architecture grew to symbolize the Russians' unending desire to bring the house of God into even closer contact with daily life. In an effort to unite this world with a higher one, churches and palaces came to be built in total concert: the church situated in the center of a palatial ensemble with secular buildings arranged at the sides like wings. This ideal of equality between Church and government lasted until the eighteenth century when, in 1718, Peter the Great rescinded the Church's independence, turning it, in effect, into a governmental department and encouraging the bureaucratization of the Church that continued throughout the eighteenth and nineteenth centuries. During the Imperial era, from Catherine the Great to the end of the Romanov dynasty, churches reflected the tastes of individual regents.

St. Isaac's Cathedral, for example, built by the militant Czar Nicholas I during the first half of the nineteenth century, gives eloquent testimony to this emperor's Napoleonic character. An imposing neoclassical edifice of overblown proportions, it was the first structure in Russia constructed of cast iron. Its copper-sheathed dome, the third largest in the world (after St. Peter's in Rome and St. Paul's in London), dominated the St. Petersburg horizon throughout the seasons. Its interior combines white marble from Italy and pink marble from France with green and gray Russian marble, and the massive columns are lapis lazuli, and malachite, bronzed at their bases and capitals. Heavy-handed in its grandeur, St. Isaac's is monumentality run mad.

Like St. Basil's Cathedral in Moscow—the masterpiece of Ivan the Terrible's

A writing desk from Pavlovsk, late eighteenth/early nineteenth century. On the desk is an autographed photograph of Alexander III, dated 1893. The other objects, including the chrysoprase and gold Kingfisher figurine, are by Fabergé.

reign—St. Isaac's served to deify the monarch who created it. It was more an exclusive place of worship than a public church, in keeping with the Byzantine tradition of the emperors of Constantinople, whose glamour and glory the Russian dynasty emulated.

This quest for grandeur was not merely a *class* characteristic in Russia, but a national one. Obviously, among the nobility, excess was standard: For example, one noble, Count Razumovsky, reportedly kept a thousand servants in his palace in St. Petersburg, and the Sheremetev and Stroganov families each possessed forty to fifty thousand serfs. But even modest landowning families spent far above their means as a matter of course. Obsessed with social standing and with attracting suitors for their daughters, they customarily indulged in dress, entertainment, and the costly social seasons in Moscow, to which they traveled with all their belongings. Some householders hosted twenty people at table twice a day.

Nor were the owners of Russia's great estates known for careful calculation of expenses. Families constantly strove to outshine one another, and prudence was foreign to their natures. Just the simple keeping of conveyances could be enough to erode the value of a landowner's property over the course of many years: Often the master, the mistress of the house, and even, in some families, the children would have carriages of their own, each requiring uniformed coachmen and several sets of perfectly matched horses. The Frenchman Théophile Gautier described arriving at a St. Petersburg hotel in 1865 "where the most varied series of vehicles appeared in the large courtyard: sleds, troikas, droshkys, kibitkas, post chaises, traveling-coaches, landaus, char-à-bancs, summer and winter coaches; for in Russia nobody walks, and

if one sends a servant to buy cigars, he will take a sledge to travel the one hundred feet that separate the house from the tobacco shop." The Russians disliked their own carriages and therefore imported ornate equipages from France and Holland, which were painted red, green, gold, and silver, embellished with wrought iron and carved wood ornamentation, and lined with costly furs, velvet, and gold lace.

Open house was another extravagant Russian social tradition. Nobles with estates in the country—near the city or on islands in the Neva River—often threw their palaces open to the public during summer months, providing, without charge, refreshments, bands, dancing, sailing, fishing, swimming, and elaborate fireworks displays. The Court itself set the example by giving two open houses each year— one at New Year's, when up to 30,000 guests of all classes filled the thousand-room Winter Palace, and the other during summer solstice at Peterhof, twelve miles outside St. Petersburg. As many as 150,000 people came each year to celebrate the famed "white nights," when the sky stays light nearly twenty-four hours a day. Their Majesties as well as St. Petersburg society also gave numerous balls, banquets, ballets, concerts, operas, private parties, and midnight suppers during the social season, which began on New Year's Day and lasted until the beginning of Lent. At the *Bal Blanc*, which honored the nobility's "virgin" daughters, white-gowned, unmarried girls danced the quadrille. Young married couples celebrated their connubial bliss at the yearly *Bal Rose*.

Balls given by the Court drew thousands of guests, all dressed in the most fashionable silks, brocades, and jewels. The women in their tiaras and the men in their high, polished boots arrived at the Winter Palace and were greeted by a parade of supremely outfitted footmen and servants. After disembarking from their car-

riages, they ascended a wide, carpet-lined marble staircase, known as the Ambassador's Staircase, which led through palm-lined, rococo galleries decorated with baskets of orchids, carloads of which had been rushed north by train from the Crimea. They would hear the ballroom before seeing it, for the din of gossip, envious exclamations, and clinking champagne flutes filled the palace. At precisely 8:30 P.M. the Master of Ceremonies would tap the floor loudly three times with a gold-embossed ebony staff crowned with the double-headed eagle of the czar, and the ballroom would come to an immediate hush. The gold-inlaid mahogany doors would swing open, and their Majesties would enter. Soon the room would become a carousel of dancers as the orchestra struck up a polonaise, followed by a chaconne, a mazurka, and, finally, a waltz. At midnight all proceeded into one of the Palace's grand banquet rooms where they would feast on a midnight supper of lobster salad, chicken patties, whipped cream, and pastry tarts.

If the spending habits of the landowning gentry were enormous, then those of the members and relations of the Court were beyond imagination. Grand Duchess Elena, sister-in-law of Emperor Nicholas I, gave one fete in which the interior of the great hall of the Michael Palace, her residence, was described by the Marquis de Custine as decorated with

> astounding richness: fifteen hundred boxes and pots of the rarest flowers form a fragrant grove. At the end of the hall, in a copse of exotic plants, one saw a fountain of fresh clear water where a sheaflike cluster of jets spouted continuously. These jets, lighted by clusters of candles, shone like a spray of diamonds. They cooled the air, which was kept in motion by enormous palm branches and banana plants, glistening with dew, from which the breeze of the waltz shook pearls of moisture onto the moss of the balmy grove.

Grigory Potemkin, Catherine II's lover, is reputed to have spent well over a million rubles during a four- or five-month stay in St. Petersburg. Count Shuvalov, Elizabeth's lover, had an annual income of 400,000 rubles, but spent on such a scale that he owed the Crown more than a million at his death. Added to this was the money spent by the nobility on gambling. Whole days, weekends, and even months could be devoted to "playing at cards," which meant gambling for very high stakes. The younger brother of Platon Zubov, another of Catherine II's lovers, once staked 30,000 rubles on a single card. In 1855, one man gambled 14,000 serfs from his estate—and lost.

When Nicholas II became Czar in 1894, his income from an annual treasury appropriation and from the profits of the millions of acres owned by the Crown (vineyards, farms, and cotton plantations) amounted to 24 million rubles (or 12 million dollars a year).* The value of the Imperial properties was estimated at 50 million dollars, and another 80 million dollars was tied to the treasures accumulated during the previous three centuries, including the royal jewels—among them, the Imperial crown and scepter with its 199.6-carat diamond, the 120-carat Moon of the Mountain diamond, and the 40-carat Polar Star ruby. Yet, despite his wealth, the Czar's expenses were so great that he often found his treasury bare. As the author Robert K. Massie has described, there were seven palaces to maintain, and in them 15,000 officials and servants required salaries, food, uniforms, and holiday gifts. There were the Imperial trains and yachts, three theaters in St. Petersburg and two in Moscow, the Imperial Academy of Arts, the Imperial Ballet (with 226 dancers to be provided for), and the Imperial Ballet School. In addition, every member of the

---

*By way of illustration of the value of a ruble, a 110-acre farm complete with houses and livestock would have cost, at this time, approximately 120 rubles.

Imperial family (with its great number of brothers, sisters, aunts, uncles, and cousins) received an allowance. Finally, in addition to the thousands of private requests made to the Czar for charity each year, hundreds of hospitals and orphanages depended on Imperial support.

Though not as vast, the debts of the Russian nobility were so great that when the question "What is the Verb conjugated most frequently of all . . . and in what Tense?" was asked, the answer, according to the *Universal Courtier's Grammar* was "Even as at Court, so in the Capital, no one lives out of debt; therefore, the Verb conjugated most frequently of all is: to be in debt." In answer to the question "Is this Verb ever conjugated in the Past Tense?" came the answer "Ever so rarely—inasmuch as he or she never pays his or her debts." And in the Future Tense? "The conjugation of this Verb in the Future Tense is in good usage, for it goes without saying that if one be not in debt yet, he or she inevitably *will be*."

———

Catherine the Great, once recovered from the months of coronation celebration, assumed the monarchy invigorated with energy and ideas for remaking Russia. Indeed, both were necessary, for the state of the nation was somber: Huge state debts and the lack of credit abroad had left the treasury empty; thousands of peasants and workers were on strike or in revolt; and within the bureaucracy, incompetence was rampant. Fortunately, Catherine was not hesitant about summoning the full measure of her political genuis. She planned to rule as persuasively and brilliantly as her predecessor Peter the Great, but without his despotic manner. In

A rare collection of objects by Hahn, Imperial Court jeweler, including presentation boxes with the monograms of Alexandra Fyodorovna and Nicholas II; a purpurin flower and clock by Fabergé; and an Imperial gift, the miniature Order of the White Elephant by Fabergé.

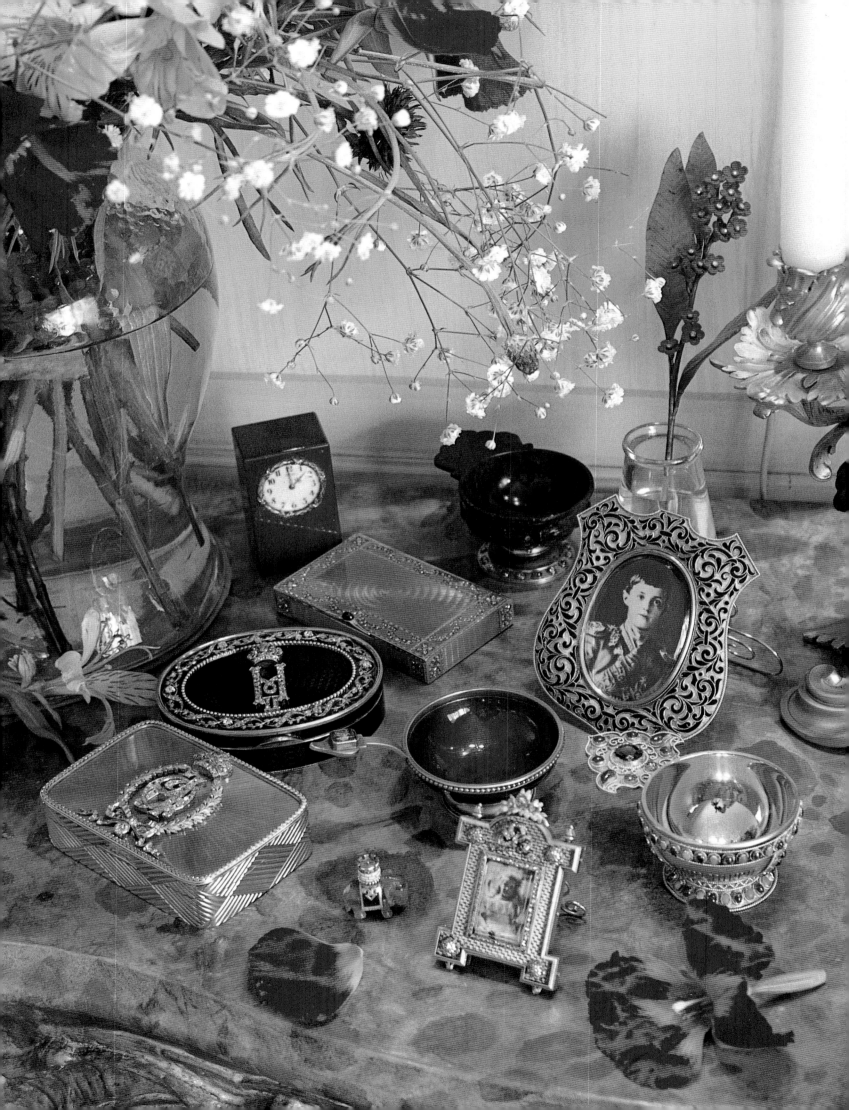

fact, however, were it not for him who, six decades earlier had forcibly amalgamated the disparate territories of Muscovy into the Russian Empire and pushed the western border of his giant domain closer to the European nations he sought to emulate, Catherine would not have had the means or the dynastic precedents by which to implement her imperial visions.

Peter the Great was a monumental builder (as Catherine would also prove herself to be). Out of an outstanding career that included military, political, educational, and cultural achievements, his greatest singular accomplishment was the creation of St. Petersburg, a European-style city built on a set of marshy islands (that belonged, technically, to Sweden and were no more than four to six feet above sea level) in the meandering Neva River (which was frozen six months out of the year). To erect his new capital, Peter had to battle the Swedes, the unforgiving Russian terrain, and a hostile climate. He put 150,000 Russian construction workers, Swedish prisoners of war, and convicts as well as 30,000 skilled artisans to work. Draining marshes (in which logs were laid for foundations), digging canals, and constructing buildings, they labored in bitter cold and were housed in clay huts insulated only with moss; small wonder that St. Petersburg has been called "the city built on bones." Known as Leningrad, since 1924, it is perhaps the only great city still in existence founded by a single autocratic will.

As a demonstration of his own will and of his determination to break with the past, Peter attempted to erect his city out of stone, even though there was none on the swampy site. In order to finance this undertaking—which also represented an

A photograph showing two of the Imperial daughters—Grand Duchess Olga (*above*) and Grand Duchess Tatyana (*below left*)—in their Red Cross uniforms beneath five gold enamel and jeweled brooches and egg pendants by Fabergé, made for use by the Imperial family to illustrate their leadership of the Red Cross.

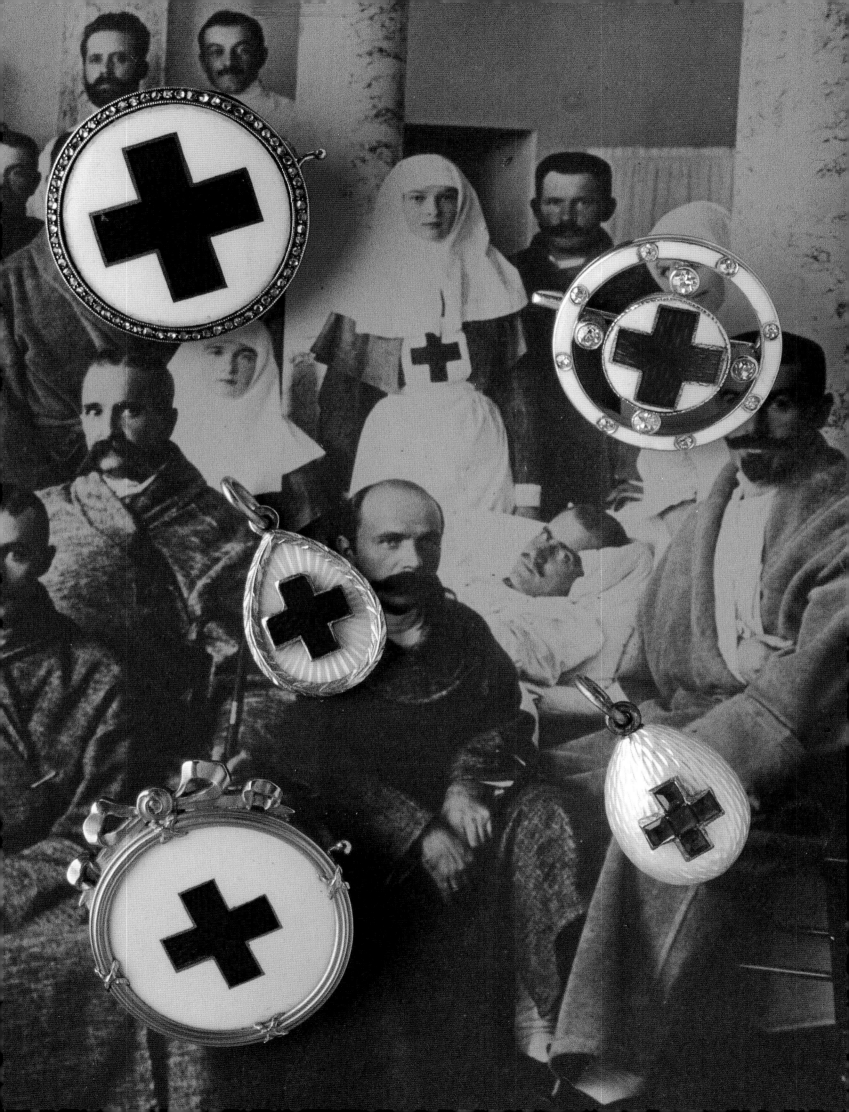

effort to supercede Russia's long tradition of wooden architecture—he enacted tariffs on wagons and ships, requiring them to bring in a specific number of stones whenever they entered the city, and he recruited architects from Copenhagen to design masonry buildings. But, despite these and other measures, Peter was not able to gather an adequate supply of stone. Finally, reconciling himself to a city of wooden architecture, he had the buildings painted and sanded to look like masonry.

After ten years of relentless labor, what began as an eighteenth-century boomtown—a violent, half-civilized place where nature was trying to reassert its dominion over the streets—grew into a city of palaces, parks, and fountains. In 1712, Peter declared it the official capital of Russia, forcing civil servants to relocate there. He further promoted population growth by passing an edict requiring every Russian nobleman to build a house within St. Petersburg's borders. (Construction costs were so high, many nobles complained, that the building of a single house had cut their fortunes in half.) By 1719, Peter's dream was complete: He had created a magnificent, homogeneously designed, Western-looking city that boasted more than 35,000 vividly colored buildings and a baroque palace that vied with the most ornate royal residences of Europe. St. Petersburg not only served as testament to the power of order and logic to dominate nature but also provided concrete evidence of Peter's determination to redirect the destiny of Russia.

As grand a city builder as Peter the Great was, he was also an astute military leader and a gifted architect of foreign policy: He was intent on gaining easy access to the world's oceans and went to war against the Tartars and Turks to break their grip on the Sea of Azov, through which Russian ships could reach the Black Sea and the Mediterranean. He created a navy in a single winter, using 30,000 carpenters to

build a fleet of thirty vessels, and was himself an accomplished woodworker. He had also studied geometry, military engineering, microscopy, architecture, mechanics, and dentistry. He brought Russia into the modern age by abandoning its previous calendar, which counted years from 5508 B.C., the supposed date of the creation of the world, in favor of the Western calendar, which counts years from the birth of Christ. He changed Russia's system of coinage (most coins in circulation were foreign) and remade the alphabet, discarding several letters and signs he considered obsolete and giving others a fresher, more readable look.

A great believer in education and travel, Peter opened vocational schools as well as schools of mathematics, navigation, engineering, medicine, and artillery. He established a Russian naval academy and instituted a service nobility, establishing a system by which citizens could ascend the ranks of society, so that, theoretically at least, even a serf could rise to become a gentleman.

After Peter the Great's death in 1725, Russia was ruled briefly by his second wife, the Empress Catherine I, a former serving girl who had once been the lover of Peter's chief adviser. Described as "extremely averse to business and particularly intemperate in the use of tokay wine, she could neither read nor write." She was, however, "pretty and of good temper."

Elizabeth, the favorite daughter of Peter I and Catherine I (conceived, however, ten years before their marriage), ascended the throne in 1741. She had been raised speaking fluent French because her father hoped to marry her to Louis XIV; instead, she devoted herself to a life of Imperial Russian indulgence. A lover of splendid attire, her wardrobe included gowns enough for her to change several times a day

OVERLEAF: A painted terracotta bust of Alexander I in full regalia.

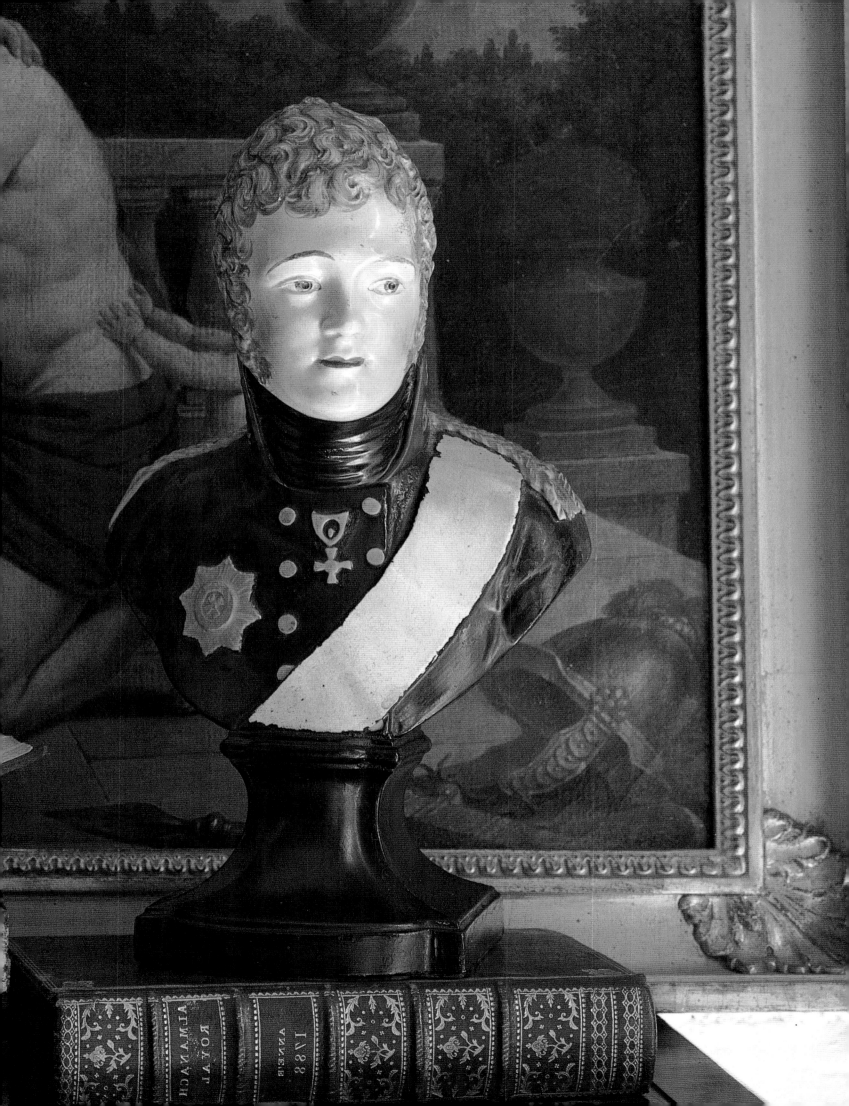

without ever wearing the same dress twice; she is said to have possessed 15,000 gowns at the time of her death.

Despite her love of luxury, Elizabeth managed to be extremely pious. Not surprisingly, she gave her attention more to splendid ceremonies of the Court and the Church than to government. Nevertheless, she established the country's first university and enhanced its prestige as a major European power. She was a patron of European architects, furniture designers, and couturiers, and during her reign St. Petersburg first achieved magnificence.

Being without issue, Elizabeth named as heir her nephew, who became Peter III, and who was, unfortunately, cruel, ugly, and degenerate. As a symbol of prestige and to avoid domestic complications, she scoured the courts of Europe to find a suitable wife for him. Her choice (one that would conciliate Prussia, a rising power on the European stage) was the sixteen-year-old German princess who, upon being baptized in the Russian Orthodox Church, became known as Catherine.

Clever and ambitious, Catherine, as wife of Peter III, heir to the throne, secured her position in the eyes of the Empress by embracing the Church, learning the Russian language, refining her French (the language of the Court) and, most desired of all, by eventually giving birth to an heir (though the father was probably one of her many lovers rather than the supposedly impotent Peter). In all matters Catherine outshone her husband, and after Elizabeth's death, Peter, fearing his wife's power, attempted to banish her. But being strong-willed and held in high esteem by the Court (which Peter was not), she quickly outmatched and outmaneuvered him. Soon realizing that abdication was his only recourse, the Czar went into exile. He died a

few days later under circumstances Catherine reported as "mysterious."

A woman of enormous energy, passion, and intelligence, Catherine determined to restore Russia to the momentum of Peter the Great's time. She rose every morning at 5:00 A.M. and worked fifteen hours a day. She was an avid builder, collector of art, and patron of literature. She wrote memoirs, letters, a history of Russia, fairy tales, allegories, comedies, tragedies, adaptations of Shakespeare, and comic operas. She replaced the previous Dutch and German influence on the Court with the French and acquired art works (4,000 paintings alone, among them 25 Rembrandts) from Europe. These became the foundation of the extraordinary collections now housed in the Hermitage in Leningrad.

Famed also for her long list of lovers, Catherine was described by Denis Diderot as having "the soul of Caesar and all the seductions of Cleopatra." Her generosity equaled her ambitions. To placate her lover of twelve years, Count Grigory Orlov (to whom she bore three illegitimate children), who wanted more than anything to rule at her side, she showered him with titles, estates, thousands of serfs, a suit covered with diamonds worth more than a million rubles, jeweled and enameled snuff boxes, miniatures, sword hilts, watches, jeweled Easter eggs, and a 3,000-piece Sèvres service, known as The Cameo Service (now in the Hermitage). In return, he presented her with the world's fourth largest diamond, the 199.6-carat Orlov Diamond (said to have been stolen by a French soldier from the eye of an Indian idol) for her scepter. Her favorite lover, however, was Grigory Potemkin, a soldier, politician, poet, builder, artist, administrator, and debauchee. One envoy to the Court recounted being received by Potemkin, who was reclining on a chaise longue in a fur robe and slippers and running his fingers through a pile of unpolished gems

while being read ancient Greek literature. He once hosted an intimate party at which the twenty-four invited couples were entertained by an orchestra of 300 musicians and a private company of actors and dancers. Potemkin had them called to the dining room at the appointed hour by a Persian servant riding atop a mechanical elephant encrusted with emeralds and rubies.

It was under Empress Catherine II that Russia rose to the position of a world power. A vigorous expansionist, she added more than 200,000 square miles of land to the country and built 100 new towns. She twice warred against Turkey—she and Potemkin dreamed of driving the Ottoman Turks from Constantinople and making it the capital of a new, Christian empire. In 1793, she annexed the Ukraine from Poland, and when Russia, Austria, and Prussia consumed Poland in 1795, Catherine took the lion's share of the country, which was divided between the three conquerors.

In 1787, the Empress appointed Potemkin governor of the recently annexed Crimea, which she had seized from Turkey on his advice. In order to impress her with his colonizing efforts, the canny statesman organized a grand tour to show off the new land: First the Imperial caravan traveled south from St. Petersburg in 200 sleds to the Dnieper River where they boarded a flotilla of boats designed to look like ancient Roman barges, each equipped with its own orchestra. Along the way they passed the new towns Potemkin had built as well as stage sets of building facades he had contrived far enough away so that the guests could not tell they were fakes. While ragged peasants were kept out of sight, neatly dressed families were lined up along the roads for Catherine to inspect from her coach. From this elaborate contrivance grew the phrase "Potemkin village"—meaning a magnificent hoax.

It was Peter the Great's genius to import the influences of Europe to Russia on a

major scale; it was Catherine the Great's to first lead the country into participation with the political and cultural forces of Europe. With the Age of Enlightenment, eighteenth-century intellectuals advocated a rational, humanistic view of the world over one dominated by religion, and Catherine cultivated the liberal European thinkers of the time. As well as promoting publishing endeavors (during Peter's reign, 7 books a year were published; under Catherine's, the number reached 8,000), she initiated the translation of a great body of European literature into Russian. She herself carefully read the works of Montesquieu and Voltaire, corresponding with the latter until his death. In fact, she was so captivated by his intellectual prowess that she bought the renowned philosopher's personal library, as well as that of Diderot, and had them installed in the Hermitage.

Yet even as she enhanced her own prestige in Europe with her liberal interests, Catherine enslaved more than a million people at home, and though she once attempted to draw up an emancipatory constitution, she balked when the nobility withdrew its support. She ended her reign not only granting heavily oppressive powers to Russia's landowning aristocracy—they were given the right to banish, deport, or subject to forced labor any disobedient peasant serf and to sell, pawn, or auction them independently of land and separated from their families—but also tightening restrictions on the peasants and extending serfdom to the Ukraine.

---

Just as Catherine II replaced the previous Dutch and German influence on the court with that of the more civilizing French, her successor, her son, Paul I, attempted to obliterate his mother's style and accomplishments by imposing Prussian

OVERLEAF: The throne room at Petrodvorets.

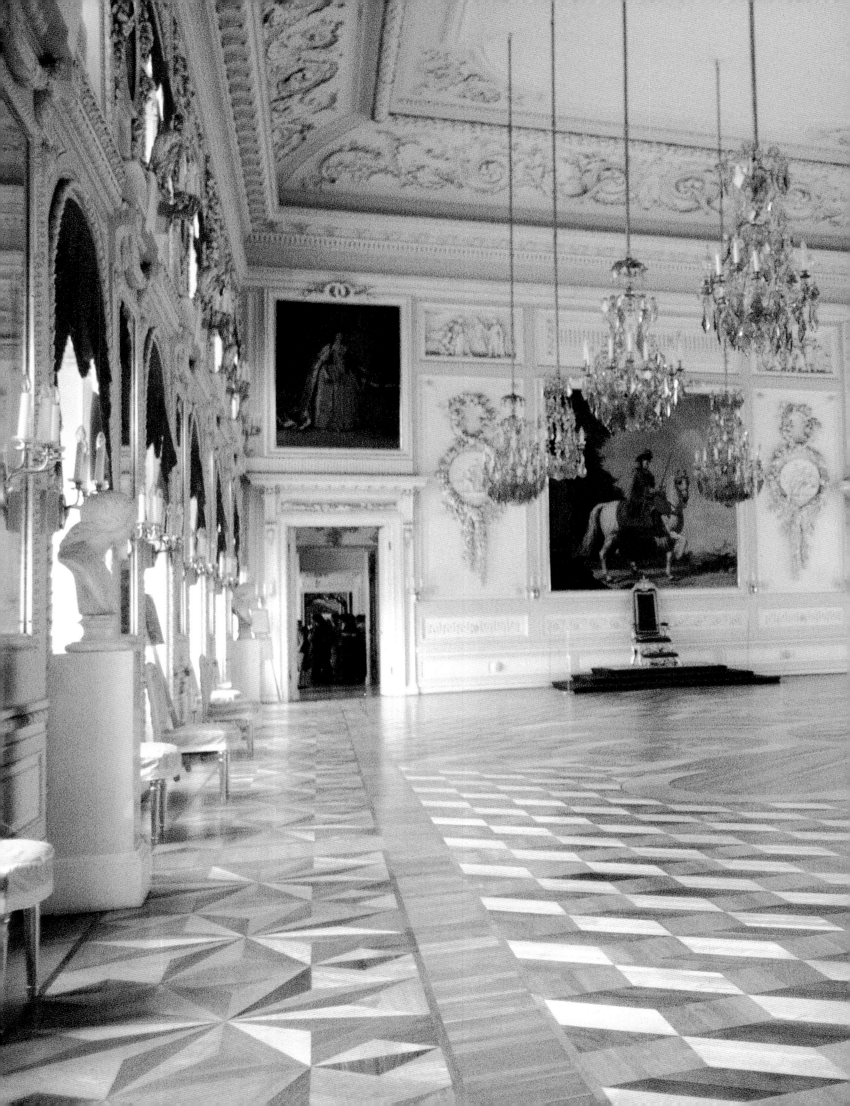

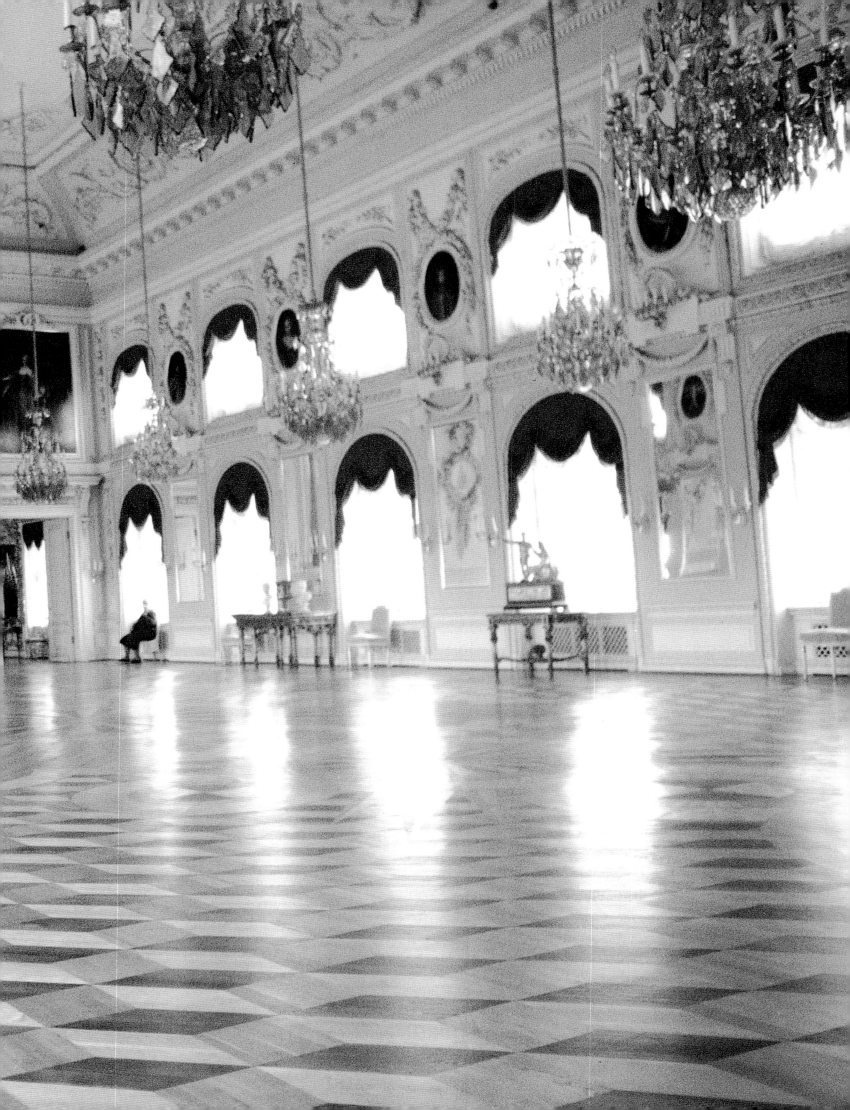

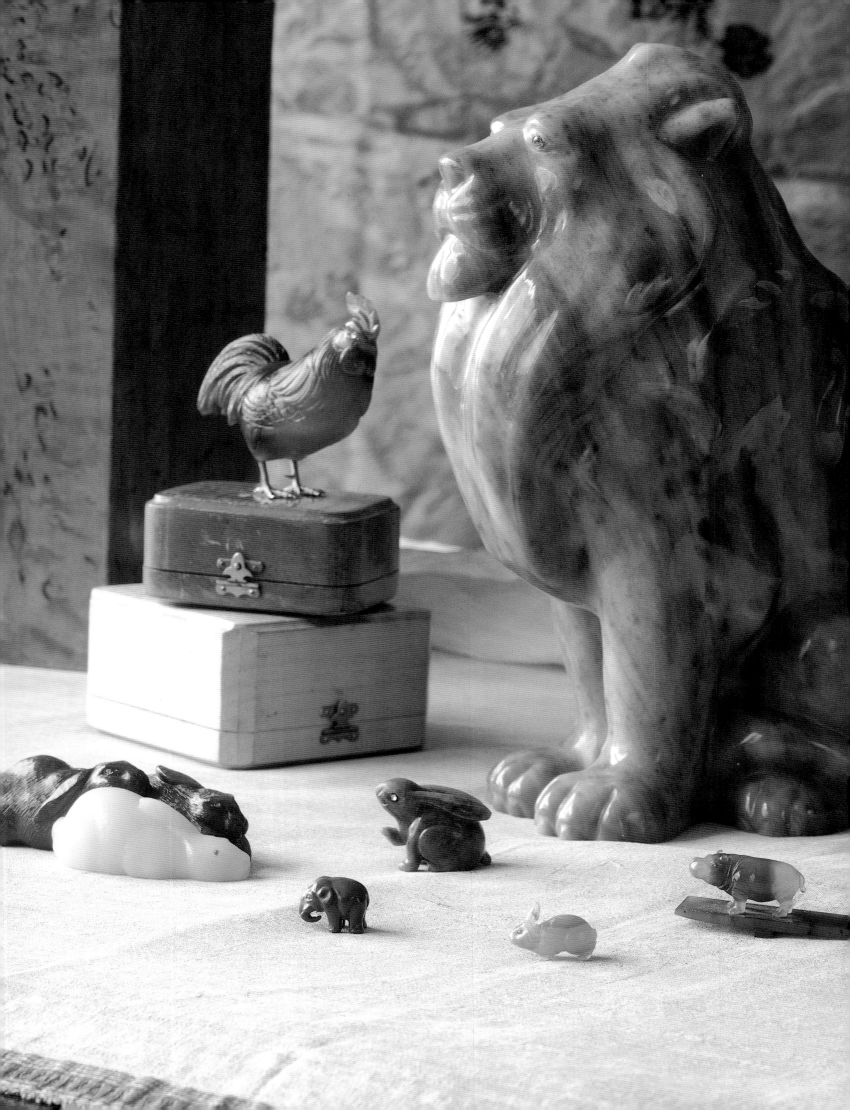

tastes. He had no penchant for the luxurious or the picturesque, preferring military displays instead. Assassinated after a reign of only five years, he was followed in 1801, by his son, Alexander I, whom Catherine herself had raised on a regimen of fresh air, cold baths, and English nannies.

Alexander I, known as the "enigmatic Czar," was a two-faced potentate who vacillated between liberal policies and despotic practices. Initially, he abolished the secret police, lifted the Court's ban on books, and even determined to give Russia its first constitution and an enforceable form of justice. As paradoxical as his grandmother, who began her reign with lofty liberal aspirations and ended it by reinforcing the government's hold on the people, Alexander grew increasingly reactionary after defeating Napoléon in 1812.

The French invasion proved to be Russia's first great patriotic war. Napoléon, who had marched through Europe in his quest to conquer the Continent had on his side what many historians have termed "the greatest army the world had ever seen," a force of at least a half million men. Alexander, with less than one quarter that number, had two formidable "allies"—his country's size and its climate. Even though the French troops managed to reach Moscow and burn the city nearly to the ground, their numbers were severely reduced by the long, bitter trek to the Russian capital and finally decimated by the brutal Russian winter. Only 30,000 of Napoléon's men survived the retreat to Paris. Ironically, although Alexander had saved Europe from Napoléon's domination, he went on to subject Russia to even deeper oppression.

Nicholas I followed his brother Alexander's regime, in 1825, with one of further increased militarism and bureaucracy. He was a great admirer of all things Prussian

A collection of Fabergé animals together with the Kozlov Lion, circa 1905. The lion which is of Eosite and has yellow diamond eyes is the largest known animal carving by Fabergé.

and resistant to any mention of reform; a strict disciplinarian and militarist, he was obsessed with uniforms and regimentation. The neoclassical style of design, with its formulas and strict proportions, appealed greatly to him and was reflected in the architecture, furniture, and clothes created during his rule.

Despite his preoccupation with the military (and his disastrous involvement in the Crimean War, which ended his reign), Nicholas managed to perpetuate the Imperial style of entertainment. The wife of a foreign diplomat described one of his *bals masqués* as so grand that

> 130,000 people were said to be assembled. . . . Upwards of four thousand carriages came to Peterhof that day, and the Emperor had four thousand horses of his own employed in the service of the Court. . . . People of every class were admitted to the palace, and it was a striking spectacle to see courtly dames in gold and jewels, Emperor, Grand Dukes and Duchesses, Princes and Counts, whirling through crowds of rustics, men with long beards, women with russet gowns.

A monumental chasm separated Russia's very small, wealthy elite from the overwhelming number of illiterate peasantry. The country's social structure was nearly medieval, a result of a governing power concentrated on a minuscule number of people (headed by the Czar), a rigid bureaucracy, and the lack of a middle class (that could have promoted and forced the adoption of liberal ideas). Even during the nineteenth century, when industrialization increased the number of city dwellers, the great majority of the people still worked the land and had seen little improvement in their manner of living for centuries.

In 1855, Nicholas was followed by his eldest son, Alexander II, an enlightened

autocrat, known for his role in freeing the serfs and called the Czar Liberator. Alexander had made the emancipation of the Orthodox people from the yoke of age-old slavery—what his grandfather had dreamed of and what his father had not resolved—his first act as Czar. Unfortunately, his efforts failed to create a politically viable class, and only further undermined the foundations of the country's landowners. He and his son, Alexander III, who reigned from 1881 to 1894, are better praised for the heights of music and literature—by such artists as Turgenev, Dostoyevsky, Tolstoy, and Tchaikovsky—reached during their reigns.

By the time Nicholas II became Czar in 1894, Russia had been subject for centuries to its nobility's hunger for magnificence and had been swinging for decades between the extremes of repression and reform. A reticent ruler with little grasp of political machinations and no clear vision of how to lead his country, the reluctant Czar preferred family life over Imperial responsibility. Unsettled by chronic political instability and beleaguered by the country's increasingly brutal economic conditions, he spent much of his time in retreat with his wife and five children at his palace in Tsarskoye Selo, an 800-acre preserve fifteen miles south of St. Petersburg. When the protests of the people finally grew too great for him to ignore, his concessions came too late in time and too little in measure. On March 12, 1917, after weeks of paralyzing strikes and severe civil disruption, soldiers in the 190,000-man garrison at the capital joined striking workers in revolt . . . and Imperial Russia collapsed. Nicholas accepted the advice of his generals to abdicate and was sent with his family to Siberia. Sixteen months later he died at the hands of assassins, violently and in destitution, surrounded only by those he cared for most in life—his wife and children.

# 1

## FASHIONS AND JEWELRY

Although she had already attended three balls that week, it would not be unusual for a Russian woman of noble standing to look forward to yet another night of festivity in St. Petersburg. In fact, she might well anticipate the coming evening's gala with special excitement because it would be taking place at the Court itself, and she would be wearing her favorite of all the gowns she had had made for the year's social season—a silk embroidered dress with three flounces (about which her husband had complained that each flounce had cost more than an abbot's robe of gold brocade). Bouquets of gauze covered the dress's wide skirt, each attached with diamond knots, and a silken ribbon that would cascade from between her breasts was clasped to the bodice by a stone so dazzling it could have been taken from the crown of the Czar. Of course, even the attendants at Court would have outfits as exotic as hers was magnificent. For example, there would be tall, black African servants dressed Mameluke style, with white twisted turbans, green jackets with gold corners, and wide red pantaloons sashed with cashmere belts—their entire outfits braided on every seam.

Such were the costumes that filled the eye of every guest at the Russian Court of the late eighteenth century, a visual feast that blended Asiatic pomp with Imperial refinement. "An immense retinue of courtiers always precedes and follows the Empress and the costliness of their apparel and a profusion of precious stones create a splendor of which the magnificence of other courts can give us

PRECEDING PAGE: The dress shirt of Nicholas II, bearing his monogram, together with a pair of yellow-enamel and rose-diamond Imperial eagle cuff links by Fabergé and an original photograph of the Czar wearing the shirt. BELOW: A large (eighty carats) star-sapphire brooch set within an *ajouré* gold-and-platinum mount and a double circle of diamonds with bowknot and floral ornaments, designed by Fabergé, who repeated the points of the star in the mount.

1

only a faint idea," noted an English visitor. "Amid the several articles of sumptuousness which distinguished them there is none perhaps more calculated to strike a foreigner than the profusion of diamonds and other precious stones which sparkle in every part of their dress. . . . The men vie with the fair sex in the use of them. Many of the nobility were almost covered with diamonds." In fact, rich jewelry was worn at all times and virtually all of it—rings, bracelets, necklaces, tiaras, pins, shoe buckles, hair ornaments, fans, watches, swords—was studded with diamonds and other precious stones.

The bitter cold Russian climate demanded equally sumptuous coats and cloaks, and, of course, these too had to be rich examples of high fashion. Théophile Gautier observed in 1865:

In St. Petersburg one could make a saying, "Tell me what furs you wear, and I will tell you how much you are worth." Coats are trimmed with furs so expensive that foreigners are astonished. They are of fine material and lined with sable or musk and have collars made out of beaver costing from one hundred to three hundred rubles, depending on whether the pelt is thicker, softer, or darker in color and on the number of white hairs sticking out. A coat worth one thousand rubles is not considered exorbitant, and there are some worth much more.

The Imperial rulers, beginning with Peter I, had total authority over the fashion of the Court as well as enor-

mous influence on that of Russian society. As part of his efforts to modernize the country, Peter dictated an entirely new style of attire for "persons of every rank and station, except for the clergy, carriers and peasants at the plough." After returning from a tour of Europe where he observed that men went without beards, he set about "like a mad barber" insisting that the Orthodox Russians and noblemen cut off their beards. In 1700, he issued an edict forbidding Russian dress to be worn, made, or sold, and ordered his subjects to don dress inspired by the Court of Louis XIV.

The men's costume of the eighteenth-century French Court—in marked contrast to the simple long robes and conical hats previously worn by the Russian boyars—consisted of a knee-length, narrow-waisted, and form-fitting coat; a vest that was shorter than the coat; and breeches with a wide waistband that reached to just below the knees, all in silks, velvets, and brocades. The coat had clusters of up to six pleats on each side to provide freedom of movement (especially on horseback), broad turn-back cuffs, and shaped flaps over the slit pockets, which were trimmed with ornamental buttonholes and buttons. The vest had no collar, and the sleeves were long and tight. Worn with this suit was a lace jabot and cuffs, silk stockings, and square-toed, heeled leather shoes trimmed with buckles or bows. These costumes were made by master tailors in Moscow's foreign quarter and by

ABOVE: An oval wedgewood plaque with allegorical silhouette of Catherine the Great in a carved bone frame, made by her daughter-in-law, Maria Fyodorovna, wife of Paul I, 1796–1801. OPPOSITE: Dressing room and costumes of Paul I and Maria Fyodorovna.

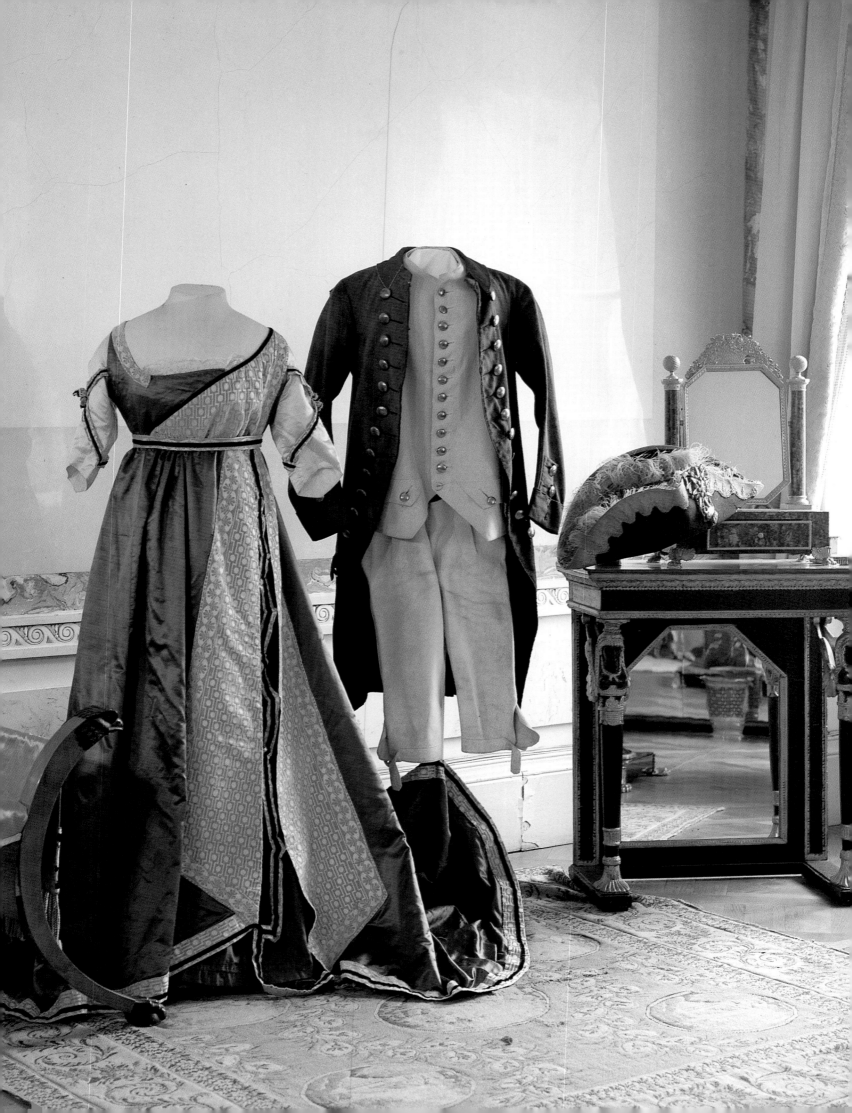

tailors at the Imperial Workshops at the Kremlin. Though the reform in style was at first met with considerable opposition, from 1725 (the year of Peter's death) onward, the urban dress of Russian nobility, government officials, the military, and the more advanced merchants and manufacturers followed European precedents.

By emancipating women from a state akin to the Muslim purdah—the forced seclusion in which they were allowed to be seen only by family and intimate friends in their own homes—Peter brought about similar changes in the female wardrobe. Until this time, aristocratic Russian dinners had been coarse, riotous, drunken gatherings held exclusively for men. Peter initiated balls and masquerades to which young girls as well as married women were invited. Discarding the old *dushegreya*, a warm, sleeveless jacket; the *sarafan*, a sleeveless tunic; and the *letnik*, a summer garment with long, open, hanging sleeves, they adopted Hungarian and German styles of dress—the closest achievable approximations to the French. These included an open robe, a tight-laced bodice with a low-cut neck, elbow-length sleeves, and a full petticoat. Like the men's garments, these were trimmed with gold and silver lace and fine embroidery. As one English traveler put it, "by teaching his bears to dance, Peter rescued them from a savage state, and elevated to her natural sphere in society, the civilizer of man—Woman."

Catherine I followed her husband's lead by establishing rules of fashion and behavior for her modest assem-

A rendering of military cadets in uniform from a book of uniforms published in the late nineteenth century by the Court.

blies (for example, no one was permitted to get drunk before 9:00 P.M.). The Empress Elizabeth expanded the practice by specifying a program of entertainment and manner of dress at Court: Sunday was Court reception assembly day; Monday was for plays; Tuesday for masquerade balls; Thursday for French comedies; and so forth. The Russian-style caftan with a girdle at the waist was deemed appropriate for evenings at the theater, and for masquerade balls, a lace-trimmed domino or hooded cloak. A great fan of transvestite balls, Elizabeth delighted in dressing in knee breeches and men's uniforms and at seeing her pretty young officers and nobles in long skirts. For many occasions during her reign women displayed themselves in splendid French gowns with tightly laced bodices, low décolletages, sleeves to the elbow, and wide silk skirts embellished with embroidery and lace. The skirts were given their expansive perimeters by means of farthingales, special hooplike contrivances made of willow twigs, whalebone, and stiff fabric. A "Watteau" fold—a long loose panel pleated into the neck, back, and shoulder seams, which fell to the ground like a train—provided a fanciful silhouette and a decorative character that harmonized with the rococo style of furniture and interior design of the time.

Men's costumes were as colorful as the women's and often made of the same textiles—brocades, velvets, silk, embroideries of gold and silver thread, spangles, and mirrors. To keep themselves supplied with their extravagant

An early Art Deco/Russian Revival *ajouré* gold pendant with diamonds and Mecca stone, by Fabergé.

1

attire, many Russian courtiers and citizens of substantial means maintained workshops, even factories, on their estates where seamstresses and master craftswomen from among the serfs executed elaborate costumes and embroideries, often incorporating the ornamental design elements of their regions and of traditional Russian embroidery.

Without a widely circulated vehicle such as the fashion magazine (which had yet to be developed) to inform their subjects of current vogues and codes of dress, the courts of Europe and Russia relied on mannequins to illustrate their edicts. Costumed in the prescribed style of the day, these dolls were posted at the city gates for all to see. And woe to anyone who ignored them. If a boyar or merchant persisted in wearing his traditional costume or beard, he could be fined by the guards, punished by penal servitude, or even have his property seized by the Crown. In Western Europe, the dolls were equally powerful: They were carried from country to country so that the rich could inform themselves of the latest in aristocratic attire, and in times of war, cease-fires were called to give free passage to the boats transporting them.

The dolls of Catherine the Great's time wore none of the brocades so fashionable in earlier courts. As a foreigner who had studiously cultivated all things Russian, and as a ruler who divided her life firmly between its public and private aspects, Catherine introduced a simpler manner of dress for all but public occasions. Her private outfit consisted of a silk pinafore in white or purple that

A rare gold pendant designed by Fabergé in the Art Nouveau style, combining two large green enameled leaves with a ribboned wreath of diamonds and containing a cabochon sapphire against an *ajouré* engraved, gold background.

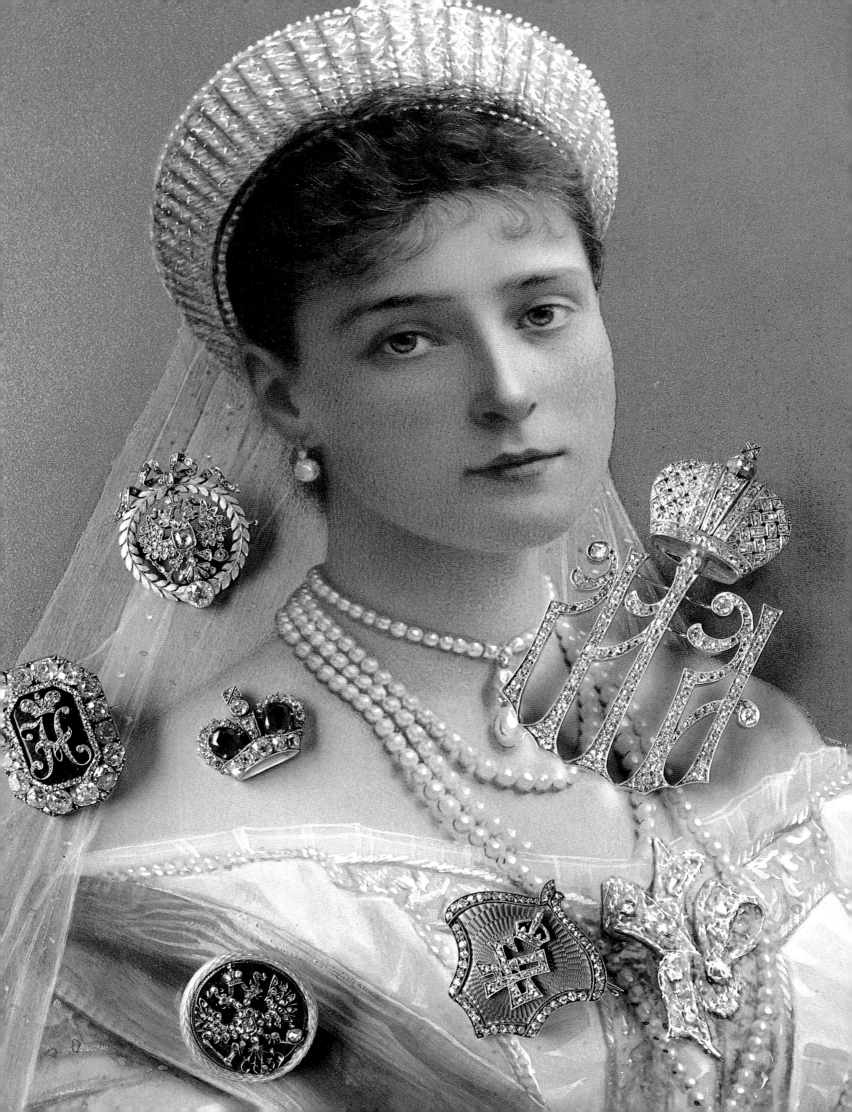

1

fell over a blouse and was worn with a fur coat shaped to the waist. It was accented only with several long rows of pearls. As she grew older, Catherine came to prefer a Moldavian type of caftan, loose at the waist, and a Hungarian-style fur hat with tassels. Rather than relying on elaborate attire and ornament to signify her majesty, she projected her stature with her upright carriage and firm step.

The clearest of Catherine's adaptations of Russian elements in fashion can be seen in her dress uniforms—peculiar costumes of her own invention that combined the traditional Russian veil and loose-hanging, capelike shoulders (instead of sleeves) with the shapes of French fashion. She would adopt the color and fabric of the regiment's dress uniform and decorate her garb with regulation galloons, buttons, and custom-designed, jewel-studded epaulets. These she wore for military reviews or ship launchings.

For gala occasions such as balls and receptions, however, Catherine abandoned all simplicity and dressed as the most regal of royals. Over a sparkling, jeweled gown she wore a long, trained robe; she decorated herself with diamond rings, bracelets, and earrings, and on her head the Imperial crown. In addition she carried her magnificent scepter in which was mounted the Orlov diamond (the fourth largest in the world).

Lovers regaled Catherine with extravagant jewels as well as foreign rulers, correspondents, and political allies.

A hand-colored Court photograph of Empress Alexandra Fyodorovna showing (*clockwise from right*) a large diamond lady-in-waiting brooch of her mother-in-law, Maria Fyodorovna; a gray enamel and diamond brooch with monogram of Edward and Alexandra of England by Fabergé; an Imperial eagle in gold enamel and diamonds; a ruby-and-diamond Imperial Crown; a diamond-and-enamel brooch with monogram of Nicholas I; and an Imperial eagle in colored gold.

One of the finest of these tributes was the jeweled equestrian gear presented to her by Sultan Abdülhamid I of the Ottoman Empire in 1774, on the occasion of making a treaty that concluded the first Russo-Turkish war. The horse tack included a gold harness ornamented with enameled leaves and flowers, a diamond pin shaped like a bouquet and set off by a huge topaz that was attached to the forehead band of a bridle, and silver horseshoes and nails.

Catherine and all of her 500 ladies-in-waiting covered themselves in diamonds. Her 250 *frelina*s (daughters of dignitaries who served the Court from the age of eighteen until marriage) similarly decorated their fingers, wrists, and gowns with jewels. On their left shoulders they wore the initials of the Empress set in diamonds on a blue ribbon of the Order of St. Andrew. Each courtier's rank was illustrated by the length of her train, and the trains of the Imperial family were each carried by two exquisitely garbed pages.

Upon his engagement to the princess of Hesse-Darmstadt, later known as Empress Alexandra, Nicholas II presented his bride-to-be not only with a pink pearl ring, a necklace of large pink pearls, a chain bracelet bearing a massive emerald, and a sapphire-and-diamond brooch but also with a jeweled *sautoir* or cross, created by the court jeweler Peter Carl Fabergé, worth 250,000 gold rubles. It was the costliest gift ever produced by Fabergé for the Imperial family. For ordinary nobles, antique cam-

An Imperial portrait of Catherine the Great in her Court regalia. Scattered across the top are some of her jeweled diamond "buttons" and a border ornament from the Russian Crown jewels, which were sewn onto her garments. All are probably by Duval, an eighteenth-century Court jeweler.

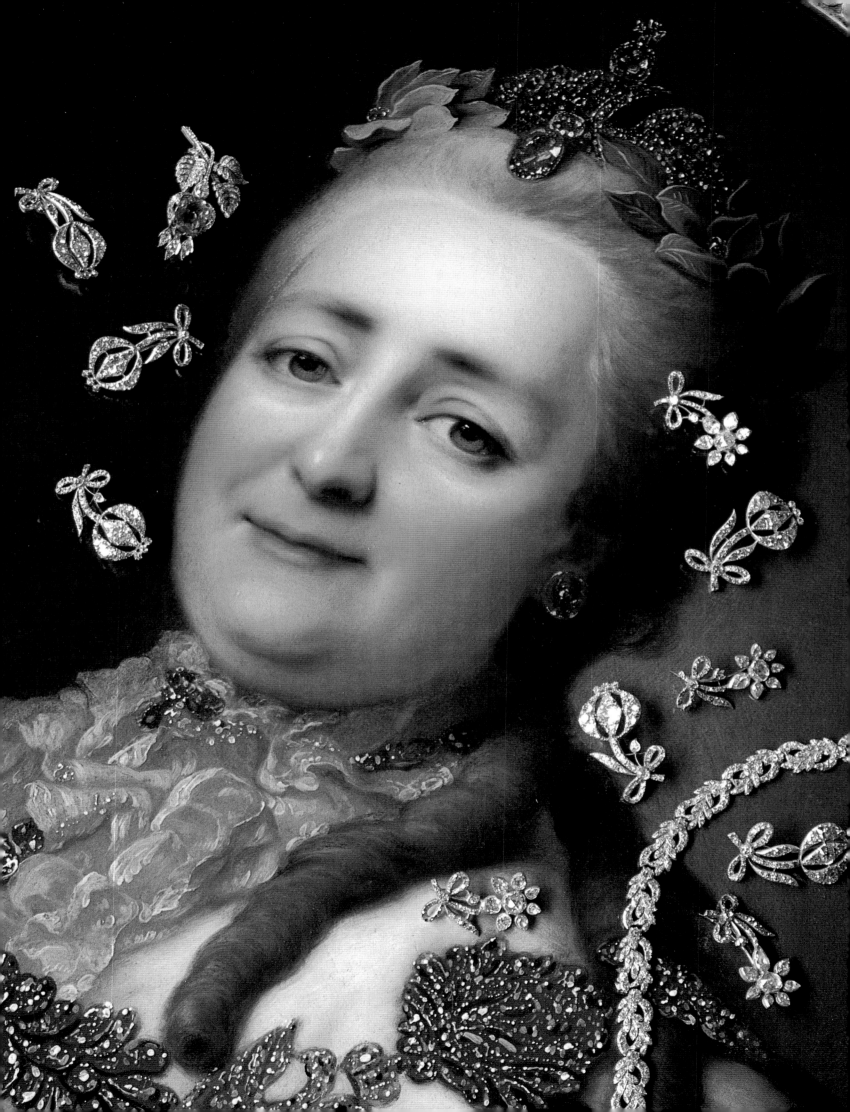

eos set in combs, jeweled finger rings and dazzling brace-
lets and necklaces filled out already spectacular wardrobes.
Rubies and emeralds were sewn into embroideries as well
as on headdresses. Pearls were also popular: real pearls for
the rich, river pearls or pearl beads for persons of more
modest means. Men wore diamond buttons, shoe buckles,
sword hilts, epaulets, and star decorations.

Throughout the Imperial era, the livery of court and
manorial servants was as colorful and varied as general
fashion. Equerries in red capes bordered with Imperial
eagles wore hats decorated with black, yellow, and red
ostrich plumes. Palace sentries were dressed in costumes
colored according to the room to which they were attached.

During the 1770s and 1780s, as Catherine became
engrossed in the ideas of the philosopher Jean-Jacques
Rousseau, who criticized luxury and the idle ways of high
society, and as her tastes turned more and more to the
classical and the aesthetic rules of antiquity, clothing be-
came simpler in line. Resplendent gowns were replaced
by tunic-shaped ones and elaborate silks and velvets with
thin, airy cottons and linens, mostly in white. Corsets,
farthingales, and whalebones disappeared as skirts now
fell from under the waistline in soft, fluid folds ending in
a train. Low décolletages and short sleeves also became
fashionable. Ever mindful of her role as political leader of
her country, Catherine encouraged the Russian textile
industry by decreeing that, rather than importing certain
fabrics, both ladies and gentlemen who attended Court

1

functions should purchase only those made in Moscow and that they should use home-produced silks for their informal clothes.

By the early nineteenth century most townspeople's clothes were sewn by Russian tailors, although there were several English- and French-owned tailors' shops in both Moscow and St. Petersburg. In fact, tailors formed the most numerous class among Russian artisans. "You can hardly find a street here with fewer than ten signs of the scissors, with tail-coats and uniforms daubed in them," described the writer Ivan Pushkariov in 1830. Many tried to attract customers by pretending to be French and were "conspicuous for trying to pass themselves off as Parisian. . . . One cannot help laughing at a sign that reads, for instance, 'Boris Yefimov, Tailor from Paris.'"

From the end of the eighteenth century to the middle of the nineteenth, colorful, intricately woven woolen scarves or shawls formed an indispensable part of women's attire in both summer and winter, in the ballroom and at home. Aristocratic girls were trained from childhood how to wear them, how to drape them alluringly around the body. Shawls made in a wealth of motifs from the fleece of Tibetan goats and Siaga antelopes in a double-faced weave (the front and back were indistinguishable) were so highly prized that one could cost as much as 100,000 gold rubles (or the price of 1,000 serfs). Originally imported from the Orient (Persia, Turkey, and Tibet), the fleece shawls eventually were produced by female artisans from among

OVERLEAF: A Fabergé platinum-and-gold mounted diamond and enamel *kokochnik*, the Russian Imperial national headdress (the color blue was used exclusively by the Empress and the Imperial Princesses), together with a pair of gold opera glasses embellished with rubies and diamonds by Fabergé; an Imperial mauve enamel, gold, and mother-of-pearl notebook by Fabergé on an original Fabergé drawing signed by the master.

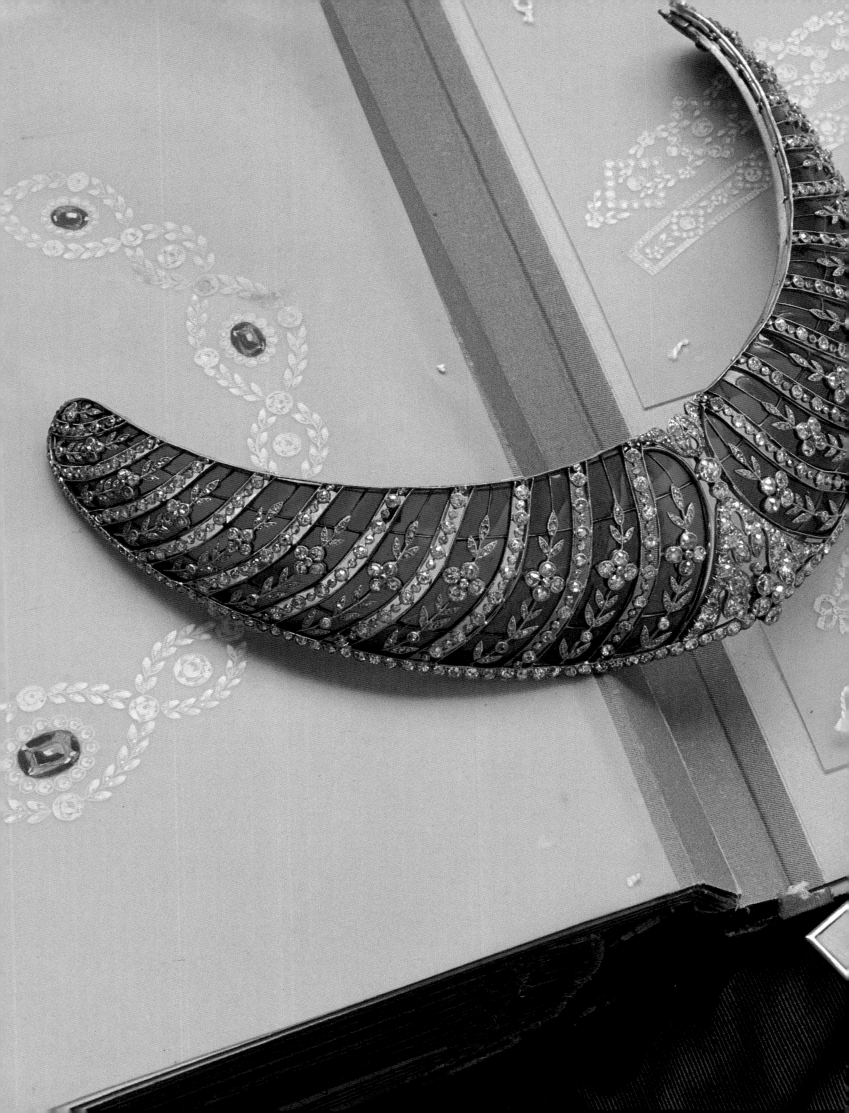

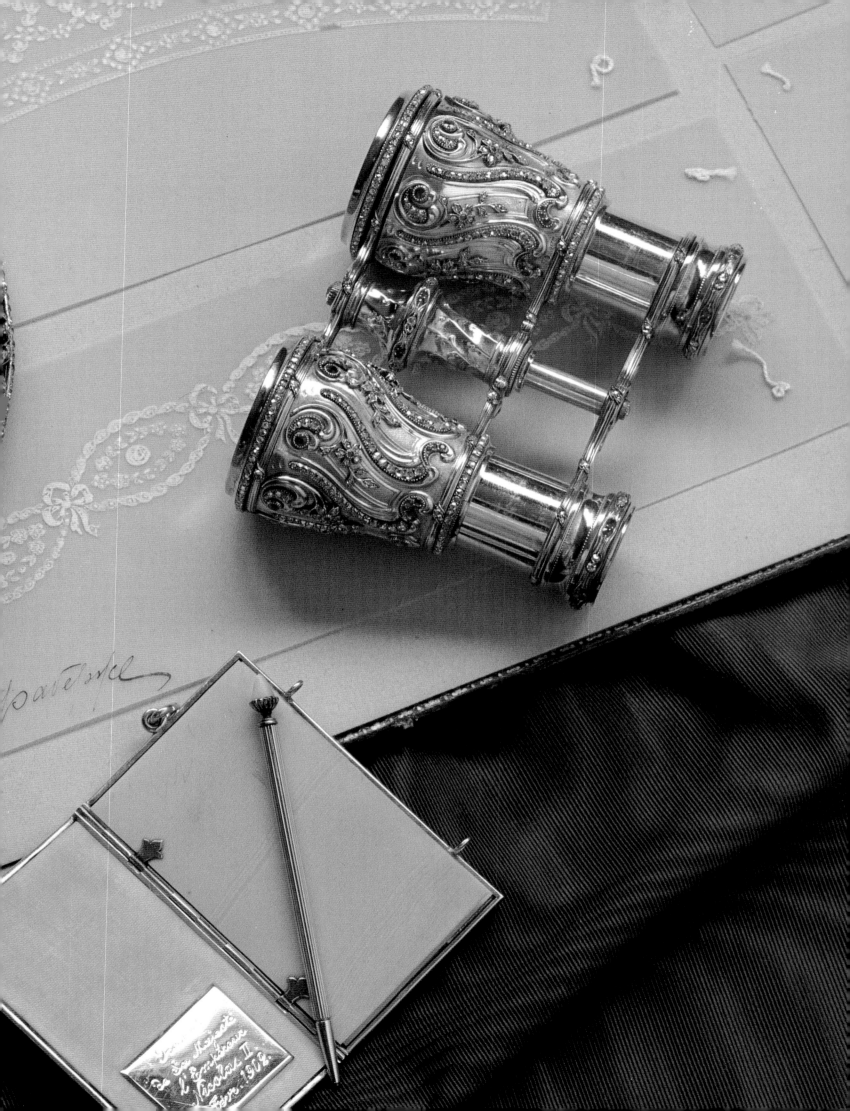

the serfs of the landed gentry. A less complexly woven scarf might require six months to make and cost around 12,000 rubles; others requiring greater virtuosity could take as long as two and a half years. Vera Yehseyeva, a landowner who employed a number of weavers, was known to grant these female serfs their freedom and give them a sum of money after they had served ten years in her workshop. By that time, however, the intensely detailed work had left most of the women blind.

Just as the shawl was an essential part of the noblewoman's costume, no eighteenth-century Russian lady of fashion would have been seen without a fan. Like every other aspect of her garb, it would, of course, be richly ornamented with gold, enameled silver, and precious stones. Some fans were made of ostrich plumes set into ivory or tortoise-shell handles; others were made of silk pulled taut in a gilded frame and decorated with watercolor paintings of allegorical or mythological scenes.

The *kokochnik*, the traditional Russian headdress worn by women to festive events, differed in style from region to region; in the north it was heavily embroidered with gold thread and river seed pearls, with a pearl net descending over the forehead; in the central region it had tall and either crecent or peaked ornaments; in the south the design was the most complicated of all—some had horns and long streamers, others strips of multicolored embroidery.

A collection of rare frost jewelry made exclusively for the Nobel family by Fabergé as dinner favors, each frost crystal a different design. Dinner favors such as necklaces and bracelets were often given to the ladies. The bracelet at right contains one of the earliest Nobel prizes: Nobel presented it to his wife, who bore him twelve children. The inscription of the reverse of the medallion means "Prize for Industry." The red enamel double-opening box and miniature candlestick in the background are also by Fabergé.

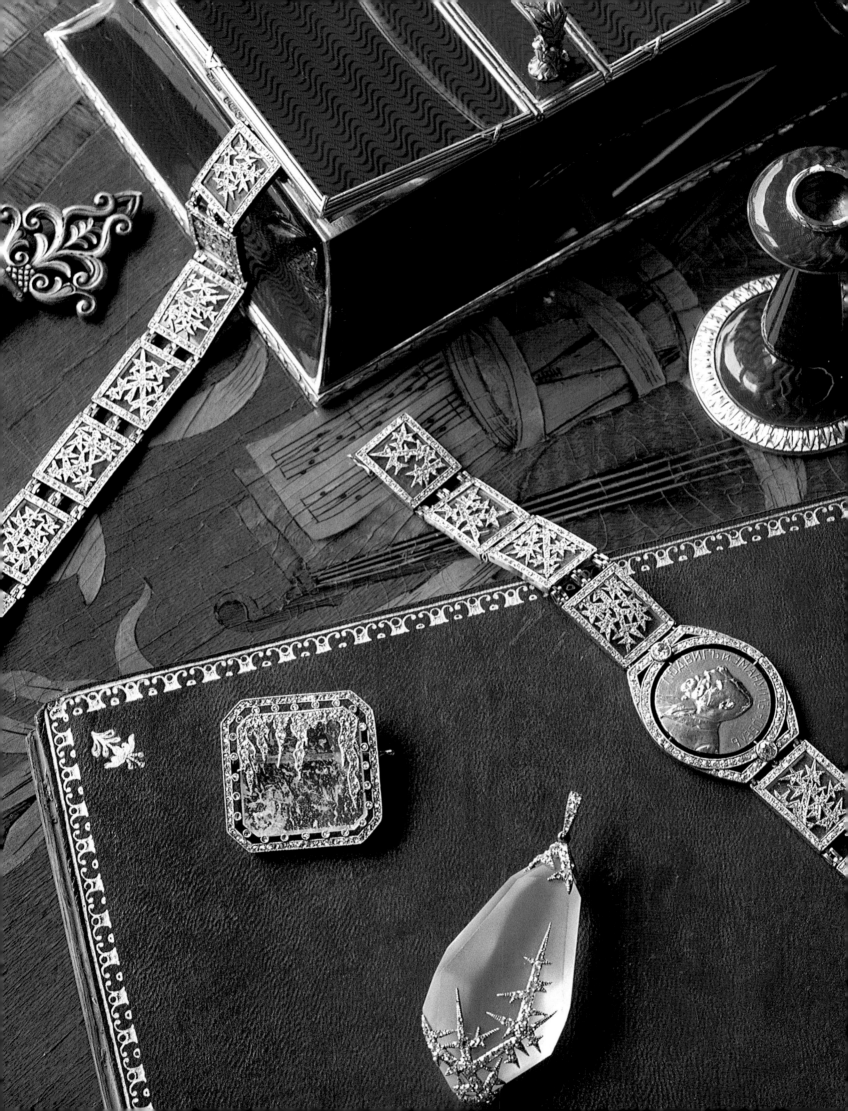

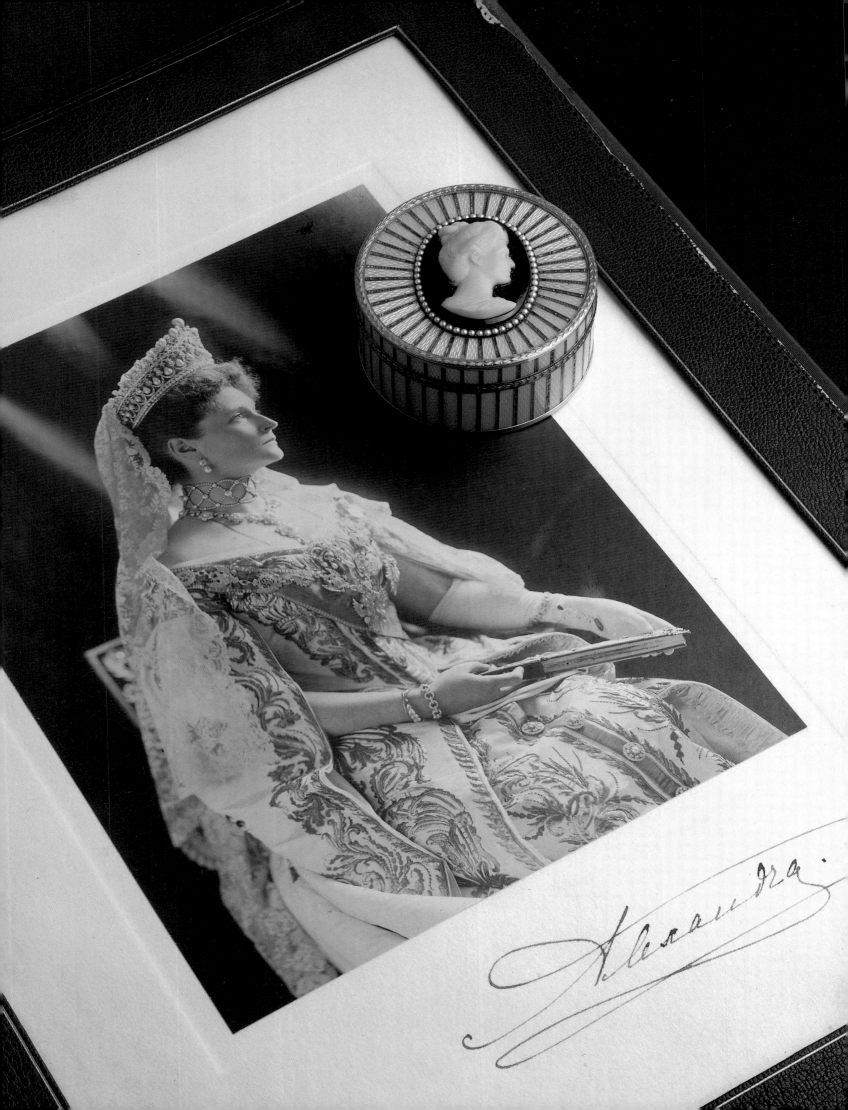

*Alexandra*

1

Unlike his mother, Catherine, Czar Paul had no use for the picturesque or the luxurious, preferring instead uniforms and military-style attire. His eldest son, Alexander, who succeeded him, had no taste for lavish entertainments and exerted little influence over Court dress.

Outside the Court, Russian fashion went its own way, with the English style the main influence for men's costume and the French for women's. Late eighteenth-century classical tastes gave way to those of the Empire style, with its love of symmetry, clear line, and splendid decoration. Cottons and linens were replaced with heavy silks and worsteds better suited to geometric shapes and sharper silhouettes. Short puffed sleeves and long tight sleeves decorated with epaulets became popular, and stays returned to support overelevated busts. Toward the end of Alexander's reign in 1825, the Court adopted a somewhat romantic look that included wide-skirted dresses, low décolletages, sleeves densely gathered at the shoulder, and wide belts with large buckles.

It was only with the reign of Alexander's brother, Nicholas I, which began in 1825, that the Russian Court regained its social brilliance. Uniforms lost the drab monotony of Paul's rule: Officers of the Guard now wore breeches of white cloth, silk stockings, and silver-buckled shoes and carried plumed tricornes—black for the infantry and white for the cavalry. The dress dictated for women, according to an edict Nicholas issued in 1834, which included the cut, color, and fabric of a garment, was a

An official autographed Court photograph of the Empress Alexandra Fyodorovna in a blue-leather presentation folio tooled in gold with the Imperial Crown and a gold-mounted black-and-gold (the colors of the Imperial family) enamel presentation box with cameo profile of the Empress from the coronation.

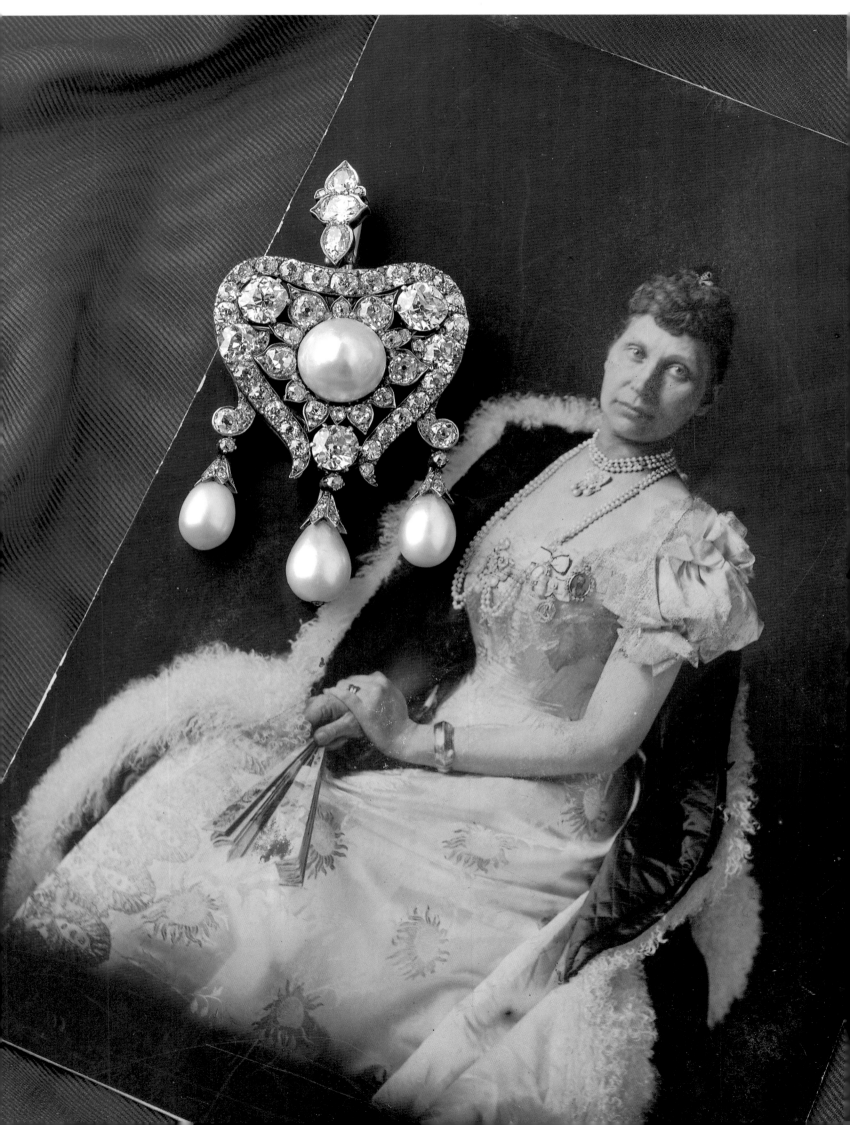

1

Lamanova won numerous prizes for Russian dress design in international exhibits.

With the popularity of the Art Nouveau movement at the turn of the century, a rather peculiar silhouette became the vogue: It consisted of a corset that pushed the bust forward and the hips back, a pouching bodice, and a skirt closely molded to the hips and flaring out below the knees before falling to the floor in sweeping folds. The pronounced S shape of this design aligned closely with the flowing lines and undulating curves extolled by Art Nouveau design. Accenting this line were fabrics patterned with plant motifs and flowers on long wavy stems. Sequins, beading, pleating, velvet appliqués, and intricate laces might all be used to trim one garment.

Finally, well into the reign of the last Czar, Nicholas II, costumes grew simpler in line though they were nonetheless luxuriously embellished. A sequined evening dress made of velvet or satin might be molded as a tunic or as a clinging, asymmetrical chiffon drapery, embroidered with gold threads. Outer garments corresponded in elegant simplicity—a kimono-style coat or evening cape would glitter all over with sequins or be draped with swansdown boas and the feathers of exotic birds. Like all the costumes of the preceding Imperial dynasties, those of the last Czar maintained their unrestrained expressiveness in color, texture, and decoration, but with the advent of the twentieth century, they gained ever-increasing freedom of movement.

OPPOSITE: A Court photograph of Queen Marie Louise of Denmark, wearing the large Russian nineteenth-century pearl-and-diamond pendant by Bolin shown at left. OVERLEAF: The State bedroom at Pavlovsk. Behind the wood, carved, and gilt armchairs by Henri Jacob is a tempera painting on silk of *The Attributes of Spring*, executed by Mettenleiter from a sketch by Van Leen.

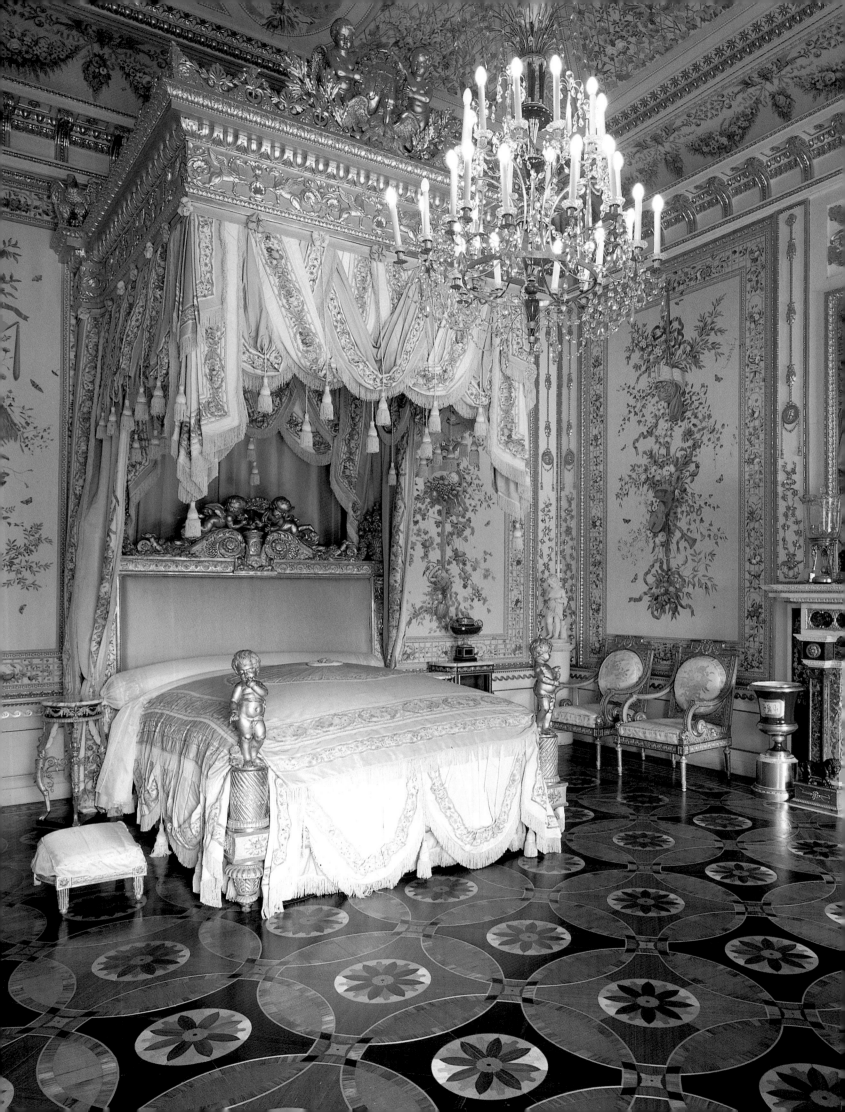

# 2

PALACES AND FURNITURE

A lilac-scented breeze blew carelessly through the birch woods surrounding the Imperial country retreat Tsarskoye Selo (the Czar's Village). Empress Elizabeth, resting impatiently against the cushioned seats of her carriage as it approached the 800-acre preserve, waved a pearl-studded fan across her shoulders and ordered her footman to urge the drivers on. Although she found the cool, sun-splashed landscape about her a relief from the summer humidity and persistent tumult of the capital, she was too consumed with anticipation to enjoy the drive. For, despite having recently completed a 10-million-ruble expansion of the Winter Palace in St. Petersburg, her appetite for architectural titillation remained unsated. Ravenous with the desire to build more, she had commissioned her favorite architect, the Italian Bartolomeo Rastrelli, to rebuild the palace at Tsarskoye Selo. It had already been enlarged and redesigned several times before (once, when totally complete, she had ordered it torn apart and done over). This time, though, she was determined to have a residence so magnificent it would rival anything in Europe.

As her carriage hurried on, Elizabeth reviewed in her mind Rastrelli's design. Even his first sketches, she recalled, had demonstrated that his vision matched her own flights of fantasy. In fact, she decided, if his work was as brilliant as she anticipated, she would make the architect a Russian count.

At length, the coach reached an ancient birch grove that marked the entrance to the royal enclave. Next it

OPPOSITE: In the Lantern Room, designed by Voronikin in 1807, are a bureau and writing table by David Roentgen. The plaster caryatid is by Demuth-Malinovsky, 1807. Paintings are seventeenth- and eighteenth-century Italian. OVERLEAF: A view from the garden of Petrodvorets.

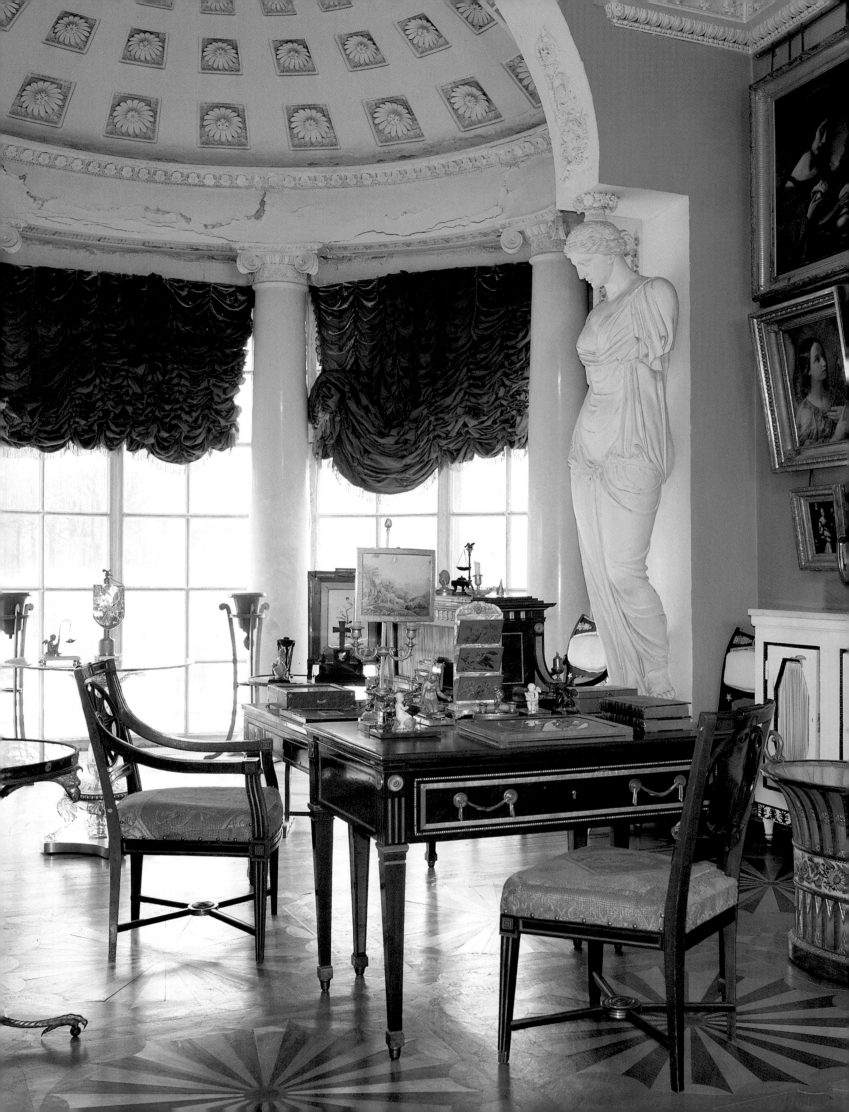

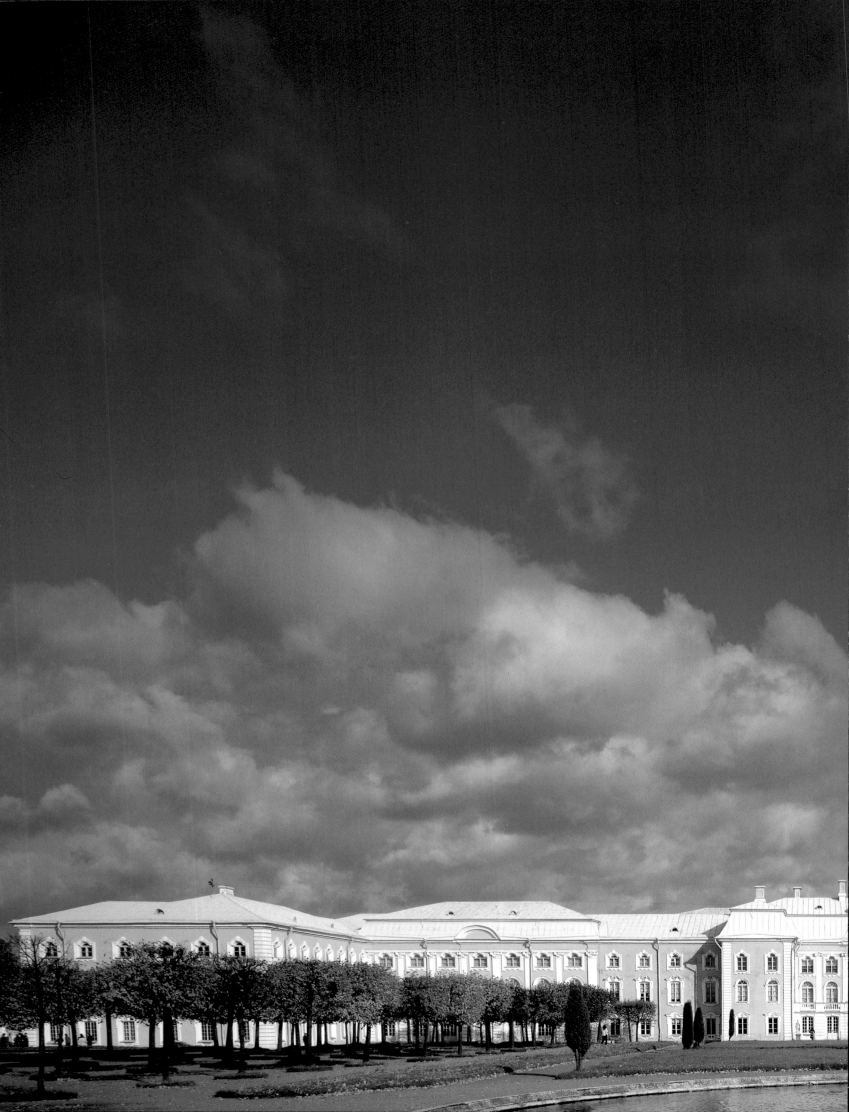

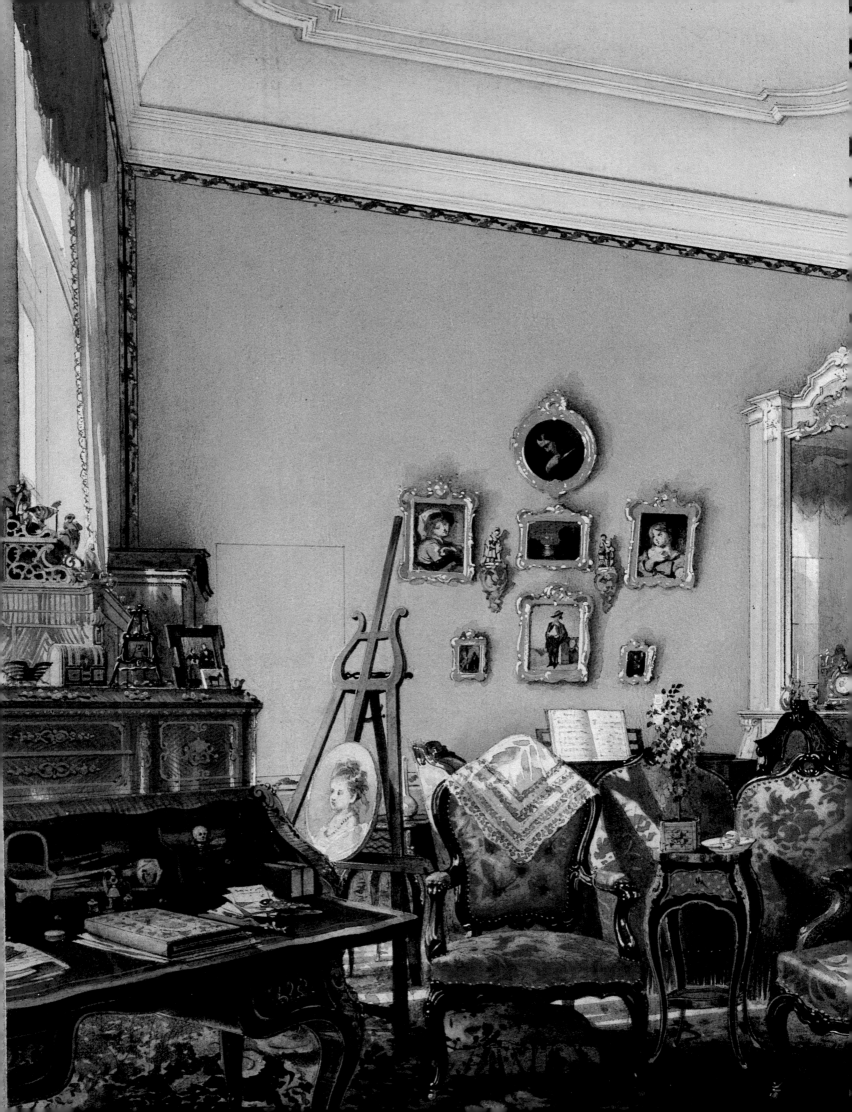

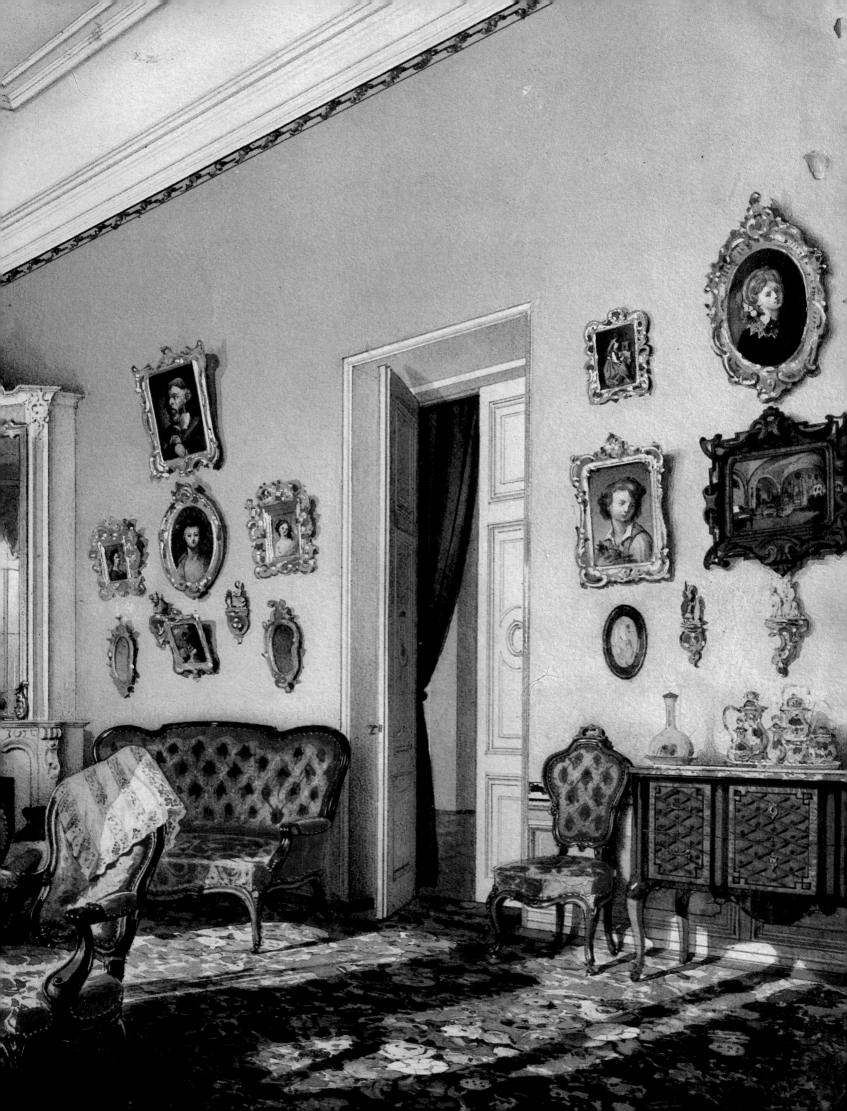

passed a series of horse trails, strolling paths, and open parks. Finally, it arrived at a lawn decorated with gilded statues and newly planted parterres. The moment the driver reined his horses to a halt, Elizabeth alighted to feast her eyes on a baroque symphony of color and architectural confection. The palace's thousand-foot-long sculpted facade was painted blue and white and gleamed with hundreds of gilt ornaments. Tall windows invited light into each of the 200 rooms that opened onto one another en suite like a continuous ribbon. Lifting the skirts of her silk traveling gown, the Empress darted up the shallow garden steps into the three-story residence where Rastrelli himself awaited her. Together, architect, Czarina, and entourage toured drawing rooms decorated with Rastrelli's signature gilded *boiserie*, anterooms in which Oriental rugs covered polished parquet floors, ballrooms lit by enormous chandeliers, dining halls warmed by beautifully colored porcelain stoves, and bedrooms in which sapphire-and-silver brocade curtains turned the chill Russian nights effervescent. The Catherine Palace, as Elizabeth would call it in honor of her mother, brought Rastrelli his title.

As the daughter of Peter the Great, Elizabeth seemed to possess her father's drive to rival the magnitude and splendor of the French Court. Upon returning from Europe, where he had reveled in the magnificence of Versailles, Peter had commissioned Alexandre-Jean-Baptiste Leblond, one of Louis XIV's own architects, to design a

PRECEDING PAGES: A watercolor of a mid-nineteenth-century Russian drawing room. OPPOSITE: The Greek Hall at Pavlovsk, built by Vicenzo Brenna in 1789 and reconstructed by André Voronikin in 1803.

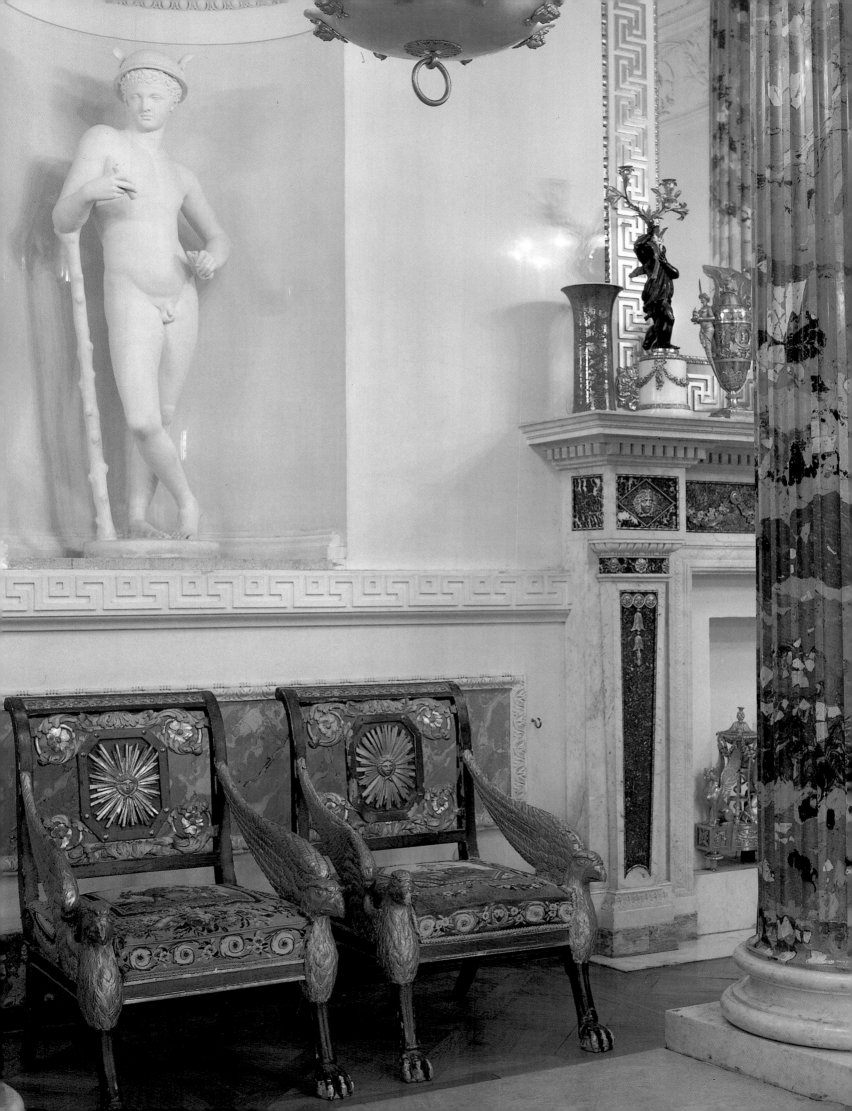

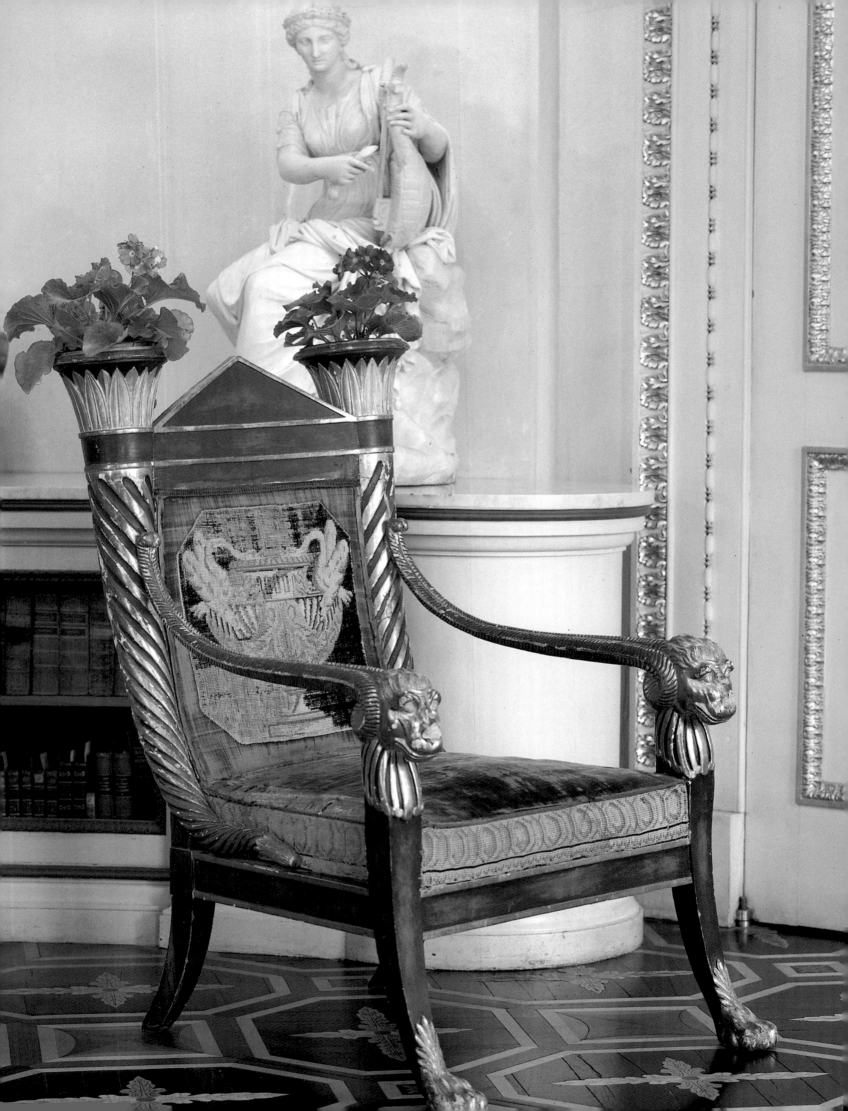

summer palace on the Gulf of Finland. Peterhof (now known as Petrodvorets) was begun in 1714 and created as a tribute to Russia's naval might—a unique ensemble of architecture and landscape, thematically unified by aquatic motifs. Today one can see a progression of terraces, pavilions, and flower beds that lead from the Gulf up to the palace complex, all dramatized by three monumental cascades and surrounded by 147 gravity-fed fountains, which shower a collection of gilded eighteenth- and nineteenth-century statuary—frolicking water nymphs and mythological figures.

Peter the Great applied his specific tastes and keenly developed eye to every aspect of the design of Peterhof—from the planning of the flower beds to the detailing of the interiors to the selection of the art. Having collected not only Western ideas but also European art in the course of his travels, Peter established Russia's first picture gallery of European paintings at Peterhof. It consisted primarily of the work of Dutch and Flemish masters and, not surprisingly, included many naval scenes. In time Peterhof became known as the Versailles of the North, but despite this prestige, Elizabeth did not find it grand enough to suit her aspirations. Here she also brought in Rastrelli, who exalted the palace's proportions (giving it a rich, impressive silhouette), crowned its wings with gilt domes, and painted the facade in bright colors. He added even more intensive decoration to the interiors and installed a staircase with gilded balustrades of carved linden wood.

Pavlovsk chair.

Like the summer palace, Peter the Great's Winter Palace was initiated with the same level of vision and ambition the Czar had lavished on the creation of his capital. He commanded that the St. Petersburg residence be completed within one year and set 6,000 serfs to work, who labored day in and day out, even through the bitterest days of winter. During freezes of between fifteen and twenty degrees below zero (Fahrenheit), the palace rooms were heated to eighty-six degrees to enable the plaster walls to dry quickly. Thus the workers who labored inside underwent changes in temperature of more than 100 degrees, obliging them to keep ice packs on their heads as they worked. Numbers died each day, but as one observer reported, "the victims were instantly replaced by other champions who filled their places, to perish in their turn in this inglorious gap . . . and so the losses were not apparent."

Elizabeth, wanting more, commissioned Rastrelli to apply his signature carved and gilded staircases, furniture, and moldings. The architect also designed a different floor pattern for every public room, requiring fourteen different types of wood in all. He called for chandeliers made in the Imperial bronze factory; doors decorated with tortoise shell, ebony, and gold leaf; and Florentine wall mosaics set with thousands of precious stones.

In addition to its stunning interiors, the Winter Palace grew into an ever-enlarging repository of the world's great art. Throughout the eighteenth century, only the Imperial

A hallway in Pavlovsk designed by Cameron in 1789.

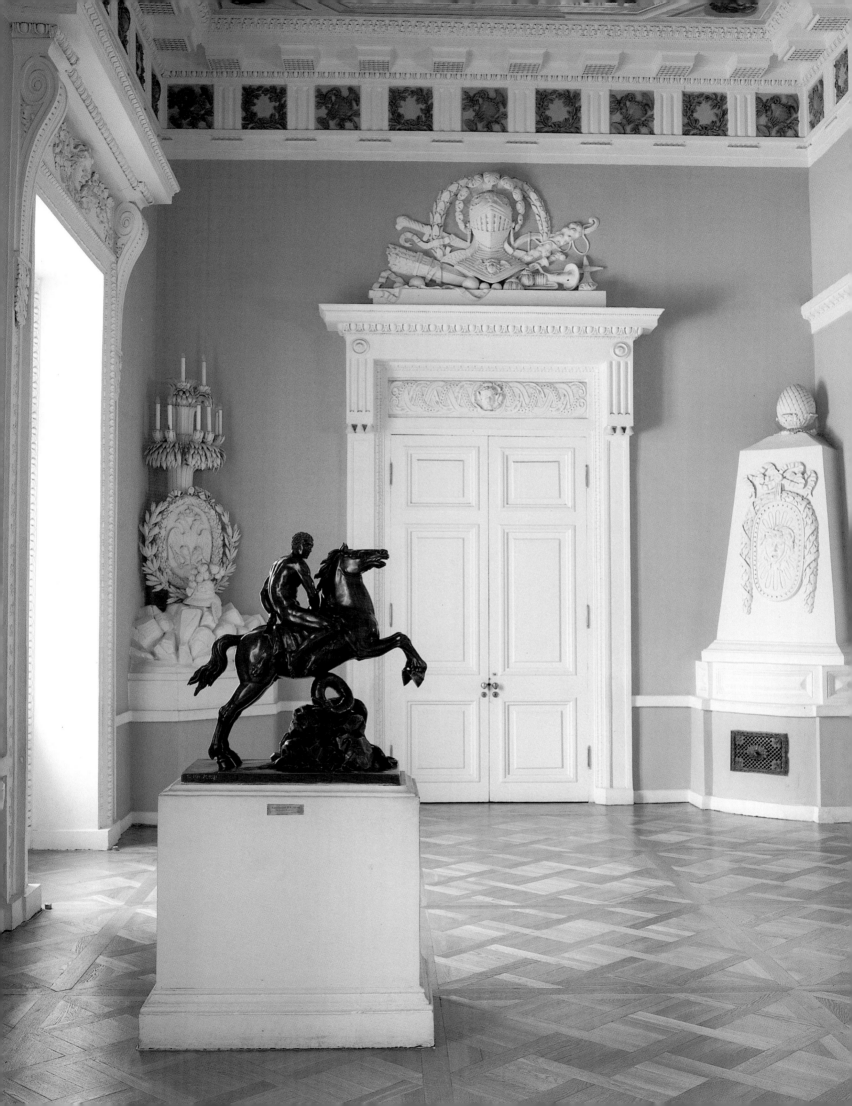

family and invited nobility could view the collections, which included the finest examples of everything from classical antiquities to the paintings and sculpture of European masters. In the nineteenth century, however, the nobility at large was given permission to visit the exhibits, as long as they were attired in formal dress, of course.

In any other nation, the architectural exuberance of Peterhof, the Winter Palace, and the Catherine Palace would have been enough to satisfy generations of rulers. But Catherine the Great, whose voracity for building surpassed even Elizabeth's, decided to redesign parts of all three residences. "At Tsarskoye Selo there is going to be a terrible upheaval in the private apartments," she wrote in a letter. "The Empress is going to pull down the main and only staircase at the end of the palace because she wants to live in the midst of three gardens. She wants to enjoy from her windows the same view as from the main balcony. She will have ten rooms, and for their decoration she will ransack her whole library and give her imagination free rein, and the result will be like these two pages, that is to say, quite without commonsense."

In 1792, Catherine decided to build another palace at Tsarskoye Selo, a mere 500 yards across the formal gardens from the Catherine Palace. Intended for her grandson, Alexander I, she commissioned the Italian architect Giacomo Quarenghi to design a residence as restrained in its neo-classicism as its predecessor was baroque in its ornateness. With only 100 rooms, the Alexander Palace was half the

In the Pilaster Study is a mahogany chased ormolu-and-brass bureau and table from the St. Petersburg workshop of Heinrich Gambs, 1810.

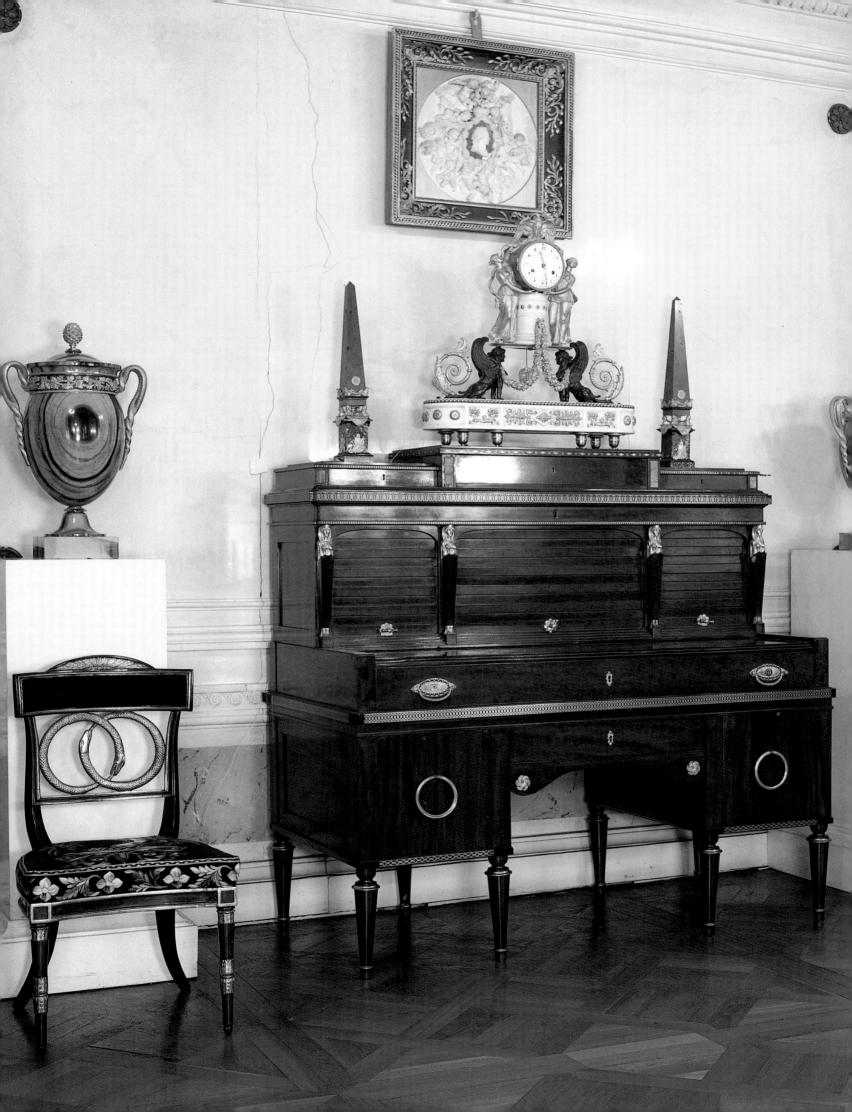

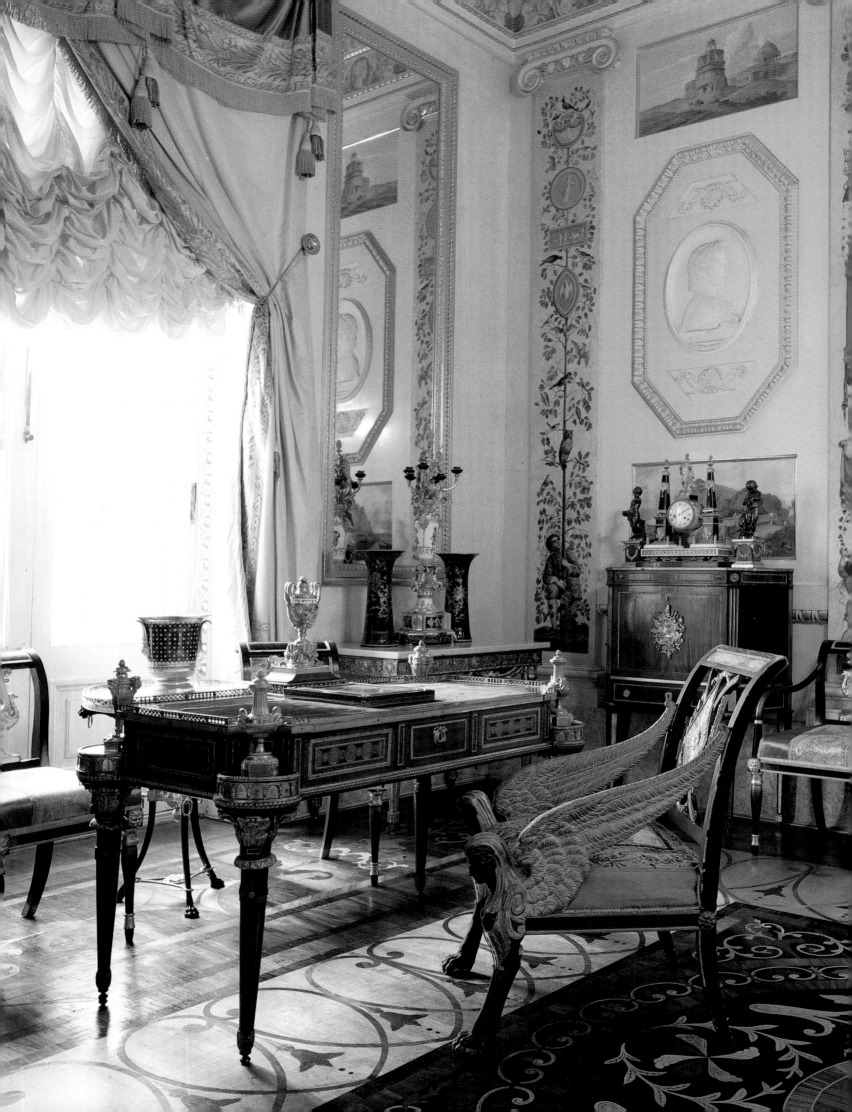

size of the Catherine Palace. The graceful two-story build-ing, made up of a center and two wings, housed state apartments and formal chambers at its center, ladies- and gentlemen-in-waiting in one wing, and the Imperial fami-lies in the other.

Though he could have chosen any one of scores of magnificent Imperial residences in which to make his home, it was to the Alexander Palace that Nicholas II brought his twenty-three-year-old bride, Alexandra Fyo-dorovna, in 1895. After months of living in a small suite of rooms (once shared as boys by Nicholas and his brother, George) as the Anitchkov Palace—Nicholas's mother's St. Petersburg domain—Alexandra was delighted at the pros-pect of serving as mistress and redecorator of a residence that would be entirely her own. A granddaughter of Eng-land's Queen Victoria, she had tastes that ran to bright English chintzes, light lemonwood furniture in the private quarters, and upholstery in her favorite color, mauve. Her personal sanctuary, in which mauve fabric was used for curtains, carpet, pillows, and even the chaise longue, came to be known as the Mauve Boudoir and in its day was the most famous room in Russia. It was in these very intimate quarters, whose atmosphere was more like that of an English country house than a grand Russian estate, that Nicholas and Alexandra lived for the last twenty-two years of the Romanov dynasty and from which they were taken to their exile in Siberia.

Pavlovsk study.

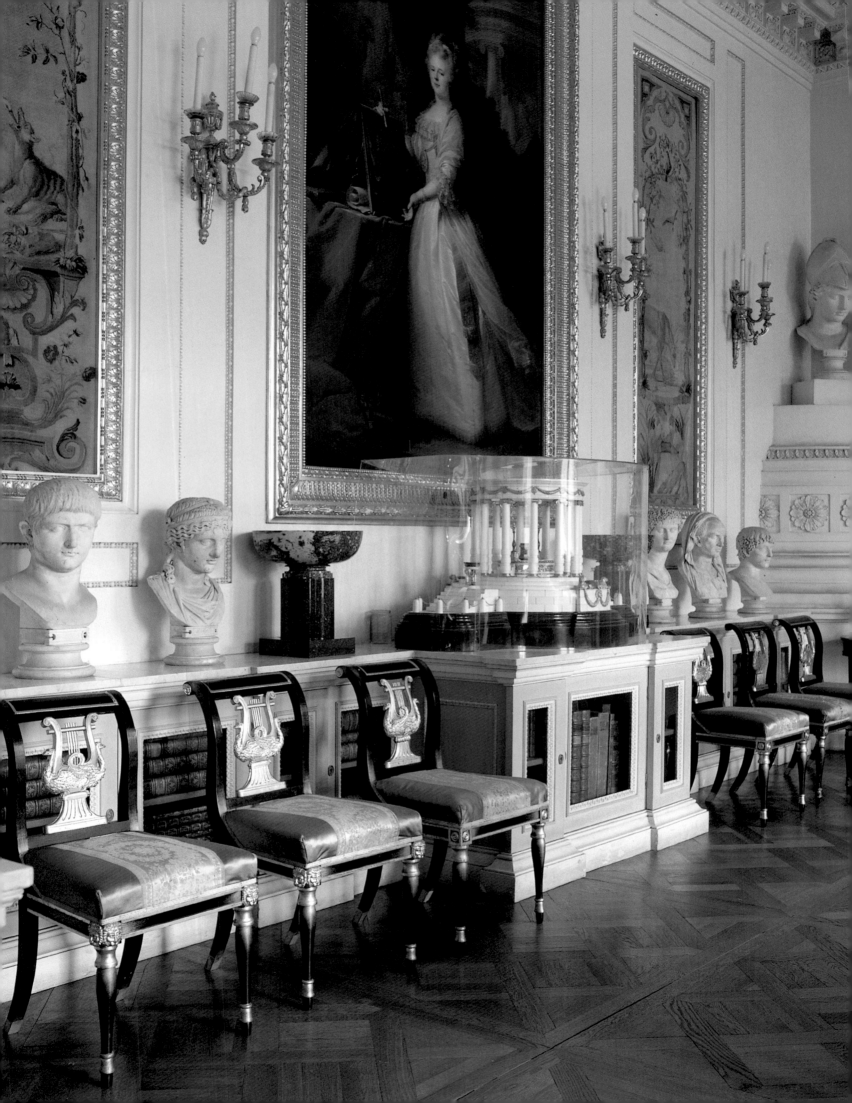

2

The Tsarskoye Selo region proved to be not only geographically convenient for the Russian Imperial family but also politically convenient for some. Nicholas II, savoring the privacy and quiet of the country site, isolated himself there from the frenzy of the capital. Catherine II built a palace for her son, the grand duke Paul, in Pavlovsk, a short three kilometers from Tsarskoye Selo, as a means of keeping the future Czar, whom she disliked and distrusted, at a distance from the Court. Though she may have had little kind feeling for her son, she spared no expense in building him one of the most exquisite royal residences in Russia—and perhaps the world.

Unlike most palaces, which are massive in scale and somber in mood, Pavlovsk is a jewel. Its scaled-down—though nonetheless lofty—proportions are classical and readily comprehensible, and its tone is serene. Unlike Rastrelli's baroque extravaganzas, Pavlovsk affects the eye quietly and is a masterpiece of picturesque composure. Designed in 1779 by the Scottish architect Charles Cameron, a neoclassicist who was influenced by the architecture of Russian country estates, the palace is shaped like a bracelet: two subtly curved wings spreading symmetrically out from a central dome-topped square into an elegant arcade.

Aiming to create an "intimate mood and sense of comfort and artistic refinement," Cameron furnished the palace rooms with the work of the most fashionable Russian and Western European cabinetmakers: carved, gilded

On the walls of Paul I's library are Savonnerie tapestries presented by Louis XVI to Grand Duke Paul in 1782.

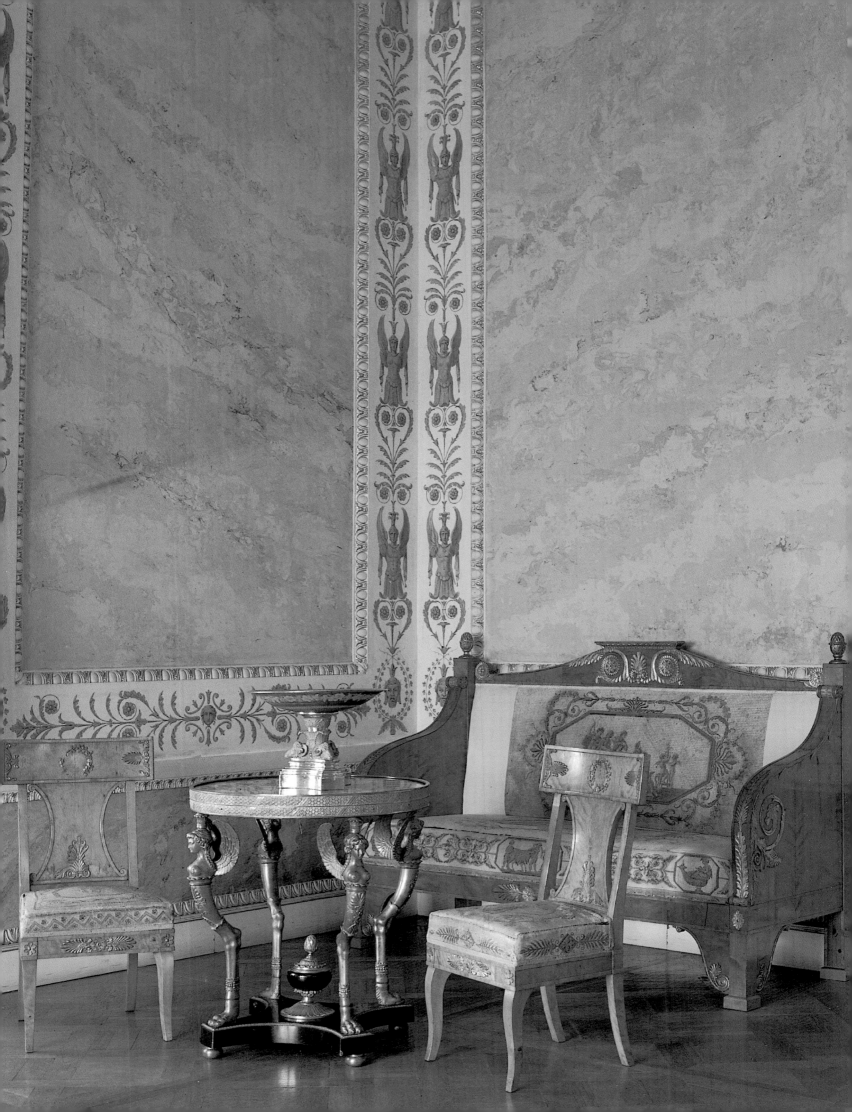

furniture in the state apartments and elegant, though more modest, ensembles from Henri Jacob in Paris for the private rooms. Tapestries given to Paul and his wife, Maria Fyodorovna, decorated the walls, along with tempera-painted silk upholstery in delicate tints with floral patterns.

Cameron's rooms were more chaste in manner than those devised by Rastrelli: Neoclassical plaster work replaced exuberant woodwork, and the furnishings, basically Louis XVI in style, were designed with an emphasis on proportion. Catherine, whose studies of philosophy nurtured her appreciation for the simple lines of classical antiquity, diligently applied her tastes to her surroundings. She fostered the attention given not only to furniture, in which precious stones were often inlaid, but equally to other appointments, such as clocks, candelabra, and commodes. She also incorporated majolica, marble, lapis lazuli, bronze, and glass into her interiors and cultivated the production of Russian decorative arts by having all the chandeliers, lanterns, and porcelain for her palaces made, according to Cameron's specifications, in St. Petersburg.

Unhappy with any evidence of his mother's influence at Pavlovsk, Czar Paul eventually replaced Cameron's dreamy elegance with the majestic austerity of the architect Vicenzo Brenna. Brenna achieved the richness and expressiveness of his own style by blending classical motifs with those of the Italian Renaissance and Italian baroque periods. His modifications—the addition of a second tier and trelliswork to the arcade, among others—changed

The corner drawing room at Pavlovsk, formerly the bedroom of Paul I, created by Carlo Rossi. The plaster wall panels are painted in tones of violet and lilac. The Russian birch settee and chairs with carved gilt decorations were designed by Rossi and upholstered in canvas with silk and crewel embroidery. The early nineteenth-century chased ormolu-and-marble table is patinated in bronze.

the character of Pavlovsk from that of a country estate to that of a fortified palace. Subsequent architects also lent their influence: Giacomo Quarenghi, André Voronikin (the first Russian architect to introduce Egyptian motifs into Russian architecture and applied arts), Thomas-Jean de Thomon, Carlo Rossi, and Pietro Gonzaga.

Because the ideal of all those who worked on Pavlovsk was to achieve a perfect harmony between nature and art, the design of the 600-acre grounds surrounding the palace was equally cultivated. The English landscape approach, an eighteenth-century style created to *appear* as if nature had been improved upon only slightly by man, was chosen for its subtle grandeur. Of course, to the Russians, subverting nature for visual effect was hardly cause for second thoughts: If Peter the Great could build St. Petersburg out of a swamp, then rerouting a river to flow more picturesquely beneath a window—as Catherine did at Pavlovsk—was a trifling effort.

Set in the Slavianka River valley, the park combines the scenery of the Russian north—groves of maple and limes, old oaks, silvery willows and aspen, slender green firs and white birches—with faux ruins, obelisks, a "Temple of Friendship," and a Pavilion of the Three Graces. Over the course of time, all the major trends in European eighteenth- and nineteenth-century landscape design came to be represented here, enlivening the park with exhilarating contrasts between the strict geometry of the formal, Dutch-style private gardens surrounding the palace and

A private collection of Imperial Russian memorabilia in Leningrad.

wild, unadorned woods with their pools, lakes, freely growing trees and bushes, and constantly changing scenes.

As spectacular as the palaces created for the Imperial families were, they were often equaled and even surpassed in splendor by those built by members of the Russian nobility. The Youssoupov family, for example, had five palaces—two in St. Petersburg and three in Moscow—as well as thirty-seven estates scattered throughout the country. On one of these estates, which stretched for 125 miles along the Caspian Sea, the ground was so soaked with crude petroleum "that the peasants used it to grease their cart wheels." On another stood the highest mountain in Crimea (which was given by a Youssoupov prince as a gift to his wife). Their estate at Archangelskoe, near Moscow, included not only huge parks and gardens with heated greenhouses but also a zoo, private glass and porcelain factories, a private theater (with its own companies of actors, musicians, and ballet dancers), and an art gallery that contained portraits of the prince's 300 mistresses. The Youssoupovs' Moika Palace housed a collection of paintings that outshone those in most European museums and was furnished with a chandelier that had lighted the boudoir of Madame de Pompadour and furniture that had belonged to Marie Antoinette.

French and Italian furniture was de rigueur in Russian palaces and manor houses throughout most of the seventeenth and early eighteenth centuries. This was a result

A room in the home of Viktor Magids, a Moscow art collector.

not only of the fashion dictates of St. Petersburg but also of the history of the nation's craftsmen as woodcarvers rather than as furniture builders. Until the time of Peter the Great, all that was within their scope were simple benches, three-legged stools, coffers, and heavy tables. Peter laid the foundation of a modern Russian cabinet-making industry by sending thirteen artisans to Europe to expand their range and refine their techniques under the guidance of English and Dutch masters. He also required the carpenters of his Baltic fleet to work during their off-season making furniture to supply the houses of the city's new inhabitants. Peter himself often labored beside his craftsmen, turning wood and bone on the lathe. But despite its European derivation, the resulting furniture—high-backed cane chairs in the Dutch style and huge

ABOVE: An array of the smallest of the miniature carved gemstone animals made by Fabergé, including a Japanese-inspired rhodonite rabbit. The smallest are a gray Kalgan jasper elephant with diamond eyes and an agate seated pig. OPPOSITE: A mahogany carved and gilded wood chair likely designed by Voronikin, in the early nineteenth century. The motif of the serpent biting its own tail is a traditional symbol of eternity.

*2*

German-style wardrobes—was of poor quality and would be inappropriate to the baroque architecture of later reigns.

In time, every Russian estate had its own carpentry workshop where hundreds of serfs were confined to making pieces for their master's personal use or as gifts for notables. Occasionally, these serf-craftsmen were removed from their original estate and sent to a private workshop where they served both a master and an "employer." A fortunate few were granted an atelier from which they could sell additional work on the open market, provided, of course, their master was always given preference.

Stimulated by the great quantity and variety of indigenous woods available to them, these serfs extended their woodcrafting skills to the arts of cabinetmaking, concentrating on the techniques that gave the most scope for their talents: marquetry and carving. Thus, what had begun as a simple necessity for the Court became a full-time creative occupation for the nobility's woodcraftsmen, the nation's most prolific producers of furniture. Furthermore, without the elaborate regulation and strict demarcations of roles within the trade in Russia (as in Western Europe), these craftsmen could work in different aspects of production and on different types of furniture. Unlike porcelain and other works of art, so much furniture could be obtained in Russia itself by the mid-nineteenth century that the Imperial families ceased spending vast sums on cabinets from abroad and supported Russian production instead.

OPPOSITE: A Russian Imperial table, circa 1820, in mahogany, ebony, and gilt with a farm scene painted in tempera. OVERLEAF: *The Fireworks over the Kremlin in Moscow*, a painting by Piotr Vereshchagin of a scene during the coronation of Alexander III in 1883: (*in the foreground*) a gray Kalgan jasper *tazza* together with a golden-and-agate kiwi and a jasper monkey on a nephrite base by Fabergé; and a piece of Imperial fabric on a Russian green faux marbre table, one of a series of tables made around 1785, most of which are still in the Hermitage.

# 3

OBJETS d'ART

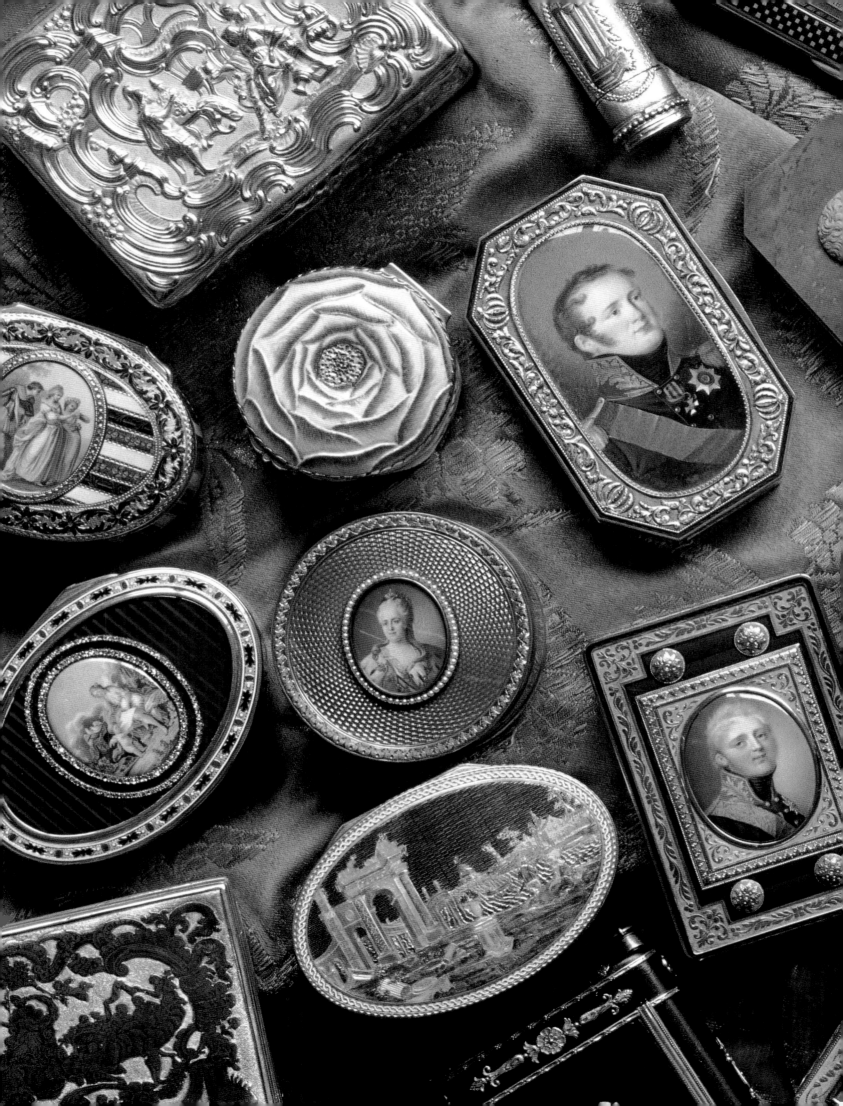

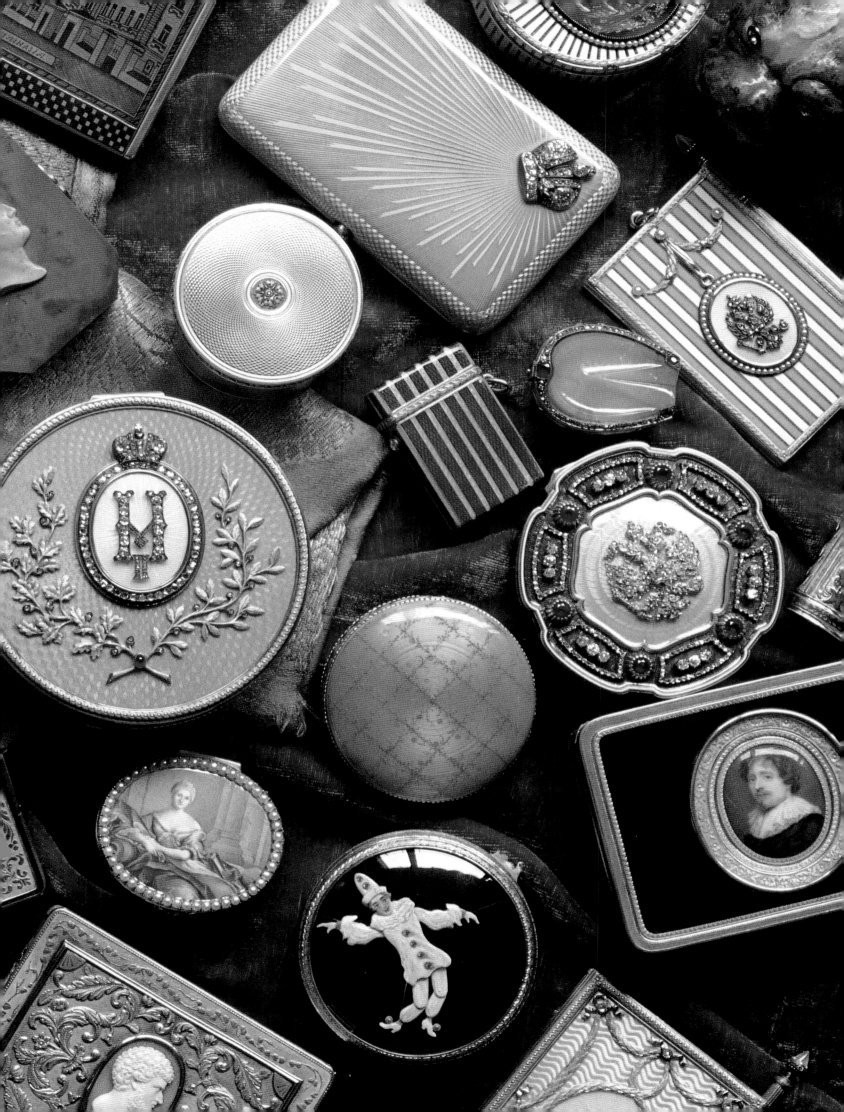

The Lenten fast had ended, and Czar Alexander III looked with relish upon the feast of Easter cakes and creamy dishes laid out before him. Like millions of reverent citizens throughout his nation, he had spent hours this day in church celebrating the climax of the Orthodox year, the holiest and most jubilant of the Russian holidays. A lover of music, he relished the choral litanies of the Easter service, and, like his devout countrymen, he had, with lighted candle in hand, joined the priest, the bishop, and the metropolitan in shouting, at the long-awaited moment, *"Khristos voskres!"*: "Christ is risen!"

On this Easter evening in 1884, however, the Czar had greater cause than usual for his good humor. Today, after years of futile efforts, he had finally succeeded in lifting the fragile spirits of his wife, Maria Fyodorovna, out of the deep melancholia into which she had fallen following the assassination of Alexander II. Months earlier, desperate to end the Empress's despair, he had approached the master jeweler Peter Carl Fabergé and given him free rein to create the most remarkable treasure he could conjure. Fabergé had been delighting the Imperial Court with the elegance and lavish whimsy of his designs since 1870, but now, the Czar impressed upon him, something even more extraordinary was called for. He described an antique French ivory Easter egg which his wife had admired as a child in the home of her father, the king of Denmark, and left the rest to the goldsmith.

Even though Alexander had complete confidence in

PRECEDING PAGES: A rare collection of boxes in all periods and all materials. *Counterclockwise, from top right:* a large Catherine II gold box by Pauzié; an eighteenth-century porcelain box in the shape of an open rose made during the first years of the Russian Imperial Porcelain Factory during the reign of Empress Elizabeth, founder of the Factory; an Ephraim Hyppen gold-and-enamel striped box with oval plaque by Theremin; a gold-and-enamel box with red crystal by Jean Ador, 1778; a dancing clown figure box by Fabergé; a tortoise-shell box with a miniature of King Christian V of Denmark 1692, by Barbé; a scalloped, circular peach-and-gray-enamel Imperial presentation box, set with rubies and diamonds by Karl Hahn, Court jeweler; a "hoof" box of green chrysoprase by Fabergé. At center is a box of blue-and-yellow striped enamel, "The Rothchild Racing Colors," by Fabergé; and a pale blue enamel circular presentation box with diamond monogram of Nicholas II by Fabergé. OPPOSITE: Animal boxes and figurines in hardstone, enamel, and jewels, all by Fabergé: a hardstone figurine of the celebrated gypsy singer Vara Panina; the figurine of a peasant woman carrying a bundle and a sheaf of wheat; a striated agate box in the form of a shell with gold, enamel, rose diamonds, and a cabochon ruby; the Royal Order of the Elephant of the Danish Royal House in gold-mounted agate, its eyes set with rose diamonds, the turret on its back enameled white and set with a band of diamonds. (It was a wedding gift from Empress Maria Fyodorovna to Princess Victoria Alberta in 1884.) A mauve enamel box in gold with carnations, in the French eighteenth-century manner; a group of three nesting rabbits, one in brown jasper with rose-diamond eyes, one in obsidian with rose-diamond eyes, and one in white jasper with emerald eyes.

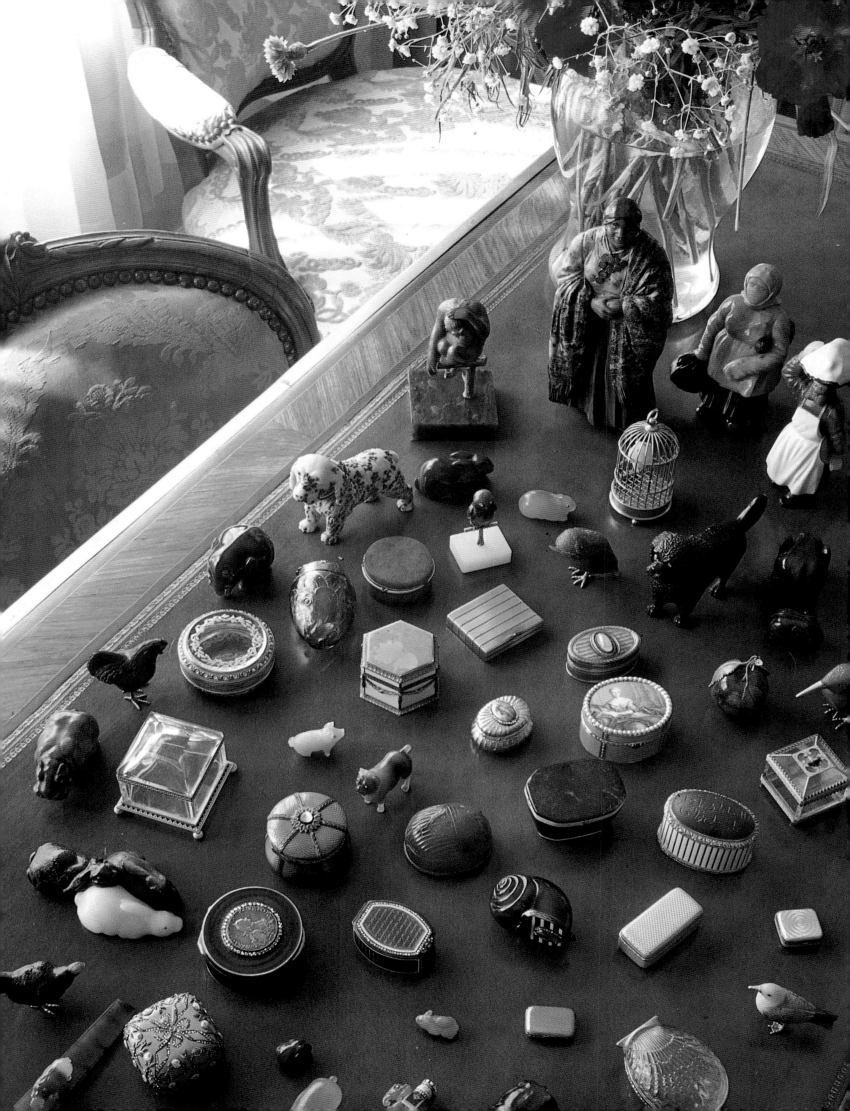

Fabergé's virtuosity, he was nonetheless little prepared for the wondrous result of his request. Inspired by the story of the Empress's childhood delight, Fabergé had crafted a special jeweled Easter egg for the occasion, and the Czar had presented it to her that morning. Lifting the eggshell-white enamel egg from its box, Maria Fyodorovna had, at first, however, seemed unmoved. The Fabergé egg simulated a real egg in size and color, and, as a woman accustomed to the most lavish tokens, she was perplexed by this gift's simplicity. But upon opening the bayonet fitting by which the egg's two halves were clasped together, she discovered inside a yellow enamel yolk, inside of which sat a gold hen with a red-gold beak and comb, sitting on a gold "velvet" cushion. Each feather of the one-and-three-quarter-inch-long bird was engraved into the body, and two cabochon rubies were set into its eyes. Amazed, the Empress daintily removed the hen which, to her greater surprise, revealed a miniature gold replica of the Imperial Crown, exquisite in detail. Examining the tiny crown, she was further delighted to discover inside it a perfect, egg-shaped ruby pendant. Fabergé's magic had worked: For the first time in years the Czar saw his wife's face glow with pleasure.

From that year until 1916 (when the last of the Imperial eggs made by the Fabergé atelier was presented by Czar Nicholas II to his mother), the creation of Fabergé eggs became part of the Imperial family's Easter tradition. In 1900 he crafted the superb Trans-Siberian Railway Egg

The Fifteenth-Anniversary Egg by Fabergé in gold, green, white, and oyster enamel with ivory, diamonds, and crystal. It was presented by Czar Nicholas II to his wife, Alexandra Fyodorovna on Easter 1911. The egg commemorates the fifteenth anniversary of the coronation, and the miniatures depict the Czar and Czarina, their children, and major events of their reign.

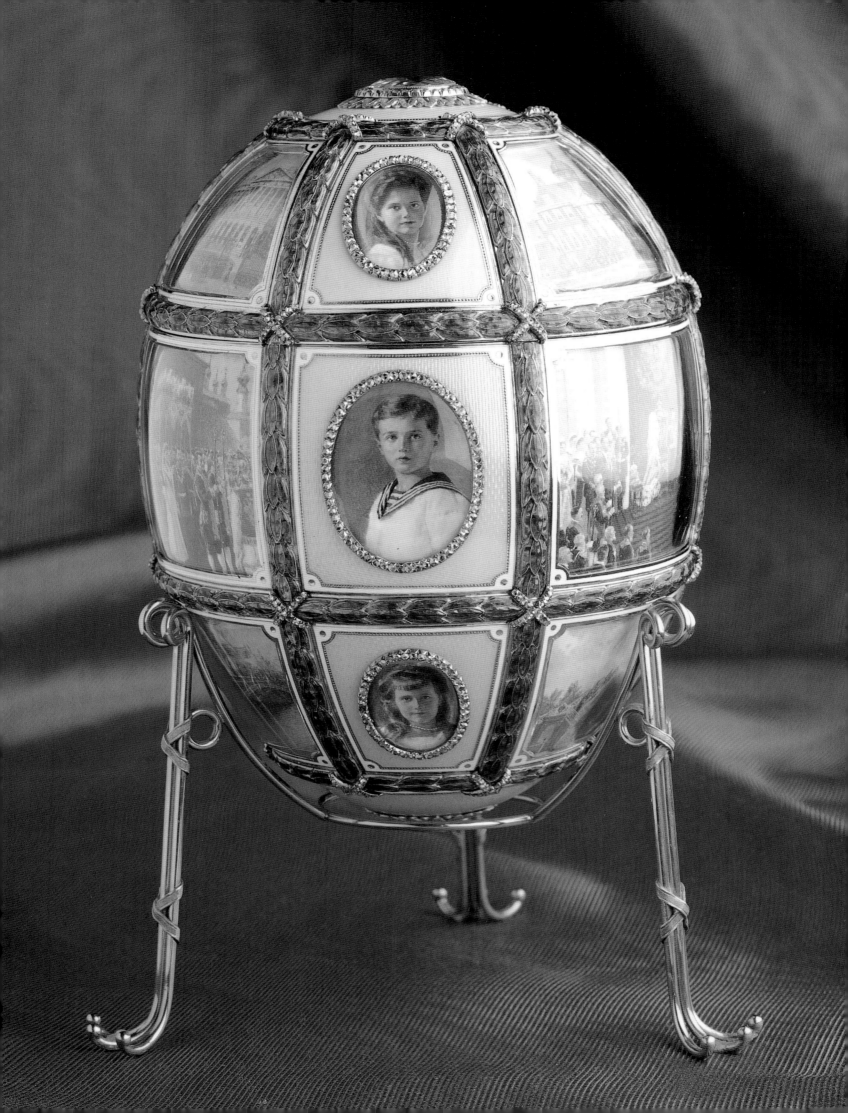

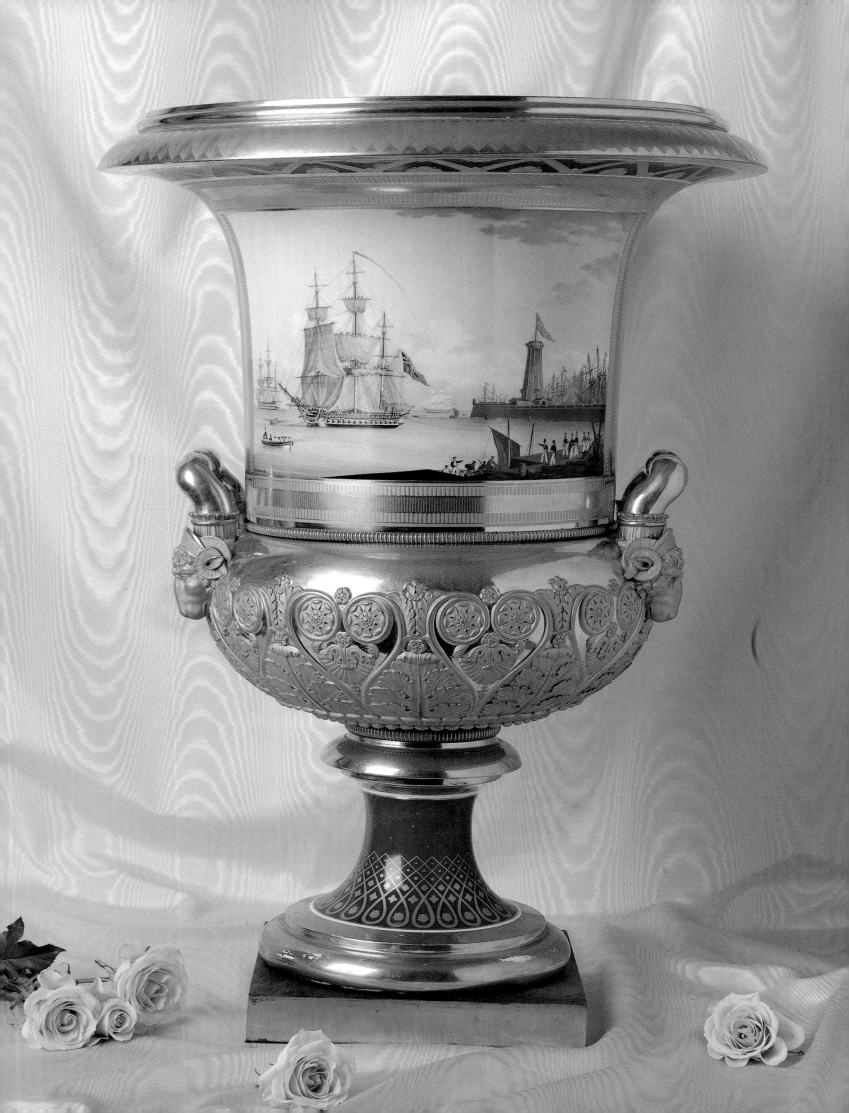

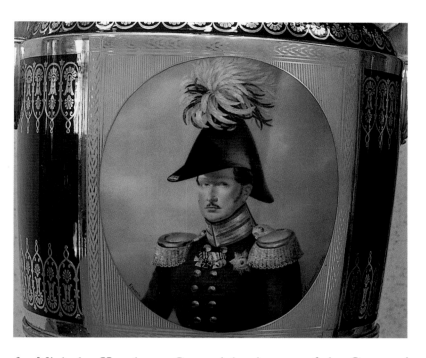

for Nicholas II, who as Czarevich, the son of the Czar and heir to the throne, was chairman of the railway committee. Across the egg's blue, green, and yellow enamel surface a map of Siberia and the route of the railway were inlaid in silver. Its top could be lifted by touching the golden double-headed eagle that surmounted it. Inside, the "surprise" was a foot-long, five-eighths-inch-wide scale model of the five cars and locomotive of the Siberian express. "Driving wheels, double trucks under carriages, and other moving parts were precision made to work so that, given a few turns with the gold key . . . the gold and platinum locomotive, with a ruby gleaming from its headlight, could actually pull the train," an observer described. "Coupled to the baggage car [were] a carriage with half the seats reserved for the ladies, another car for children . . . and still another car for smokers . . . [and a] church car with Russian cross and gold bells on the roof."

ABOVE: A porcelain vase bearing the portrait of Frederick William III of Prussia, made in the Russian Imperial Porcelain Factory during the reign of Nicholas I, 1825–1855. OPPOSITE: The Treaty of London Vase, made in the Russian Imperial Porcelain Factory in 1828, during the reign of Nicholas I (1825–1855). Its scene of the Allied Fleet commemorates the 1827 treaty by which Russia, Great Britain, and France forced Turkey into accepting an autonomous Greek state.

Like all Imperial-era objets d'art, the approximately fifty-seven Fabergé eggs fully indulged the Russian impulse toward visual glory with their rich colors, succulent details, and pictorial touches. Russian decorative artists of the time reveled in foreign influences and in the use of exotic materials. From Italy they borrowed the techniques of mosaics and marble painting; from India they imported stained woods and mother of pearl. Prussia gave them moldings and plasters inlaid with precious stones; China and Japan inspired porcelains; and Tibet yielded metal idols, vessels, and other artifacts. From France came fabrics, particularly the beautiful silks woven with peacock designs from Lyons. The Ural Mountains provided gold, silver, lapis lazuli, varicolored agate, porphyry, and marble; and from Siberia came fruit trees and flowering trees to fill the Imperial gardens.

Although he preserved the traditional Russian crafts of wood carving, painting on wood, bronze casting, and ironwork, Peter the Great initiated the production of European-looking objects. Stylistically, the mirrors, tapestries, and other ornamental art forms that were developed in his factories followed baroque and rococo models; however, not until the era of the architect Rastrelli did the decorative arts flourish. In Rastrelli's hands the Russian rococo became, as the French author Georges Loukomski wrote in 1924, "a rich fantasy heavily overlaid with detail in a luscious and fluid manner." His *boiseries*, overdoors, wooden wall lights, and other carved giltwood decorations, includ-

ABOVE: A large nephrite Fabergé vase carved to simulate an opening water lily, standing on a Renaissance-style gold base enameled white, red, and green and elaborately decorated with garlands, leaves, and tassels, set with rubies and diamonds. The piece still has its original price label—3,250 rubles (at that time, a 50-hectare or 110-acre farm would have sold for around 120 rubles). OPPOSITE: An original photograph of a pleasure trip showing members of the Imperial family in front of a nephrite ruby-and-diamond egg and a silver-rabbit bell push, both by Fabergé. OVERLEAF: A collection of flowers by Fabergé to heighten the spirits of his clients during the long Russian winters. (*From left to right*) A nephrite carved vase holding gold, spiky trees, combined with a single luminous white enamel flower with rose-diamond center and two slender nephrite leaves (Japanese Garden); flowering currant in a crystal vase; red flower with nephrite leaves in a crystal vase; lily of the valley in a crystal vase; a smaller Japanese garden, of white flowers; apple blossoms with nephrite leaves in a crystal vase; strawberries with nephrite leaves in a crystal vase; dandelion "puff-balls," on diamond-tipped gold stamens with nephrite leaves, in a faceted crystal vase; buttercups in a crystal vase.

ing the framework for the closely set ceiling pictures, exhibited the distinctly Russian character of unrestrained embellishment.

The eighteenth-century fashion of taking snuff promoted widespread production of a popular decorative object, the snuffbox—small, chased gold containers, intricately decorated with bright-colored enamel and gems. Oval shapes were preferred because they could be slipped easily into a pocket and were comfortable to hold, and hinged lids allowed the owner to open the box with one hand while taking a pinch of snuff with the other.

Small, ornamented boxes were also popular for the carrying of pills, cigars, cigarettes, rouge, bonbons, breath sweeteners, and toothpicks. "Presentation" boxes were made specifically as gifts, usually bearing the monogram or a miniature of the donor or recipient, and were often showcased in display cabinets. As Katrina Taylor, curator at the Hillwood Museum, notes, "The gift of a finely crafted and expensive decorative object was often a more discreet method of winning favor than a present of money."

Perhaps the most distinctly Russian-looking of the boxes and objets d'art produced at this time were those that had been decorated with a technique called niello. This centuries-old process calls for making fine incisions in a metal surface and then filling the cuts with a dark gray sulfide. The effect is black, velvety and enamellike. Throughout the nineteenth and early twentieth centuries, everything from saltcellars and silverware to picture frames

were given intricate nielloed patterning. The designs changed from mythological and commemorative scenes to battle and hunting scenes to geometric and abstract motifs according to the fashion of the period. Boxes often displayed maps and views of Moscow and St. Petersburg; goblets bore medallions depicting fanciful buildings and towers topped by flags; and tea, coffee, and vodka services frequently exhibited architectural monuments.

The Russian aristocracy, as connoisseurs of elaborate gifts and objets d'art, heavily patronized goldsmiths and silversmiths throughout the eighteenth, nineteenth, and early twentieth centuries. Though they bought objects from Cartier in Paris and from German and Swiss jewelers, the Russians also commissioned many pieces from their own workshops: Otto Samuel Keibel and his son Johann Wilhelm produced fine gold tea services and classically proportioned boxes characterized by symmetrically placed chased leaf scrolls and garlands and by diamonds mounted in high settings; the St. Petersburg atelier of Nichols and Plinke, whose firm was referred to as "Magasin Anglais" ("the English shop") manufactured silver of high quality; the jeweler Karl Karlovich Hahn produced decorative tokens covered with showy, faceted gems; and the Finnish artisan Alexander Tillander was known for his jeweled objects and gold badges. In Moscow, silversmiths and goldsmiths produced multicolored enamels in the "old Russian" style, based on sixteenth- and seventeenth-century

ABOVE: Antique playing cards with a nineteenth-century porcelain cup, from the Popov Factory. RIGHT: Three Simian-form engraved-silver table lighters by Fabergé.

ABOVE: Two fine-shaded Russian enamel Easter eggs by Chlebnikov, circa 1900, and a parcel-gilt silver sculpture of a water bearer by Samuel Arndt. LEFT: An 1896 enamel-and-copper "Coronation Cup" for the coronation of Nicholas II and Alexandra Fyodorovna, sometimes referred to as the "Cup of Sorrows." They were distributed from the Imperial coronation train, and it was erroneously rumored that one contained a five-ruble coin, causing a stampede that resulted in the deaths of hundreds of Russians.

models that used a profusion of repeated abstract motifs in bright colors, patterns akin to the arabesques on Eastern tiles or the stylized flowers on Oriental carpets.

Peter Carl Fabergé, on the other hand, liked to combine elements from styles of the Italian Renaissance; sixteenth-century Germany; Louis XIV, XV, and XVI; Oriental; Greek; Old Russian; and, eventually, Art Nouveau and Art Deco. This eclectic taste fit perfectly with the decorative-arts fashion of the time, which favored the mixing of designs and snapes from the past. Often called the Cellini of the nineteenth century (a reference to the great sixteenth-century Italian goldsmith), he was made goldsmith to the Crown in 1885, and the Court grandly presented his work to the world in the Paris Exhibition of 1900 where he won the Gold Prize.

In addition to Imperial Easter eggs and ornaments, Fabergé also created jeweled divertissements for the Russian aristocracy. To relieve their boredom with the long, cold winters, he crafted flowers out of hardstone and enamels. (A hothouse maintained at the top of his Moscow shop enabled him to copy flowers year round.) He replicated furniture in miniature—a gold Louis XVI cabinet five inches tall, and three-inch sedan chairs made of gold and enamel with interiors of mother-of-pearl. From other of his miniatures small models were made for furniture makers to follow. Others, pure whimsies, included parasols, garden watering cans ornamented with diamonds, and a gold equestrian statue of Peter the Great less than

ABOVE: A late nineteenth/early twentieth-century tea-cozy doll. OPPOSITE: A collection of early to late nineteenth-century lacquerware that includes portrait boxes from the Loukoutine Factory.

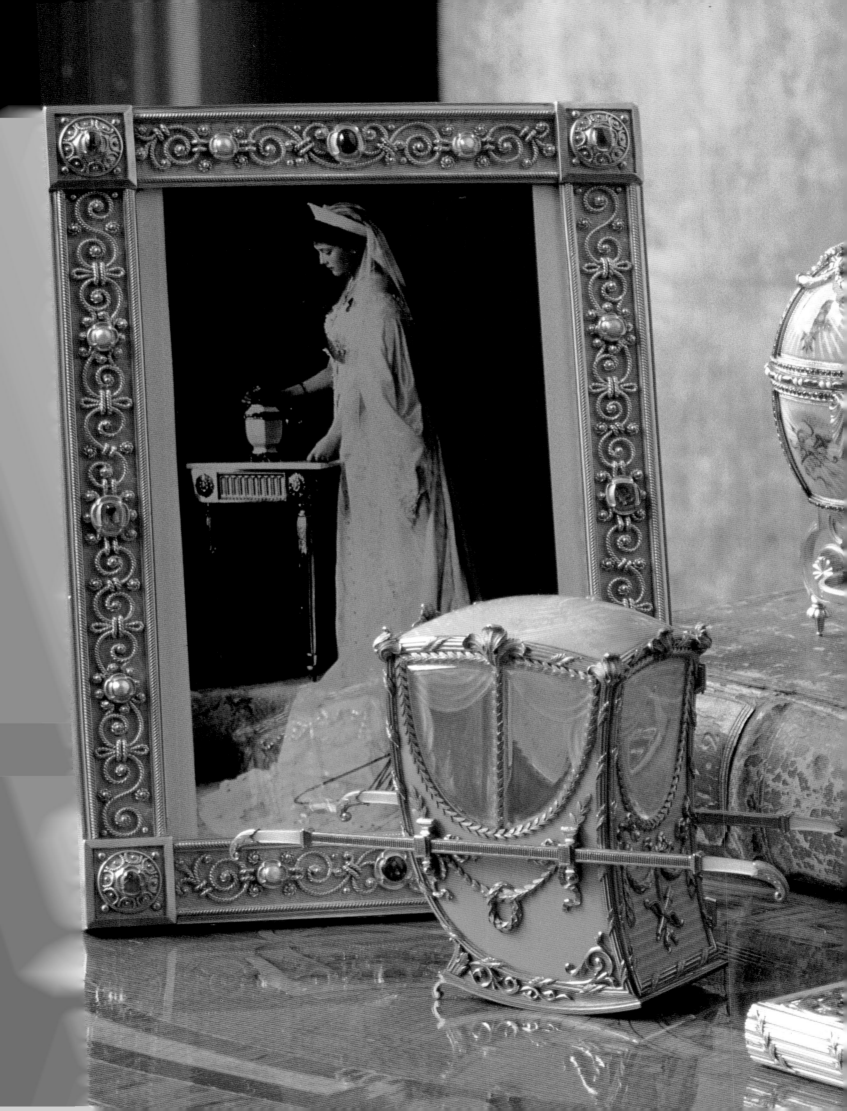

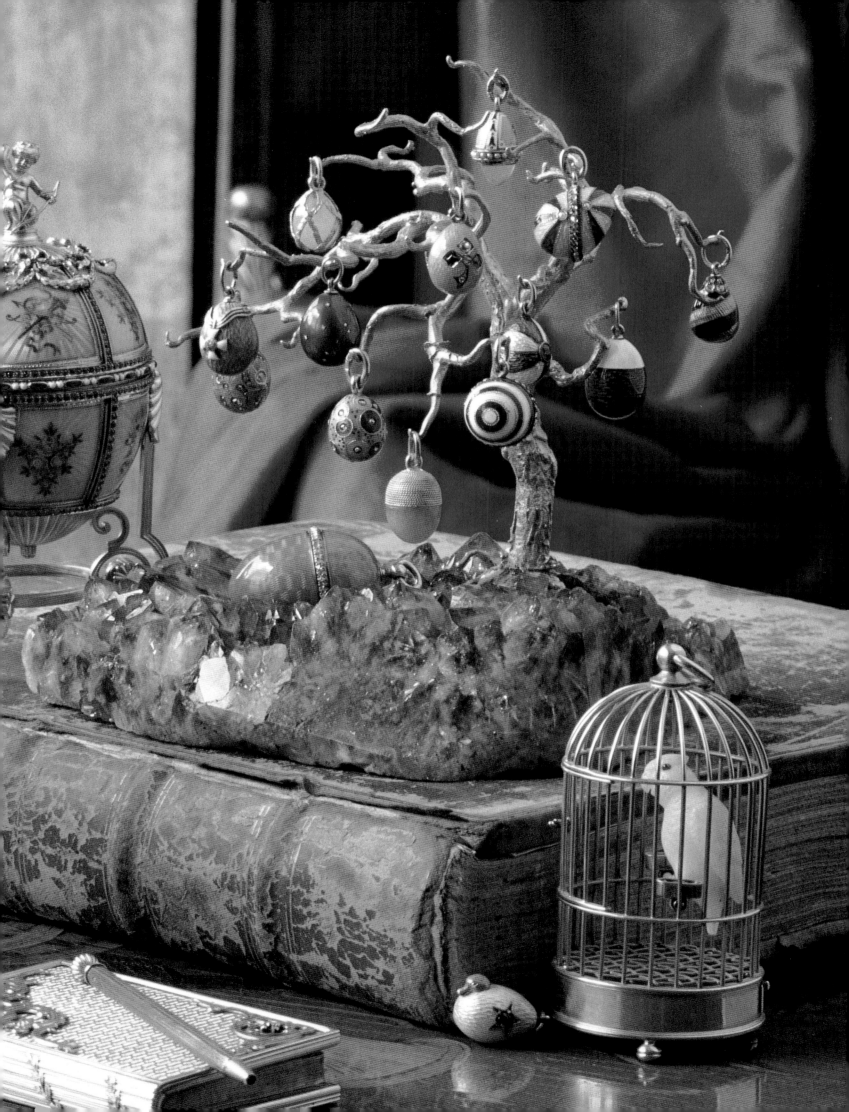

an inch high. Fabergé sculpted figures representing different Russian nationalities—Cossack horsemen, gypsy singers, Siberian peasants—in varicolored stones, each distinct in personality and piquant in its portraitlike quality. Similarly individual were his tiny sculpted animals, fish, and birds.

The Fabergé atelier was commissioned to produce a seemingly endless list of functional objects as well, for it was as if the nobles wanted everything they touched to bear his mark of splendor. He made everything: silver trays; gold candlesticks; enameled bowls, plates, and champagne flutes; jeweled tea services, flower vases, and place markers for the table; inkwells; stamp moisteners; pens; pencils; letter openers; letter holders; pencil holders; desk lamps and clocks; exquisite cuff links and cane handles; precious cigarette lighters and magnifying glasses; silver-tipped thermometers; lacquered pill boxes; engraved horse tack; and even gold dog collars. A favorite item of the Court of Nicholas II was the decorative picture frame: The Czar was fascinated by photography and delighted in surrounding himself with images of his family. Collecting ornately framed family photos had become fashionable during the reign of his father, whose desk had been cluttered with scores of small, large, oval, and rectangular framed pictures, and Nicholas was only too pleased to perpetuate the practice. He commissioned Fabergé's frames to complement specific photos and to reflect his family's personal tastes, such as Alexandra's preference for mauve-

PRECEDING PAGES: A tableau including (*from left to right*) a jeweled yellow-enamel picture frame; a pink enamel miniature working model of a sedan chair with engraved rock-crystal and mother-of-pearl interior and with poles of gold and mother-of-pearl with gold tips; a mauve enamel-and-gold notebook with pencil containing Ascot winnings and losings; an opal parrot with ruby eyes in a gold "working" cage; a miniature egg tree with an egg of the Russian National Flag (white, blue, and red); an egg with the "Rothschild Racing Colors" (yellow-and-blue stripes); a modern, multicolored "disc" egg; an electric-blue enamel egg with the Cross of St. George; and a large pink enamel egg pendant, all by Fabergé. The rare Imperial Easter egg at center is by the Court jeweler, Karl Hahn.

colored enamel. As valuable objects enclosing cherished mementos, these frames were doubly precious to the Imperial family.

So vast was the Russian appetite for Fabergé's jewelry and jeweled objets d'art that it is estimated he produced more than 126,000 pieces for Russian consumption alone. In fact his work was given so frequently to visiting royalty, friends, and ambassadors that "something from Fabergé" became the fashionable answer to the perennial problem of gifts for weddings, name days, birthdays, and anniversaries. To fulfill this demand, his firm at one point employed more than 500 artists—goldsmiths, enamelers, gem carvers, and others—and maintained stores in St. Petersburg, Moscow, Kiev, Odessa, and London.

The results of Fabergé's art were masterpieces of decorative restraint, material elegance, and overall beauty. His work, which enchanted royalty and influenced fashion throughout Europe and Asia, was also collected by monarchs around the world. King Edward VII of England was a regular customer, and in a single day the House of Fabergé could play host to the King and Queen of Norway, the kings of Denmark and Greece, and Queen Alexandra of England, King Edward's consort. Though some of his contemporaries may have had equal technical skill, none, with the exception of Karl Hahn, had his visionary strength, and none ever approached Fabergé's artistry in scope or imagination. His workshop enameled in an unparalleled range of colors, techniques, and effects and was

equally unsurpassed in its use of remarkable numbers of stones of different kinds. For Fabergé, the concept transcended the material, and thus he chose his diamonds, rubies, sapphires, emeralds, lapis lazuli, opals, amethysts, corals, agates, jaspers, quartzes, obsidians, bowenites, topazes, and rock crystals not for their monetary value but for their artistic effect, applying them only when the design of an object required them, and then employing them only as accents or in decorative borders.

Fabergé consistently amazed the eye by applying startling, complex combinations of color whose effects were wholly original, yet expressly Russian—for example, pink enamel and white diamonds with gold figures or pale blue enamel with carved jade in a yellow gold setting. By adding different alloys to pure gold, he developed a palette of colored golds that further contributed to his work's sense of fairyland opulence: The addition of copper produced a red gold; fine silver, a green gold; other metals, gray, orange, and blue golds. And to even further enhance the magical effects of his objets d'art, he would polish some of the gold parts of a piece to a sparkling finish and leave other parts matte.

Simple enameling involves the application by fusion of semiopaque glass to a metallic surface, usually at a temperature of about 600 degrees Centigrade. Fabergé worked at between 700 and 800 degrees Centigrade and specialized in *en plein* enameling, a technique in which a large, uninterrupted area is covered with a smooth, even enamel

The Peter the Great egg by Fabergé, presented in 1903 by Nicholas II to his wife Alexandra Fyodorovna. The egg commemorates the bicentenary of the founding of St. Petersburg in 1703 in four-color enamel, set with diamonds and rubies. It embodies the Russian Imperial style, as it shows the humble beginnings of St. Petersburg in the northern marshes, growing into colorful brilliance. Four miniature paintings by Zuiev depict Peter the Great, his wooden hut, Nicholas II, and the Winter Palace. As the egg is opened, a miniature figure of Peter rises. He is depicted on horseback, on a sapphire pedestal, surrounded by a gold railing. The inside of the yellow enamel lid is engraved with a pattern of concentric circles.

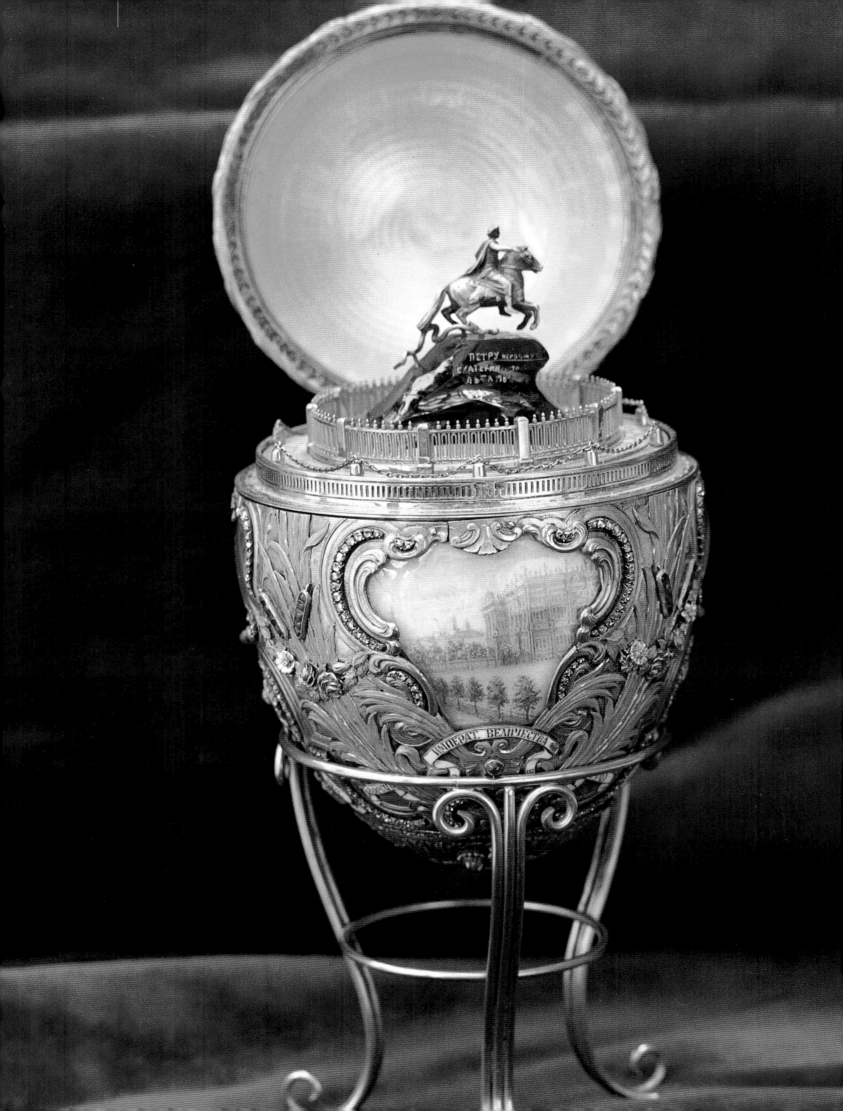

surface (a technique that allows for absolutely no margin of error). Fabergé was just as fond of combining opaque and translucent enamels in a single piece as he was of blending polished and dull golds. Frequently, the enamels were applied in layers so translucent that their nuances were as delicate as butterfly wings. Beneath these fine layers, wavy, zigzag, sunray, flame, scallop, scale, or basket weave patterns were engine-turned (guilloché) gold and silver backings.

In addition to these techniques, Fabergé's impeccably trained artisans also employed the centuries-old traditions of cloisonné, champlevé, and plique-à-jour. In cloisonné, a network of raised metal enclosures (or *cloisons*) are soldered to the body of an object. Enamels are then poured into them like jewels into a setting. In champlevé, deep grooves are cut into a piece and then filled with enamel. The surface is then polished flat and smooth. Plique-à-jour produces a stained glass effect because the enamel is not backed and becomes transparent when held up to the light.

Fabergé did not invent the ornamented Easter egg, but with the patronage of Alexander III and Nicholas II, he took it and other decorative art forms to their zenith. Some see the unrestrained lavishness of his work as a "symbol of an age brewing for itself a cup of poison." For others, his art illustrates how, even in times of extreme political and social brutality, great beauty can flourish.

An Imperial corner table once located in the living apartments of Pavlovsk. The mahogany table was made in St. Petersburg at the end of the eighteenth century by Jonathan Otto, partner of Heinrich Gambs after a Voronikin design. On top of it is a colored gold, green garnet, and purpurin basket by Fabergé filled with miniature Fabergé eggs, including a duck-shaped gold-and-enamel egg with ruby star, a swirled blue-and-gold egg in the Rothschild racing colors, a white enamel egg with ruby-set Red Cross, a rooster-shaped gold egg, an electric-blue enamel egg decorated with the Cross of St. George.

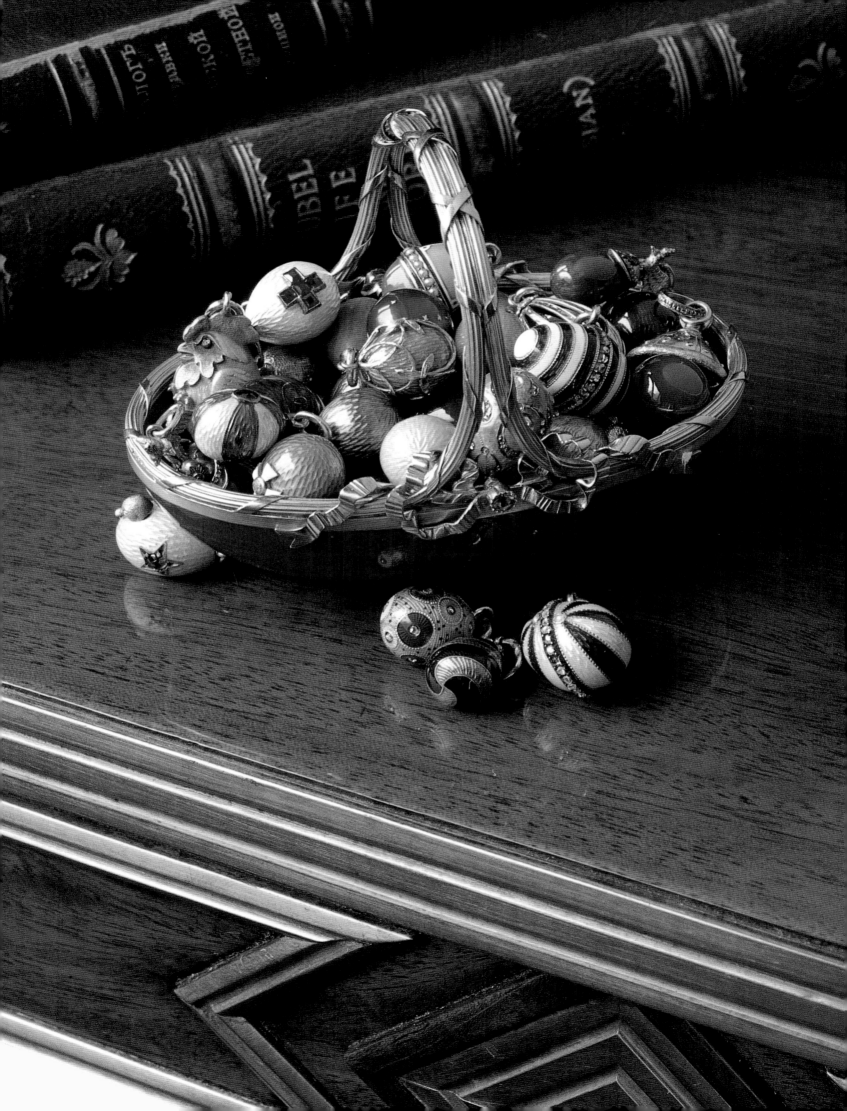

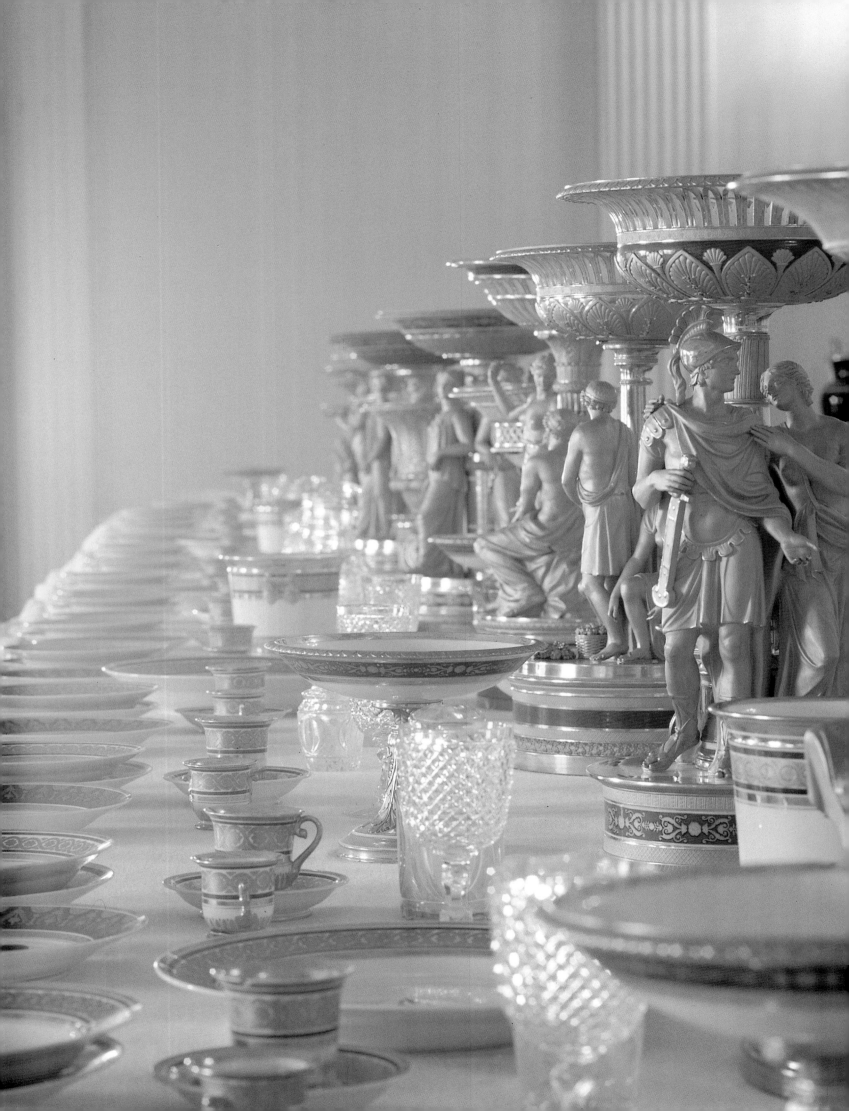

# 4

## TABLE SETTINGS

The coronation of Nicholas II on May 25, 1895, gave the Russian people cause for double celebration. It marked not only the perpetuation of the nearly 300-year-old Romanov dynasty but also the end of the twelve-month period of mourning for Nicholas's father, Alexander III. Thus, the 7,000 guests who had been invited to join the new Czar and his bride, the Empress Alexandra, at the coronation dinner following the five-hour church ceremony were prepared for the utmost in Russian revelry. Hundreds of tables lined with tall gold and silver candelabra had been set throughout the Kremlin's banquet halls, their walls hung with blue silk. A dais on which Nicholas and Alexandra would sit had been built for the occasion beneath a gold canopy. There, according to ancient tradition, the couple would dine alone on golden plates, still dressed in their coronation garb: he in the blue-green uniform of the Preobrajensky Guard and still wearing the miter-shaped coronation crown; and she, surrounded by the twelve attendants who carried the train of her silver-white Russian Court dress, wearing a red ribbon sash across one shoulder and the single strand of pink pearls Nicholas had given her as an engagement gift.

In addition to grand dukes, royal princes, emirs, ambassadors, and members of aristocratic society from Europe and Asia, the guest list that night included a number of ordinary Russian citizens. These men and women had been invited by hereditary right, for they were the descendants of people who, at one time or another, had

PRECEDING PAGE: The "Green-and-Gold Mythological Service," decorated with different mythological subjects, including Perseus and Andromeda (shown in foreground); with matching crystal. Made in the Russian Imperial Porcelain Factory in St. Petersburg, circa 1820, during the reign of Czar Alexander I, 1801–1825. OPPOSITE: The "Elizabeth Service," the first service made in the Russian Imperial Porcelain Factory, founded by Empress Elizabeth, who reigned from 1741 to 1762. This rare porcelain plate was part of her personal place setting in that service.

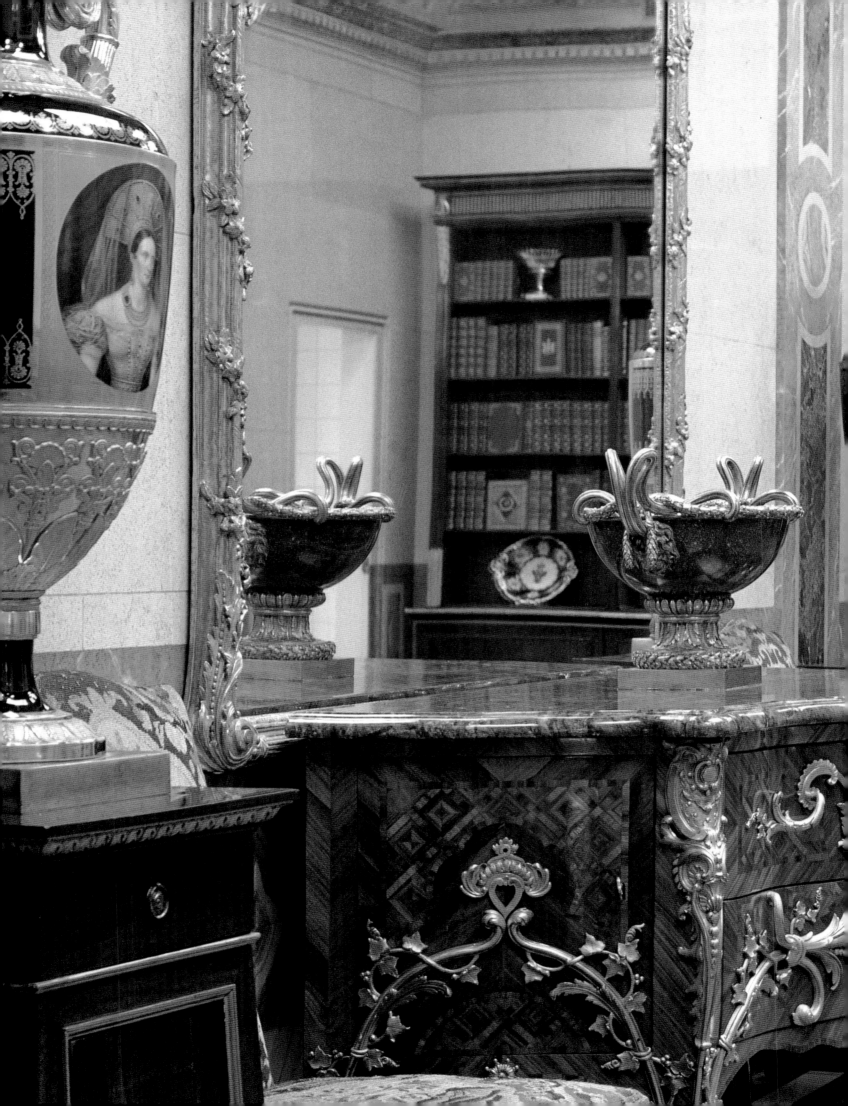

saved the life of a Russian Czar. Like all the other guests, once they had seated themselves on the gold chairs arranged around each table, they found at their places a roll of parchment tied with silk cord. Inside, written in medieval illuminated manuscript, was the evening's menu: That night they would dine on borscht, pepper-pot soup, meat-filled turnovers, steamed fish, whole spring lamb, pheasants in cream sauce, salad, asparagus, sweet fruits in wine, and ice cream.

Each course would be served on a colorful, exquisitely made porcelain plate from one of Russia's renowned porcelain factories. The pepper-pot soup, spooned from tureens decorated with mythological scenes, would fill scallop-edged soup plates; the lamb would arrive on gilt-bordered, Empire-style platters illustrated with scenes of patriotic life; grapes from the Crimea would fill leaf-shaped and basket-shaped bowls; the ice cream would come in tiny cups glazed with colorful floral motifs; even the handles of the gold and silver cutlery would be made of fine Russian porcelain.

Ceramics, of all the decorative art forms, was the one most intensively cultivated in Imperial Russia. Its development began not with Peter the Great, who had sent emissaries to Peking to wrest from the Chinese the secrets of their exquisite ware (and failed), but with his expansive, beautiful, and willful daughter, Empress Elizabeth. Though beautiful dishes imported from Europe graced

PRECEDING PAGES: The grand hall of a contemporary apartment featuring, in the foreground, a pair of large St. Petersburg porcelain portrait vases, one bearing the portrait of Czarina Alexandra Fyodorovna, wife of Nicholas I, the other, a portrait of her father, Frederick William III of Prussia. Both were made in the Russian Imperial Porcelain Factory. In the background, a pair of Russian bookcases flank a view of a collection of Russian Order porcelain from the Gardner Porcelain Factory.

her table, she nonetheless felt her Versailles-like surroundings were incomplete without an abundant supply of porcelain produced in her own factories. Elizabeth's pursuit was not, in all fairness, entirely self-serving, for she also saw it as a means of generating commercial profit for the country and as a way of nurturing a "home art." Russian ceramics, i.e., majolica and porcelain replacements of common earthenware, would represent "the first in Russia from Russian soil."

Elizabeth's mission had been accomplished by the middle of the century when production of majolica—decorative glazed ceramic developed in fifteenth-century Spain and Portugal—was perfected in Moscow, and the first Russian porcelain formulas and technology were created in St. Petersburg. The latter occurred in the laboratory of a Russian priest's son, a chemistry student named Dmitry Vinogradov, who threw himself heart and soul into experimentation with the ingredients of paste and glaze as well as with methods of firing in a kiln. As promising as Vinogradov's experiments were, he was given to violent bouts of drunkenness—prompted, no doubt, by the pressure of bearing the full weight of this monumental endeavor along with the prospect of enduring the Empress's wrath should he fail. The purposeful Elizabeth ordered him fastened to his workbench by an iron chain, perpetually watched, and forced to write down every technical recipe he concocted. At length, Vinogradov succeeded (though he died at age thirty-nine as a result of his labors),

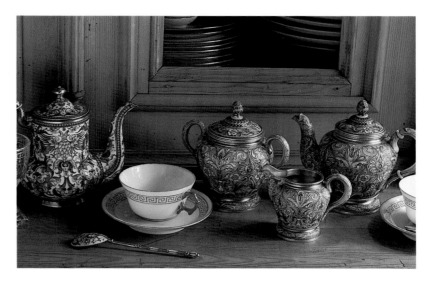

RIGHT: A three-piece silver-gilt and shaded-Russian-enamel tea set by Fyodor Ruckert, workmaster of Fabergé; two cups from a set of six white porcelain cups and saucers with gilt-and-orange decorations and organic handles by the Kornillov Brothers Porcelain Factory, late nineteenth century; one spoon from a set of twelve silver-gilt and shaded-Russian-enamel teaspoons by Chlebnikov, circa 1900; and a pair of late eighteenth/early nineteenth-century gilded crystal wine glasses made in the Russian Imperial Glass Factory, St. Petersburg. OPPO-SITE: A rare Oriental Export plate, circa 1785, from the Court of Catherine the Great, with the Russian Imperial double-headed eagle; an early eighteenth-century copper presentation beaker with the Russian Imperial eagle from the period of Peter the Great, 1621–1725; a wood-and-metal Russian Revival *kovsh* of Scythian inspiration, circa 1900, from the Talachkino Workshops.

and his workshop grew to become one of the world's leading porcelain manufacturers.

While the St. Petersburg Imperial Porcelain Factory established the prevailing traditions of Russian ceramics—stylistic conformity with architecture, tendencies toward the expressive and the picturesque, and refined artistry—like many European porcelain manufacturers, it began by imitating its immediate European predecessors, primarily Meissen. In fact, Catherine the Great's extensive The Hunters' Service had been made by that famed German porcelain factory, and when a number of its plates and dishes became broken, she had the Imperial factory produce replacements. Their work, though more compact in line, less elaborate and mannered in decoration, and freer and more naive in painting style, nearly equaled Meissen's in quality. Satisfied, Catherine went on to order a number of other services, among them the thousand-piece Arabesque Service, which was inspired by the frescoes then recently excavated at Herculaneum and used to illus-

trate the Russian victories that brought the Crimea under Russia's control, and the Cabinet Service, an artistically splendid gift for her lover of the moment, Count Bezborodko. Designed with luxuriant Italian ornament, this service was later revised and reproduced by Catherine's grandson Alexander I as a present to his sister.

With characteristic ambition, Catherine the Great furthered the evolving art of porcelain production by importing highly skilled painters, modelers, and craftsmen from Germany, Austria, France, and Scandinavia. In time, foreign entrepreneurs, attracted by the considerable financial opportunities in Russia, followed these artists and began establishing private factories. Most prominent among these was one opened in Moscow in 1766 by Francis Gardner, an English businessman. Catherine herself was so impressed by the workmanship and beauty of items from the Gardner Porcelain Factory that she ordered from it a number of services decorated with the ribbons, badges, and stars that depicted four of the Russian Imperial orders. These were used once a year when the knights dined at the Winter Palace on the feast days of their patron saints.

In addition to its creation of this and numerous other dinner services commissioned by Catherine, the Gardner Porcelain Factory became famous for its development of a large range of decorative objects and realistic-looking sculpted figures in folk settings. The silhouettes of Gardner's vessels were well regarded for their graceful simplicity as well as for the originality of their decorative motifs.

Part of the eighteenth-century "Meissen Rose" dinner service from the Gardner Porcelain Factory, with a cut-crystal wine carafe and glass, circa 1855, made in the Russian Imperial Glass Factory, St. Petersburg, engraved with grape motifs and decorated with a gold-and-enamel monogram of Nicholas Nicholaievich (1843–1886), brother of Czar Alexander II. The monogram is completely encased in the glass (verre eglomisé). The linen napkin came from the Imperial household.

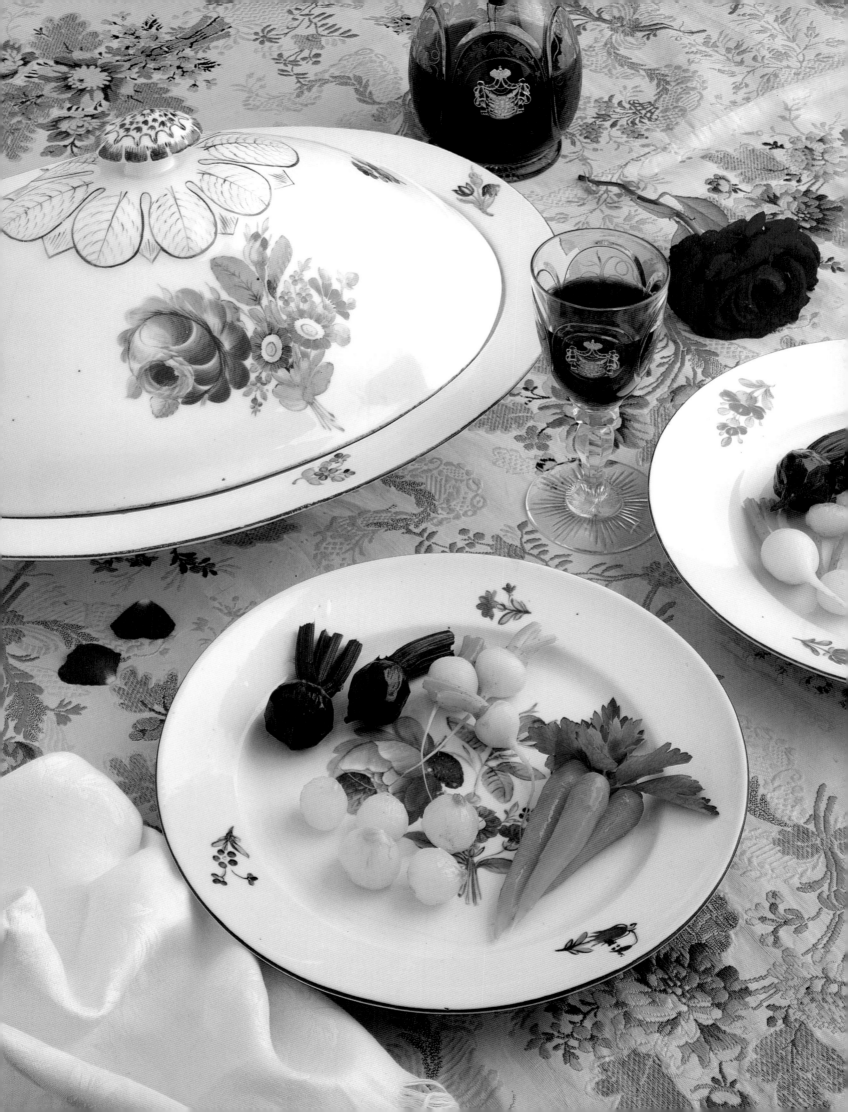

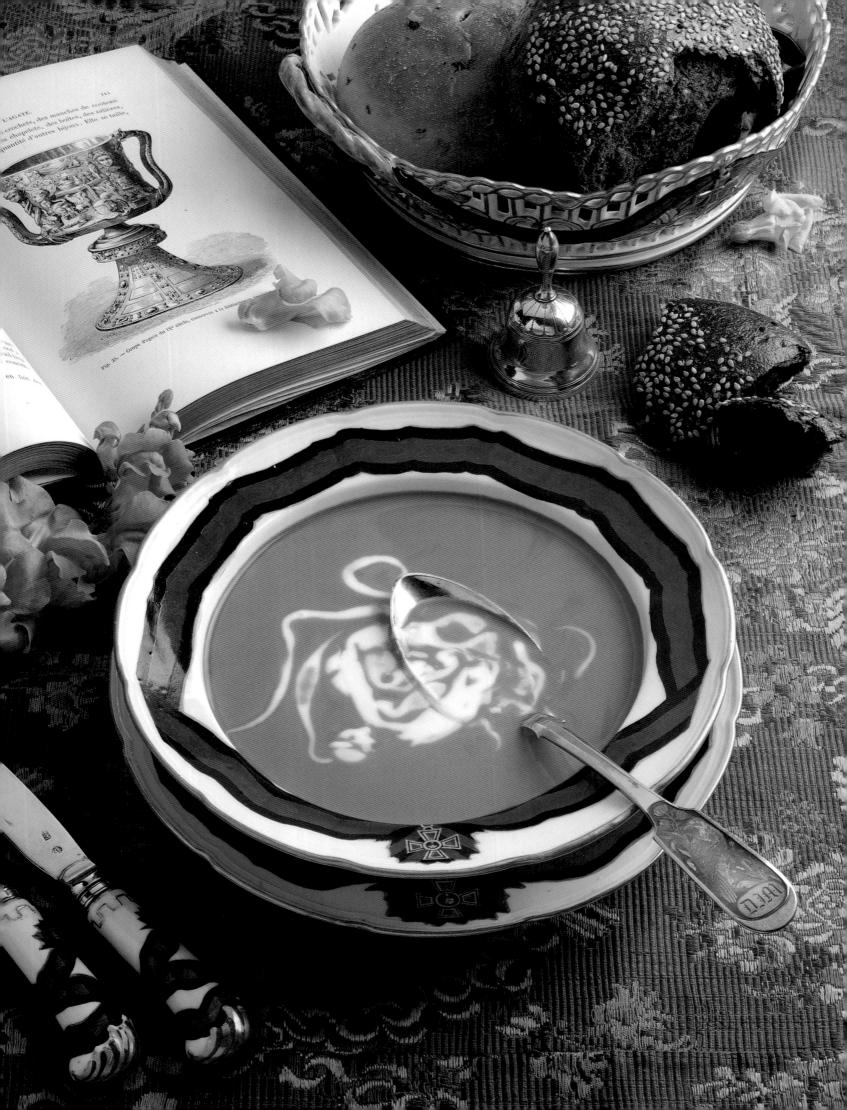

4

These qualities, in addition to their impeccable workmanship, placed the Gardner Porcelain Factory on a par with the most prominent porcelain manufacturers in Europe, including Meissen.

Private porcelain factories multiplied further under Alexander I, who imposed a prohibitive tariff on the import of foreign porcelain into Russia. While some of these ventures were run as straightforward businesses, others, like that of Prince Youssoupov, were designed to gratify the tastes of wealthy connoisseurs and to make unique presents for their personal friends.

With the rise of patriotic feeling in Russia as a result of the War of 1812, portraits of military leaders, inscriptions, and allegorical compositions, popular themes of the Empire style, appeared on vases, plates, cups, wineglasses, and glassware of all kinds. The Gardner Porcelain Factory produced a service that portrayed the Russian people as the victors over the army of Napoléon. At the Imperial Porcelain Factory, a democratic line begun in the eighteenth century was revived. A series of figurines of townspeople—drivers, footmen, postmen, moneylenders, and food sellers—from which whole street scenes could be assembled, was introduced in 1820. Idyllic depictions of peasant life also appeared during the century's first three decades.

From the 1830s through the 1850s, Russian ceramics preserved its taste for picturesqueness. Though the palette of decorative devices grew ever richer and the tech-

OPPOSITE: Five pieces from the St. Vladimir service commissioned by Catherine II, as they would have been used. The knife and fork are made with silver-gilt blades, and the soup spoon made of silver-gilt and niello is by Mikhail Koshkov, Veliki Ustyug, 1868. OVERLEAF: A plate from the St. George service together with an Alexander Nevsky fruit basket, knife, and fork, commissioned by Catherine II, with an Imperial linen napkin on a documented marquetry table from Pavlovsk Palace, made between 1796 and 1801.

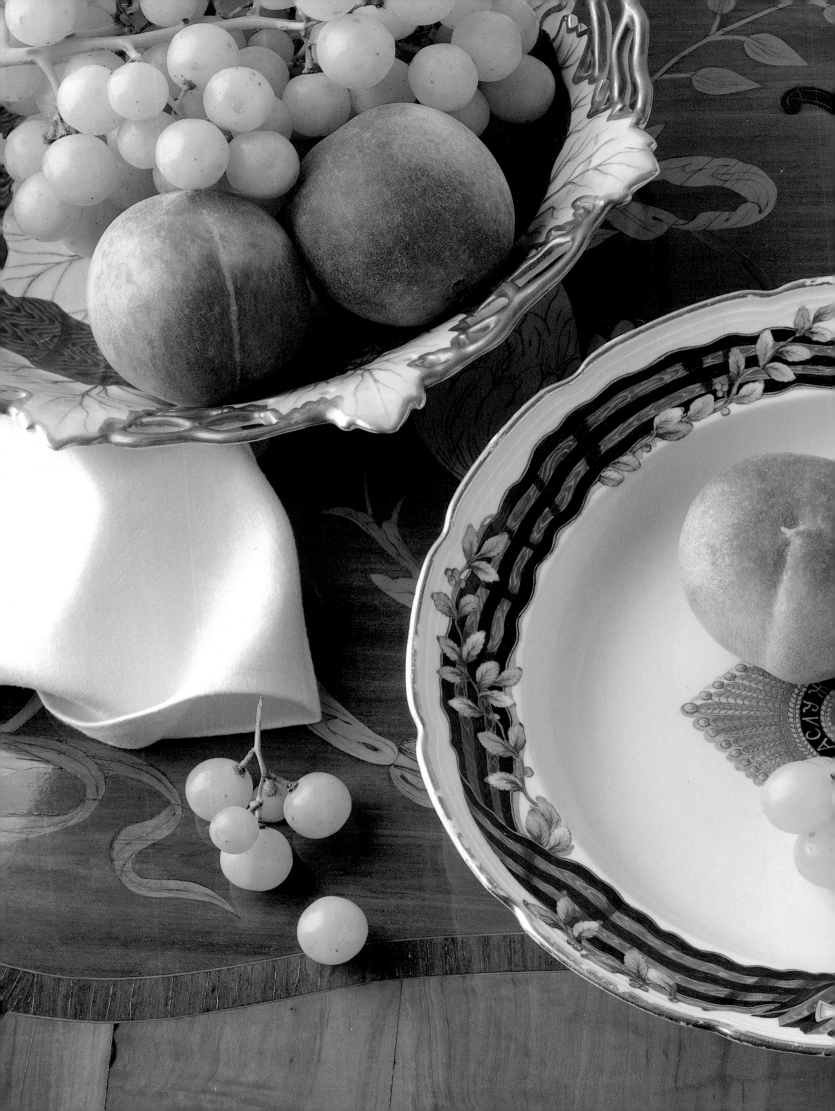

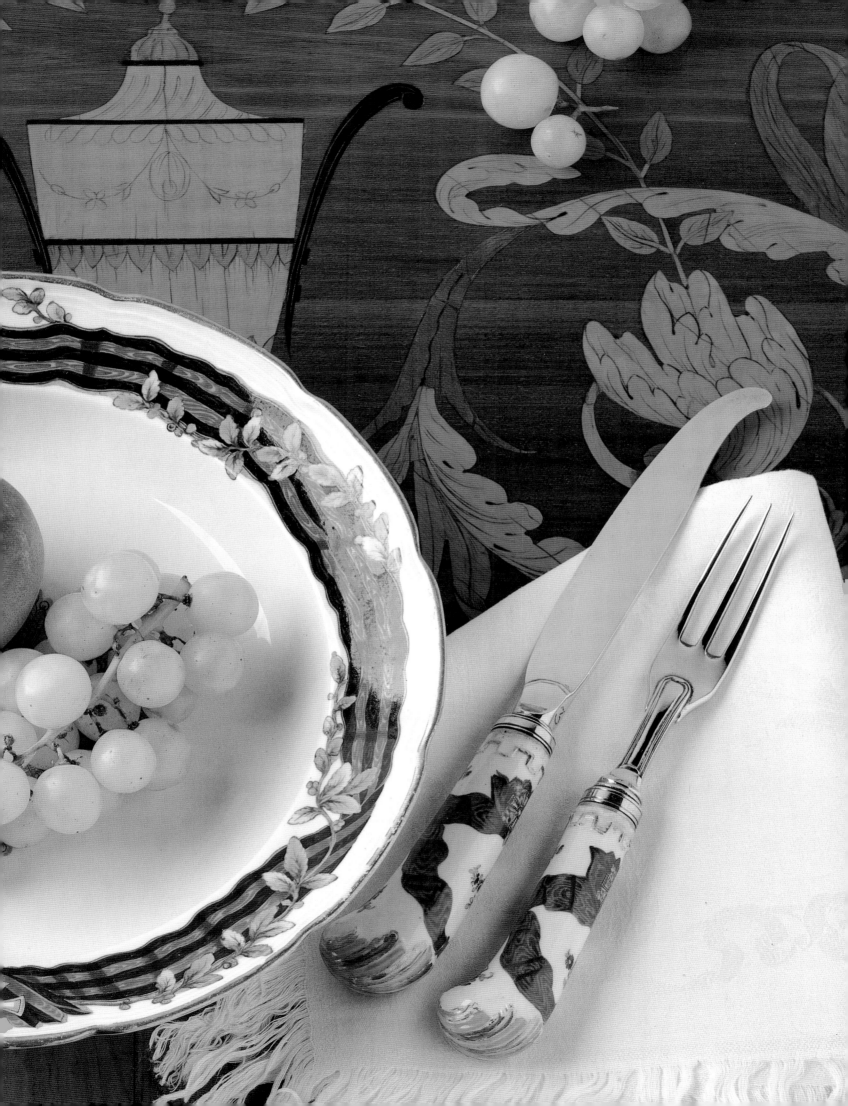

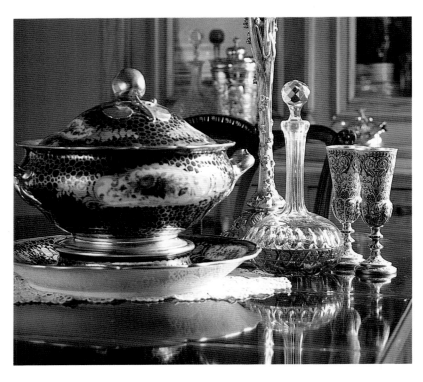

niques of porcelain painting remained at a high level, little of the stylistic integrity of earlier days remained. As the century wore on, the yoke of political reaction excluded heroic motifs from art, and the themes of ancient myths were used more for their lyrical quality than for their heroic spirit. Likewise, landscape painting acquired an elegiac shade. Although porcelain painting reached the peak of its virtuosity during this era, the quality of the relationship between the form of the chinaware and its decoration diminished.

Though form now took a backseat to style, Russian porcelain artists continued developing new decorative techniques. They began painting with liquid porcelain and enamel and crystalline glazes. These more painterly applications lent themselves to the lanquid imagery of the emerging Art Nouveau style.

A soup tureen in the Sèvres pattern made in the Russian Imperial Porcelain Factory during the reign of Alexander III, 1855–1881. (*At right*) A pair of silver gilt-and-shaded Russian enamel champagne flutes.

4

At the end of Nicholas II's coronation feast came the traditional Russian tea, poured into porcelain cups from steaming samovars. First appearing in the eighteenth century as a teakettle with a chimney, the Russian samovar was fashioned, over many decades, into a host of forms, some preserving the classical shapes of eighteenth-century vases, others made with detachable legs to meet the needs of travelers who liked to take their tea in their carriages or on the train. The detailing on the samovar also changed over time—the tap and handles made in the shapes of twigs, dolphins, and curved, abstract stalks.

Other examples of uniquely Russian objects found on Nicholas's banquet tables were jeweled *kovshi*; there were large ones from which punch was poured and miniature ones that were used as saltcellars. The stylistic origins of this vessel in the shape of a duck or a Viking ship and used primarly for drinking or ladling liquids reach as far back as prehistoric times. *Kovshi* became popular in Russia in the fourteenth century when they were first made out of metal. From the end of the seventeenth century, silver *kovshi* began losing their practical function and became popular ceremonial objects, often given to military leaders and tax collectors in recognition of their service. (The more money a tax collector turned in, the bigger and heavier the *kovsh* he received.) The Czars ordered *kovshi* made of gem-studded gold. In time this unusual-looking object became so identified with Imperial honor that it grew to be more desirable than any other ceremonial gift.

OPPOSITE: Part of the porcelain service commissioned by Frederick William III, king of Prussia (1797–1840) and made in the Royal Berlin Factory as a gift for the Grand Duchess Catherine (daughter of Paul I), who was married in 1809 to the Duke of Oldenburg. The conjoined crests are the Romanov double-headed Imperial eagle and the coat of arms of the Schleswig-Holstein principality; both are held by the black Russian Imperial double-headed eagle. Replacements were made in the Russian Imperial Porcelain Factory. FOLLOWING PAGES (*left*): A mauve-bordered Imperial military plate made in the Russian Imperial Porcelain Factory from the period of Alexander III (1881–1894), with a pink egg bearing the Imperial eagle, also from the period of Alexander III. Both pieces are on a background of gold-embroidered fabric from a garment. FOLLOWING PAGES (*right*): A red-bordered military plate from the period of Alexander I (1801–1825), made in the Russian Imperial Porcelain Factory, on a nineteenth-century print of a military formation.

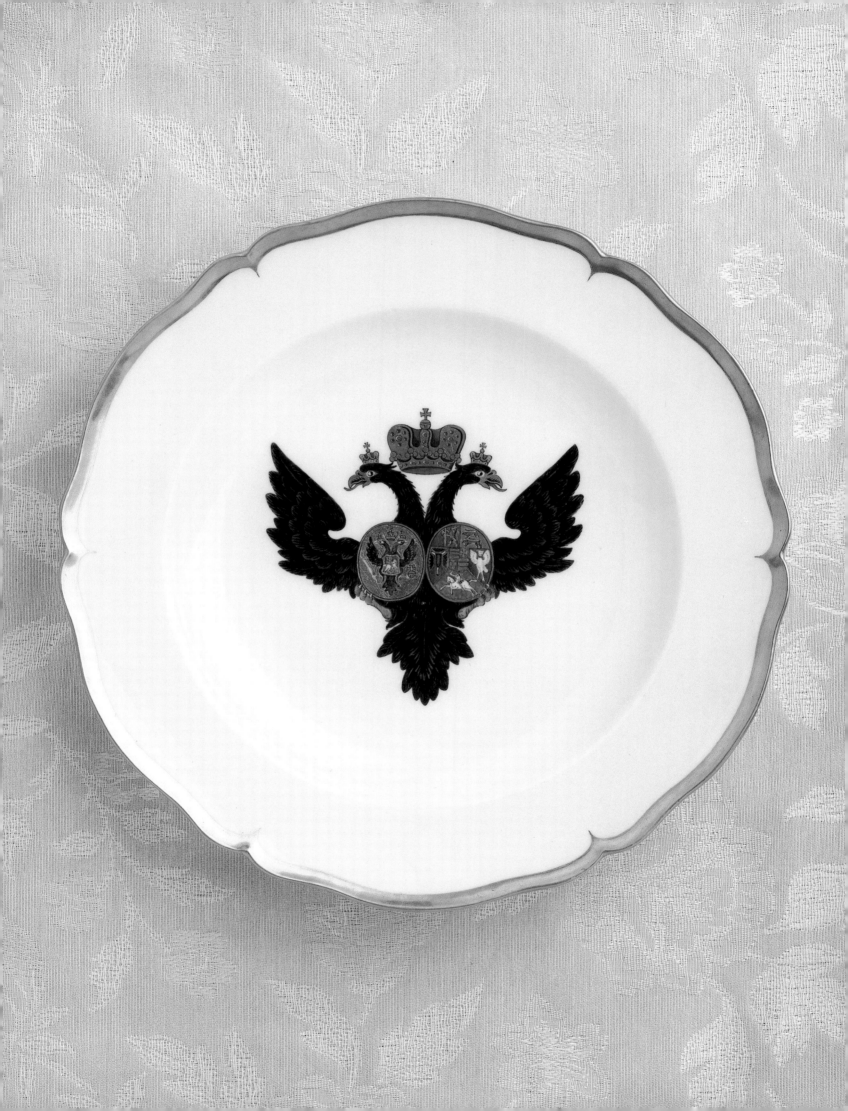

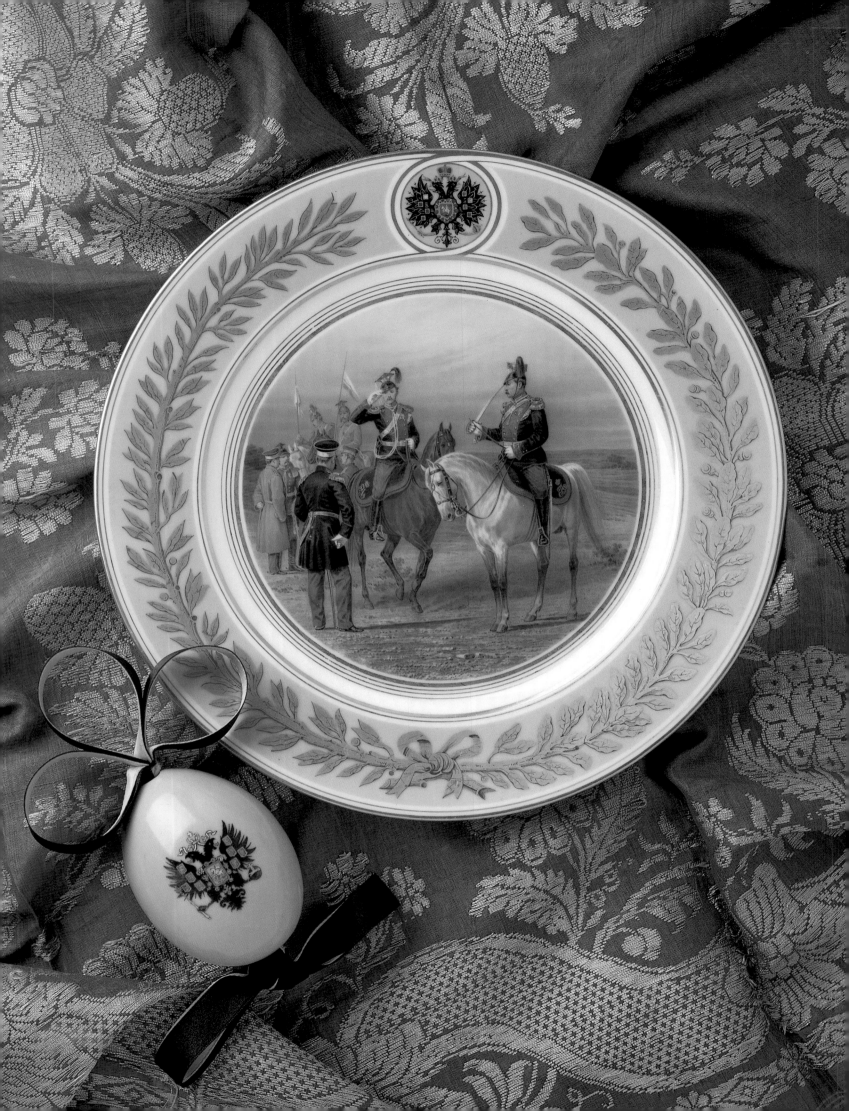

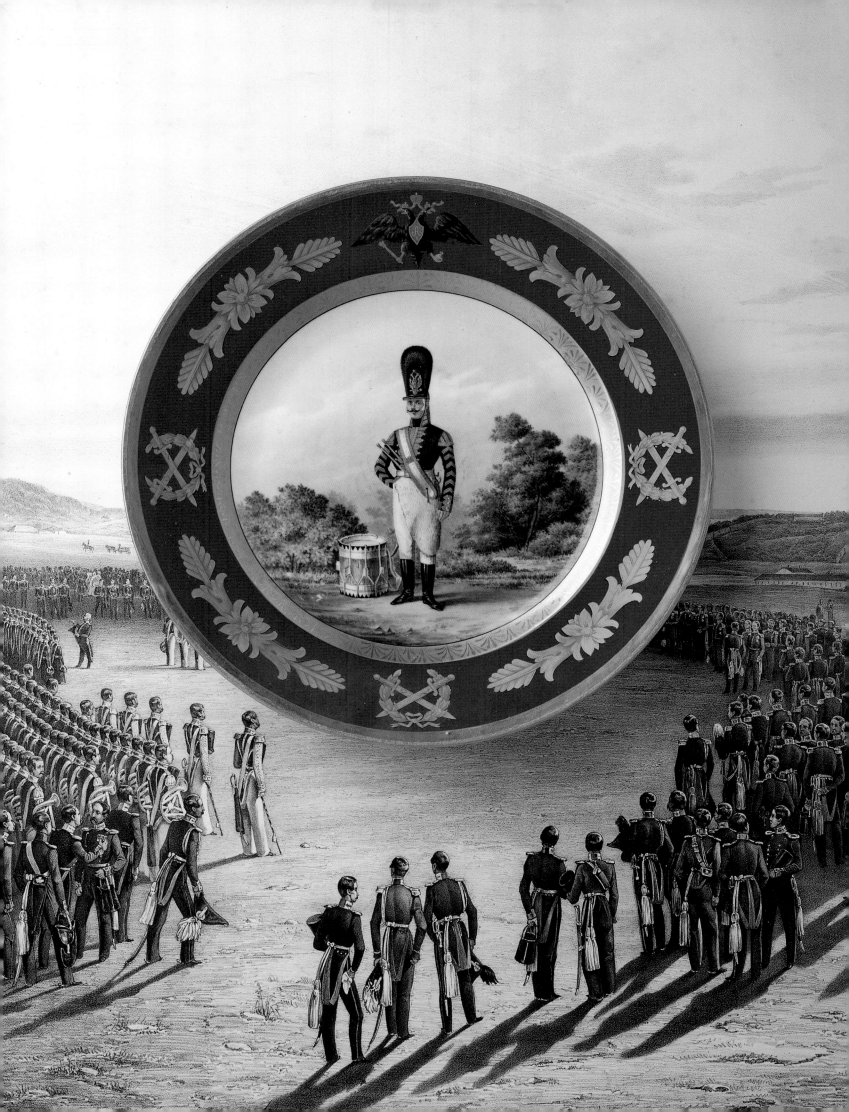

A green-bordered military plate from the period of Nicholas I, made in the Russian Imperial Porcelain Factory, with two silver helmet cups of the Imperial Horseguards on an early eighteenth-century colored print that shows Peter the Great on horseback.

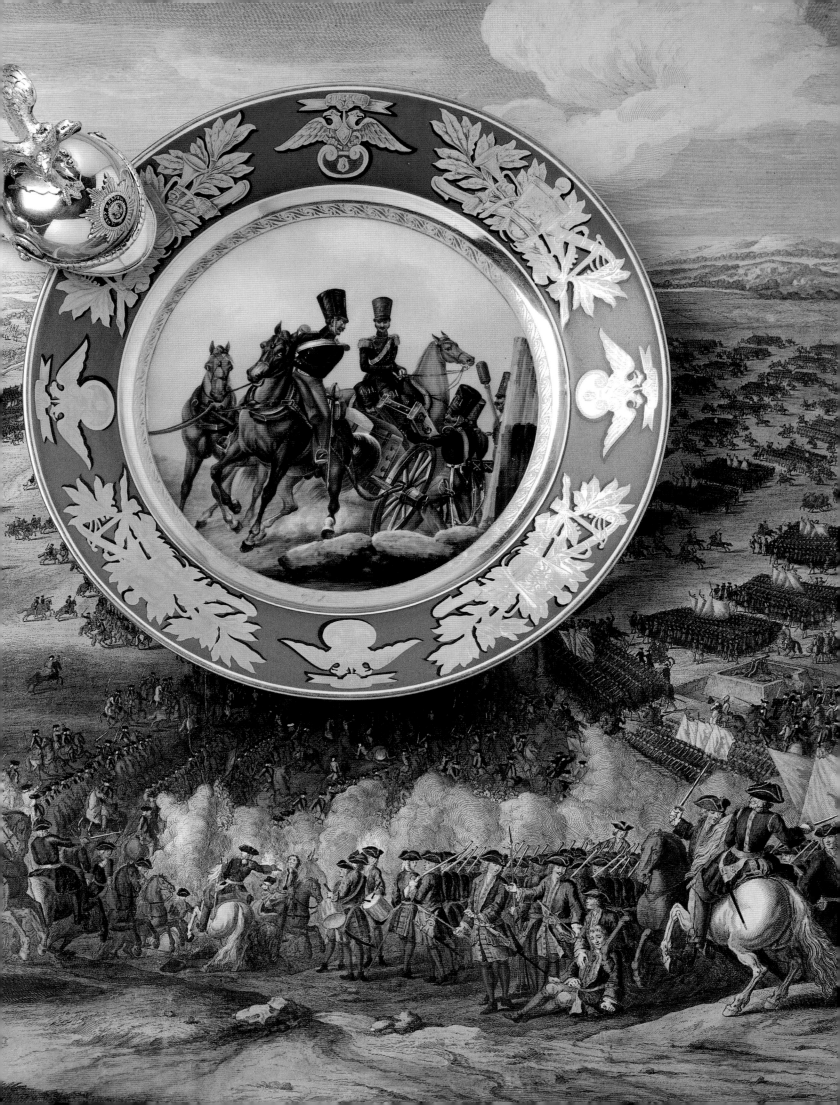

Discouraged over the ever-growing discontent within the ranks of his military and tired of ruling a country unresponsive to his personal zeal, Czar Alexander I sought solace for his failing spirits: He needed to look into the faces of his officers, to be reminded of their valor, to recall the glory they had brought Russia in the victorious battle of Borodino, thirteen years earlier in 1812. Abandoning his private study, he embarked upon a solitary walk through the Winter Palace en route to the destination that would refortify his flagging faith.

Striding through the galleries of the Hermitage, he passed the seventeenth-century Van Dyck portraits of the grand dukes and duchesses of England. How invigorating it was to be in royal company, how ennobling to consider the regal echelons Russia now shared with Europe, he thought as he turned to regard a portrait of his distant cousin, King Philip IV of Spain. Gazing with pride at the seventeenth-century Velázquez masterpiece, Alexander recalled the exhilaration with which the painting had been received at an exhibition in Rome: "Everything else is art," the audience had agreed, "but *this* painting *alone* is truth." The canvas had earned Velázquez the title "painter of kings and king of painters."

In the next gallery, Titian's sixteenth-century mythological painting of *Danaë* commanded the Czar's attention. He mused over how much more voluptuous the Italian courtesan of this rendition was than the short, domestic-looking Dutch nude of Rembrandt's depiction of the same

PRECEDING PAGE: A rare collection of Imperial family miniatures. In the middle is an enamel of Peter the Great (1682–1725) on horseback, by Mussikissky, and all the subsequent Czars: Paul I (1796–1801), Alexander I (1801–1825), Nicholas I (1825–1855), Alexander II (1855–1881), Alexander III (1881–1894), and Nicholas II (1894–1917). OPPOSITE: The Romanov portrait wall of the grand staircase of Hillwood. (*Center*) a portrait of Catherine II attributed to Dimitri Levitsky. (*Top left*) Maria Fyodorovna and (*top right*) Paul I, both by Lampi. Below these (*to the left and right*) are Alexander II and Nicholas I. Below the portrait of Catherine is Alexandra Fyodorovna.

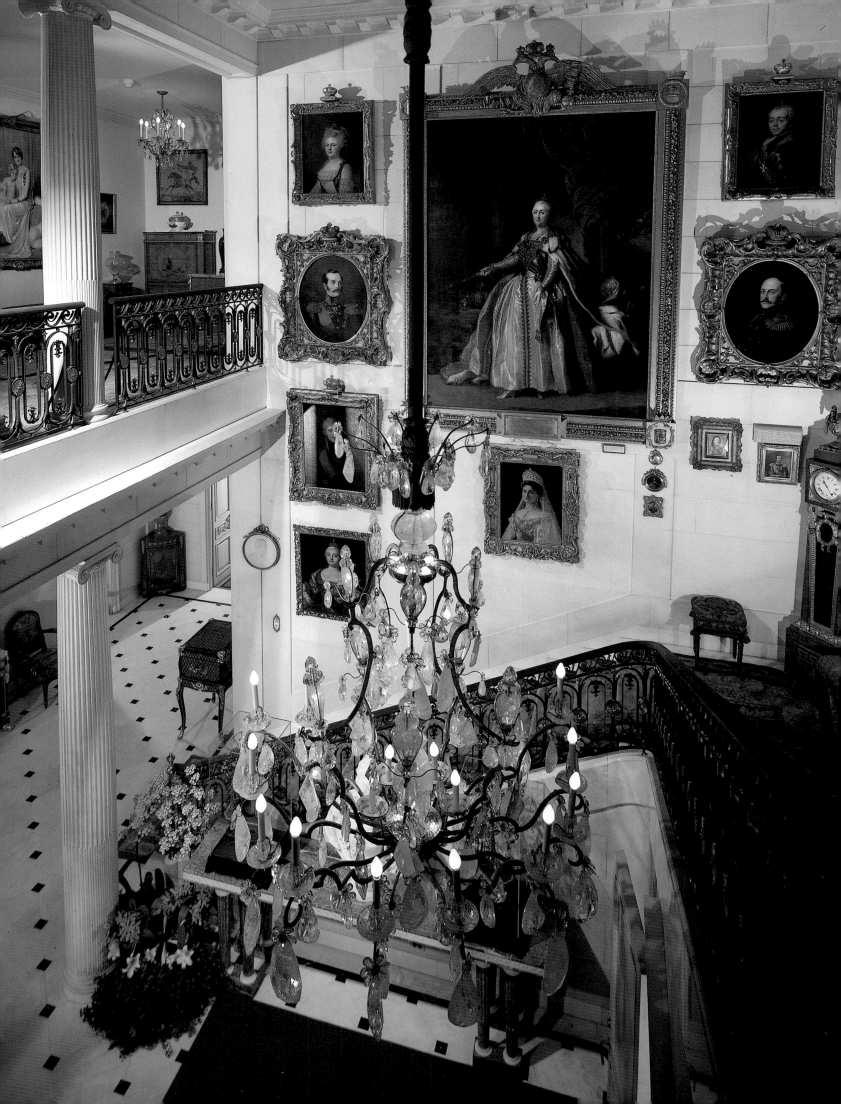

subject. How could an artist be more interested in light and drapery than female flesh, he wondered, allowing himself a moment's gratitude to his grandmother Catherine II. For it was her cheerful pillage of the museums and collections of Europe that afforded him such opportunity to feast his eyes on so many deliciously painted unclothed women.

Titillated, the Czar proceeded through a gallery of seventeenth-century Rubenses. Yes, the flesh was there, the voluminous bodies, the evocative poses. But the baroque paintings were of a fashion so contrary to that of the time—French classicism—that Alexander found them distasteful and quickly crossed the room. He lingered only over Titian's *Perseus and Andromeda*. The serpentine hair of the Medusa reminded him of the insurgent forces that threatened his hold over his empire. Staring at Perseus, who had cut off the Medusa's head, Alexander resolved to shear the rebellious locks of his nation.

ABOVE: On the top shelf is a miniature oil portrait of Count Ivanov, a high functionary of Paul I, by Levitsky, wearing the Order of St. Andrew, from the late eighteenth/early nineteenth century. On the center shelf, a copy of the Russian version of Jules Verne's *Twenty Thousand Leagues Under the Sea*.

ABOVE: A large porcelain plate of Bohdan Khmelnytsky, a leader of the Ukrainian Cossacks, who united the Ukraine and Moscow in 1652. This plate was made by Popov to commemorate the 200th anniversary of this event. To its right on the wall, is a portrait of Sheremetev, and to its left, Makovsky's *Moslem School*. In front is a framed miniature painting of Alexander II. RIGHT (*top to bottom*): a gun-metal cigarette case beneath a miniature portrait of Alexander I by Moerden, circa 1820, in a gold frame; miniature portraits of Nicholas I and his wife, Alexandra Fyodorovna, by Winberg, circa 1835; a pair of white-enamel and nephrite four-leaf clover buttons by Fabergé, mounted as cuff links.

Giorgione's sixteenth-century *Judith* further aroused his confidence. The womanly figure in the painting, holding the decapitated head of Holofernes, evoked the memory of his own military decapitation of Napoléon: With an army only a fraction of the size of the French Emperor's, Alexander had, like this mere woman, vanquished an "unconquerable" villain. Part of his booty, ten Poussin canvases, which had been the pride of the French academies, lined the walls of the next gallery. The proud Alexander, now hailed as "Liberator of Europe," had finally brought Russia to the attention of the European powers. And, as had been the tradition since Rome conquered Greece, the culture of the vanquished was to be absorbed by the conqueror. Soon all the classical tastes and Imperial pomp of the French Court would be assimilated into Russian fashion and imagery.

Finally, entering a long, skylighted, barrel-vaulted corridor decorated with Corinthian columns and crystal chandeliers, Alexander arrived at his destination—a unique "memory album," one of the most monumental portrait galleries ever to glorify a reigning monarch. The room was lined with likenesses of every general and officer who had brought Russia to victory at Borodino. There was Count Kutuzov, Alexander's brilliant strategist; Count Delambesh, resolute in his gaze; counts Trubecky, Stroganov, and Polvektov, all upright and loyal. At the apex of this parade of Russian military glory was mounted a ten-foot portrait of Alexander himself on horseback, looking as imperious

OPPOSITE: Paul I's study in Pavlovsk with a portrait of the Czar hanging above the sofa. OVERLEAF (*left*): From left to right, bisque busts of Czar Paul I (1796–1801), and his sons, Alexander I and Nicholas I standing in front of a painting by Alexandre Benois of the "Old" Bolshoi Theater in St. Petersburg. In the bookcase is a set of Imperial books: the biographies of Alexander I and Nicholas I. OVERLEAF (*right*): The study of a contemporary apartment lined with (*from left to right*) *Field Marshall Suvorov*, 1804; *Nicholas II on Horseback*, by Makovsky; *Catherine the Great in Mourning for Elizabeth*, an oil on copper by Chemesov, 1763–1764. On top of the bookcase are (*from left*) a bust of Alexander I and a figurine of Tchaikovsky.

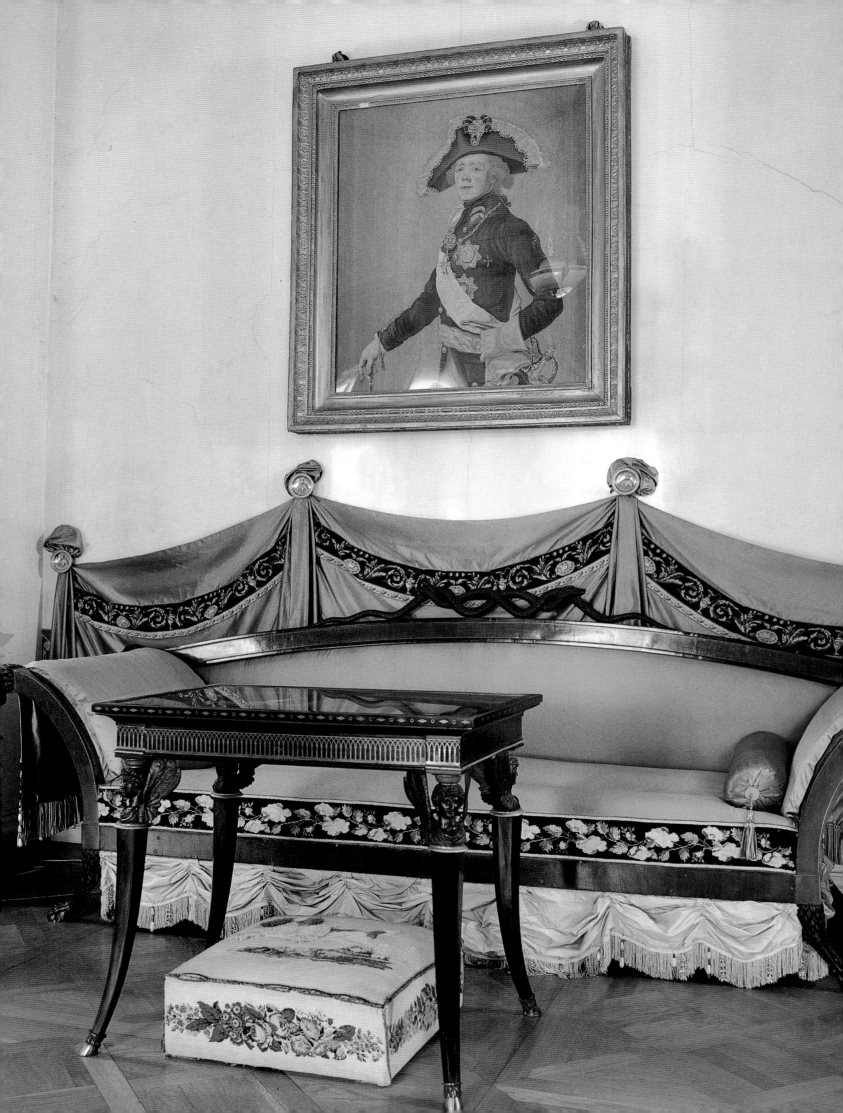

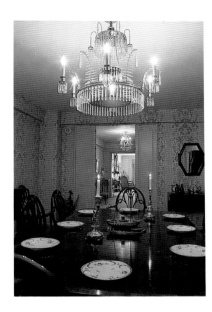

in the saddle as Napoléon had looked before Waterloo. The Czar stared hungrily at the portraits until, restored by their military majesty, he felt sufficiently uplifted to return to his labors.

—

Like a true Russian, the Czar had responded readily to the lure of imagery. Ever since Prince Vladimir of Kiev had introduced Byzantine Christianity and its soul-captivating symbols to Russia in the tenth century, pictures had served Russian rulers—from bishops to emperors—as potent instruments of power. The icon, an earthly image imbued with mystical influence, had evolved from ancient Egyptian death masks and was adapted to Christian symbolism in the centuries following the death of Christ. According to Church teaching, icons are created not by the design of an artist but by direct communion with the Holy Spirit. Iconography is a form of prayer and an occasion for ascetic effort, a means of uniting the sensory world with the celestial, an earthly process used to acquire heavenly experience. These pictures of godly faces were produced according to strict aesthetic and technical canons: The mineral world was represented by use of natural pigments—marble dust, red clay, and gold leaf; the vegetable world by use of wooden boards covered with linen cloth; the animal world by use of rabbit skin or fish glue, egg-based tempera paint, and animal hair brushes. Because divine light was believed to pervade every aspect of an icon, the human figure was never portrayed in shadow,

ABOVE: A New York apartment with two blue glass and crystal chandeliers from the Russian Imperial Glass Factory, late eighteenth century; a set of Peterhof Banquetting service plates designed after the *feuille de choux* pattern from Sèvres; a pair of Russian mid-nineteenth-century silver stag candlesticks. OPPOSITE: A collection of Russian paintings, including, at top left, *Women in a Field*, by Mikhail Nesterov, 1911, and *Olive Trees*, by A. A. Ivanov, circa 1830.

for "there are no shadows in the Kingdom of Heaven." The movements of the figure were restrained, and all architectural or pictorial background was depicted in a manner, as one icon painter described it, of "reverse perspective," thrusting the focus of the painting forward toward the viewer, who would in turn be "freed from the horizontal experience of the sensory world." The worshiper who understood how to view an icon was led into a state of self-immersion: He would have difficulty taking his eyes from the image and would be drawn into a state of deep prayer.

In Greek Byzantine iconography, God was represented as a stern, severe judge, a strong, powerful, expressive ruler. When the Russians formed their own version of Christian orthodoxy, His image had became that of a Savior who took upon Himself the sins of men—a meek, quiet, and merciful God. Nonetheless, this gentle image—as well as those of the Virgin, the Christ Child, and the apostles—was used as an effective tool by which the Church promoted its ideology and sustained control over the Russian population.

———

Similarly, the Russian emperors turned to visual imagery to assert their own secular power. Not surprisingly, it was Peter the Great who initiated the shift from the exclusive traditions of religious art to a new kind of pictorial representation, choosing as his subjects portraiture, battle scenes, and naval victories. Because no Russian

ABOVE: A porcelain-and-metal caviar tureen replicating the Imperial yacht of Czar Nicholas I, a gift to Czar Alexander III in 1895; on the desk are four Fabergé animals and plique-à-jour gold-and-enamel shield-shaped photograph frame by Hahn; on the wall are two costume sketches by Leon Bakst. OPPOSITE (*foreground, counterclockwise from left*): A silver box with massive turquoise relief by Bolin; three war ashtrays by Fabergé; copper, brass and silver wine glasses with encased gold-and-enamel monograms of Alexandra Fyodorovna. Two rock crystal Renaissance-style boxes by Fabergé, two late seventeenth/ early eighteenth-century *kovshi*—one with porcelain interior and one with agate interior. An Imperial glass with a gold monogram and Imperial eagle. An eighteenth-century wine bottle with Imperial eagle finial by Fabergé. On the mantle, an Orlov plate with the monogram of Count Gregory Orlov in colored golds and silvers. He was one of Catherine the Great's "favorites."

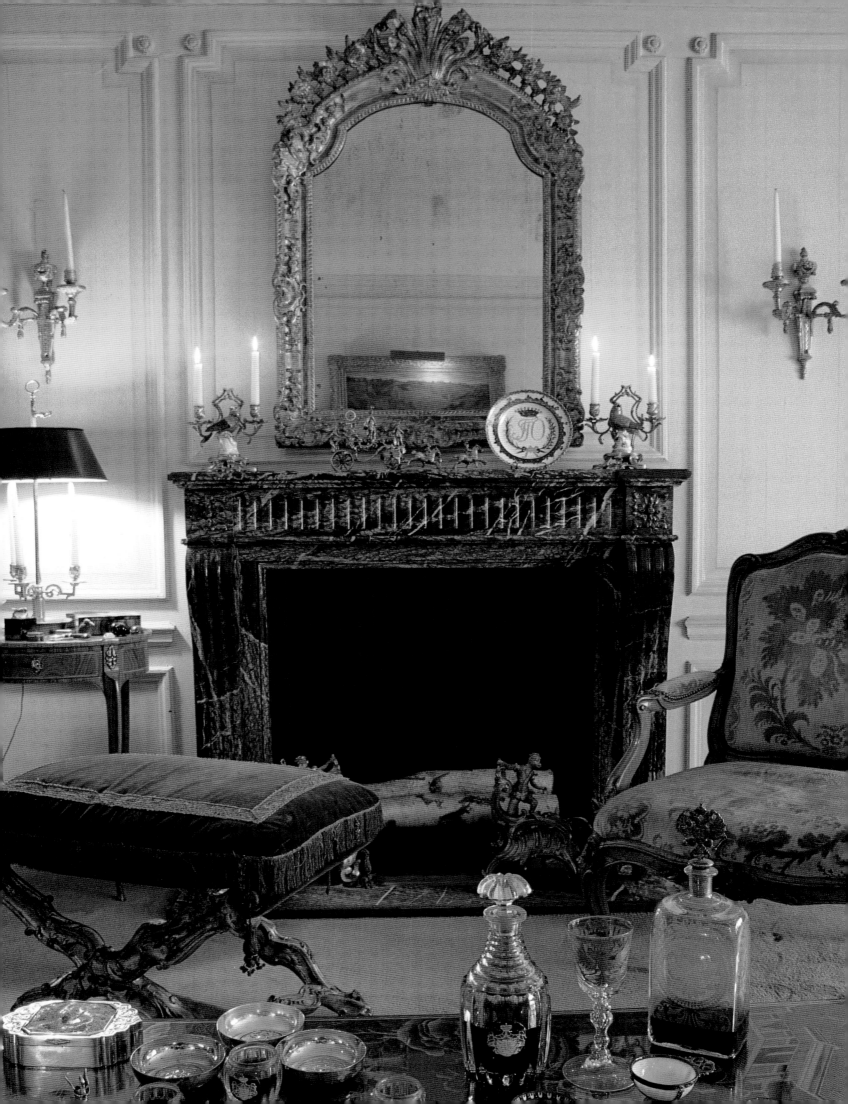

artist had the contextual background or technical expertise to generate such pictures, Peter sent five of the country's most promising pupils to Europe and at the same time imported painters who could both produce and teach. The first of these was Gottfried Danhauer, a portrait painter born in Bavaria and trained in Venice. Like many of the itinerant masters who were to follow, painters who were searching for work because they couldn't obtain places in the prominent schools of their own countries, Danhauer remained in Russia from the time Peter brought him there in 1710 until his death, incorporating in his work both the somber palette of the Flemish school and the more characteristically colorful one of the Russians.

As intent on the cultural development of his nation as he was on building a European capital, Peter proposed establishing an Academy of Art. His plan, however, was not officially inaugurated until the reign of Elizabeth, the ruler under whom Russia began to come of age artistically. Her artists, primarily portrait painters, adhered to her ceremonial and rococo tastes, and though they brought the flavor of French and Italian styles to the Court, the touch of the theological pervaded: Faces were basically inexpressive, and, like the patterns of texture in icon painting, the representation of textile remained an obsession.

The Academy of Fine Arts in St. Petersburg was permanently organized under Catherine the Great, who had its regulations modeled after those of the French academy. But unlike the French academy, where the disci-

*Winter Scene* in the Karelian birch forest, by Julius Von Klever, 1899.

plines were taught separately, the Russian school brought under one roof the study of architecture, painting, sculpture, and the minor arts.

In 1764, Catherine had the walls of one of the largest halls in Peterhof hung with a collection of 368 portraits of girls in various everyday costumes painted by the Italian artist Pietro Rotari, who had worked and died in St. Petersburg. Although an expression of docile piety on each girl's face ties the paintings to Russia's religious tradition, their humble dress and realistic depiction places them definitively within the traditions of the eighteenth-century West. These portraits are radical not only because they are *not* Madonnas but also because the subjects are not shown as nobility. Within a mere fifty years, Russia had not only transcended its purely iconographic approach to art and the succeeding impulse to glorify the nobility in majestic portraiture but also gained the visual and psychological confidence to romanticize the domestic.

Portraiture of a loftier approach became the vogue with the overnight success of the painter D. G. Levitsky. At the first exhibition of the reorganized Academy in 1770, he submitted a portrait of the Academy's architect, A. F. Kokorinov, elegantly attired in a lilac satin suit and fur-trimmed coat. In the painting, Kokorinov stands before a fine French bureau upon which the scheme for the Academy is spread out. Levitsky rendered the three-quarter-length figure, which is turned slightly from the viewer toward the plans, with unexpected grace, while also de-

An illustrated coat of arms of Paul I as Czarevich, from a book with the collective coat of arms of his Court together with a collection of miniatures of ladies who graced the Imperial court: Empress Catherine I (wife of Peter the Great); Empress Anna Ivanovna (1730–1740), daughter of Ivan V and niece of Peter the Great; Empress Elizabeth I (1741–1762), daughter of Peter the Great; Empress Catherine II (1762–1796), mother of Paul I; Empress Maria Fyodorovna, wife of Alexander III; Empress Alexandra Fyodorovna, wife of Nicholas II; and Grand Duchess Maria, daughter of Nicholas II.

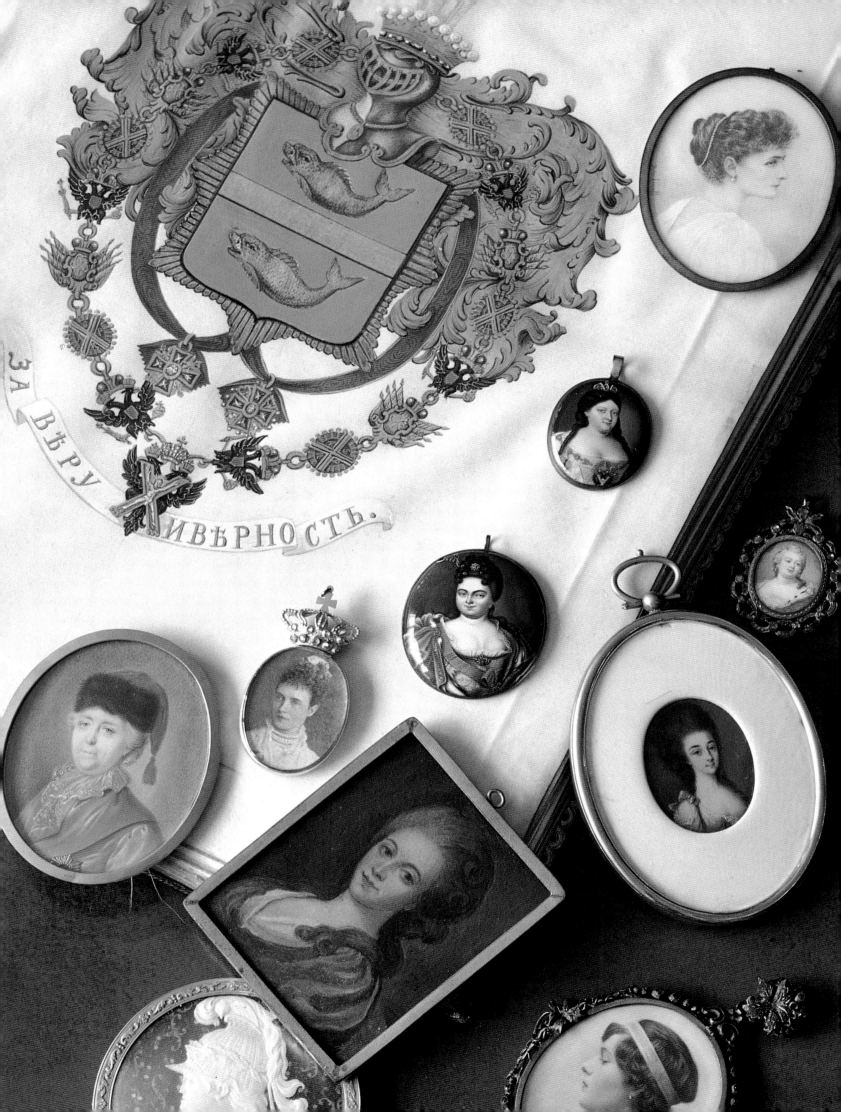

picting the materials with which the garment and the furniture were made with surprising mastery. His work demonstrated that the influences of European Court portraiture had been both absorbed and reinterpreted within Russia's artistic ranks and to Russian society in less than a generation.

As Russian artists learned to embrace realistic and romantic subjects, their work took on a rude vigor that was often combined with unexpected psychological insight. Between 1773 and 1776, Levitsky painted a series of portraits commissioned by Catherine the Great of the Empress's favorite pupils at the Smolny Institute, the St. Petersburg school for daughters of nobility. These beguiling portraits, which reveal the girls' pubescent awkwardness and blossoming coquetry, are considered among the most enchanting depictions of childhood and adolescence of the eighteenth century.

With the outbreak of the French Revolution and because of Catherine's fundamental predilection for British civilization, the 1780s saw a shift from the French influence to the less formally costumed and less sentimental style of the English, specifically that of the painters Thomas Gainsborough and Sir Joshua Reynolds, who often set their subjects in a landscape, stressing the relation of human personality to nature. A well-known portrait of Catherine by Vladimir Lukich Borovikovsky shows her not as an Empress but as an elderly woman walking with her dog in the park at Tsarskoye Selo.

A Court portrait of Nicholas I, 1825–1855.

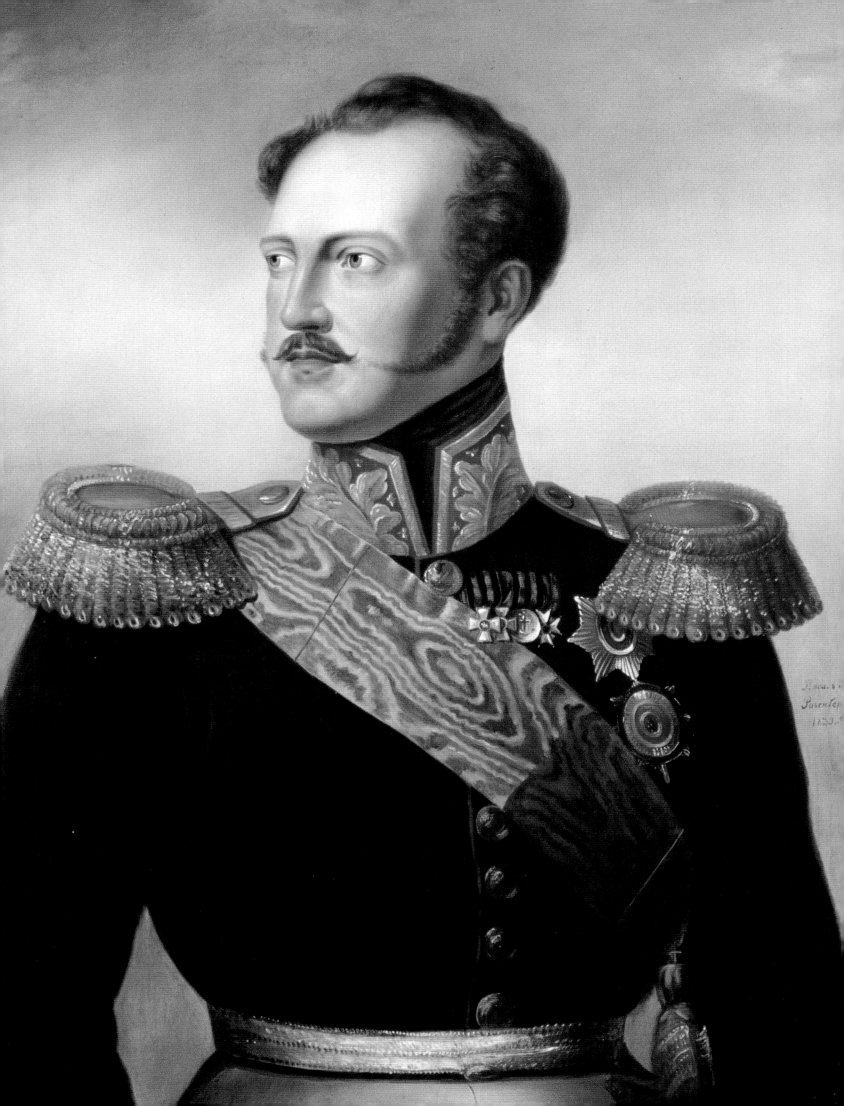

Just as Rome and Paris each became a nexus of artistic exchange for Western artists during the nineteenth century, so did they become centers of pictorial research for Russian artists. Russian canvases were filled with the same sequence of styles that marked the era, spanning cool neoclassicism, the romantic baroque, and the development of naturalism. Generalized depiction—that which saw men and women as types or members of a class first and individuals second—gave way to the representation of a person as one individual with special psychological responsibilities to himself and society. Karl Briullov, the first Russian painter to enjoy an international reputation, was celebrated, like Géricault and Delacroix, for the wealth of realistic detail in his work and for his achievement of drama and surprise. His famed *The Last Day of Pompeii* was hailed as a masterpiece by the Italian press, and none other than Sir Walter Scott is said to have remarked that it was "not a painting, but an epic."

The Russians also followed the developments of the Nazarenes, German forerunners of the English pre-Raphaelites, who restored an interest in biblical subjects that had been in decline after the French Revolution. A. A. Ivanov, a Russian painter who like Briullov studied in Rome, produced otherworldly scenes whose brightly colored landscapes anticipated the vision of the French Impressionists. The naturalism and immediacy with which he painted classical nudes also prefigured the images of Degas.

A room of Russian icons, including a large *Life of St. Nicholas*, and *Christ, the Pantocrator*, dating from the seventeenth century onward.

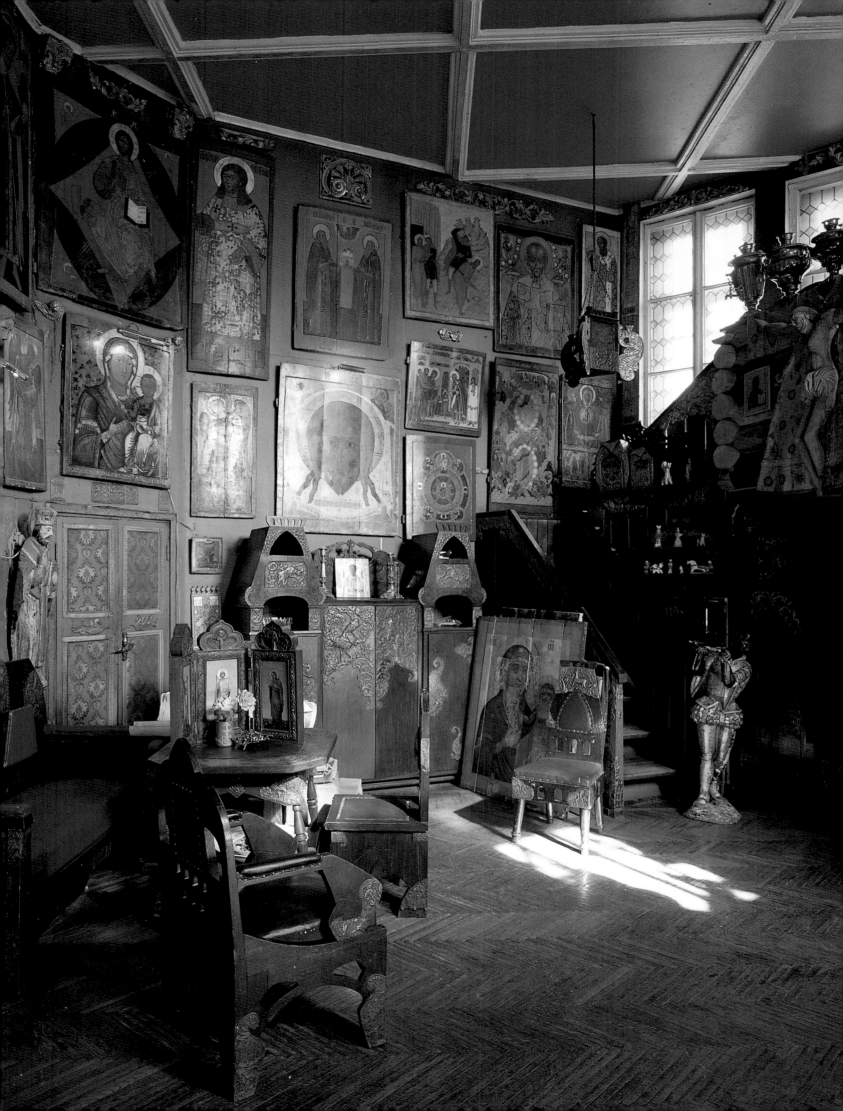

The late nineteenth century brought the evolution of social realism to Europe and, despite the government's continued intolerance of social criticism, paintings depicting unendurable human toil and tragedy emerged in Russia. Among the most piercingly emotional canvases produced in the genre were those by the artist Ilya Yefimovich Repin. His *Bargemen* of 1870–73, a devastating study of the wretches who hauled boats up the Volga—against the current and by sheer physical exertion—exposes the brutality of the country's labor conditions. His history painting *Czar Ivan IV with the Body of His Son* reveals both the Czar's madness and the essential human tragedy of the ruler's insane act (he murdered his son with a blow to the head in a fit of rage). In these and in his domestic genre scenes and portraits, Repin addressed himself to "human relationships as the manifested themselves in moments of antagonism and conflict," as the Russian art critic Dmitry Vladimirovich Sarabianov has noted. As master of form and expression, he combined compelling composition (stark asymmetries) with raw emotion, crowning the history of ideological realism in Russian painting.

A member of the international artistic generation of the fin de siècle, Mikhail Aleksandrovich Vrubel was one of the first Russian artists to create artwork purely for aesthetic purposes. By treating form, color, line, and texture with the same interest as the artwork's subject, he replaced the emphasis on realism with one on symbol. Abandoning the use of muddy mixtures of local hues

A silver-gilt-and-Russian-enamel icon of St. John the Theologian from the seventeenth century in the foreground and a silver-gilt-and-Russian-enamel icon of *The Veronica Veil* by Ovchinnikov, Moscow, 1889.

common to much contemporary Russian painting, he employed the exotic harmonies of Persian carpets and Oriental glass. His bold splashes of color stressed the tragic expressions of his figures, and his work as a whole served as a portrait of his own tortured soul. Though he contributed much to creating the conditions that fostered the evolution of modern art (as did his contemporaries Edvard Munch in Norway, Gustav Klimt in Austria, Aubrey Beardsley in England, and Paul Gauguin in France), Russian tastes were still shackled by academic canons. Even the painting of still life, a natural segue into the realm of abstraction, did not evolve in Russia until the twentieth century.

Still life developed independently from the main movement of Russian painting, for until the 1900s, even when objects were spotlighted in portraiture and domestic interior scenes, they were treated as part of a bigger whole. The first Russian compositions of stylized fruit and flowers were produced in the eighteenth century under Empress Elizabeth as part of the elaborate decoration of the *dessus de portes* (lintels) in her palaces. These complex designs, however, were more concerned with general ornamental and spatial effect than with replication of detail or the cultivation of three-dimensional illusion. Later trompe l'oeil patterns focused attention on surfaces without risk of disturbing the unity between space and volume.

With the evolution of a bourgeoisie in the nineteenth century came a greater desire to capture the domestic

OPPOSITE (*foreground*): *The Virgin and Child*, Moscow, 1893; (*to the right*), *The Veronica Veil* by Chlebnikov, circa 1900; (*background*) two rare silver-gilt-and-Russian-enamel tryptichs, the smaller by Lubavin, the other set with rubies, diamonds, and sapphires, by Ovchinnikov. OVERLEAF (*left*): A gilded silver and niello Russian chalice depicting apostles and the Holy Virgin, circa 1685, in front of a late fifteenth-century icon of St. Nicholas the Wonderworker, one of the most venerated of Russian saints, patron saint of Russia. OVERLEAF (*right*): A seventeenth-century silver gilt framed Russian wooden icon of St. Macarius of Alexandria and St. Macarius of Egypt lying atop a chromolithographic illustration of the icon in a five-volume catalog on the entire Imperial collections of Nicholas I, published in 1855, entitled *Antiquities of the Russian Empire*. Beneath them, a piece of Imperial silver-and-gold vestment.

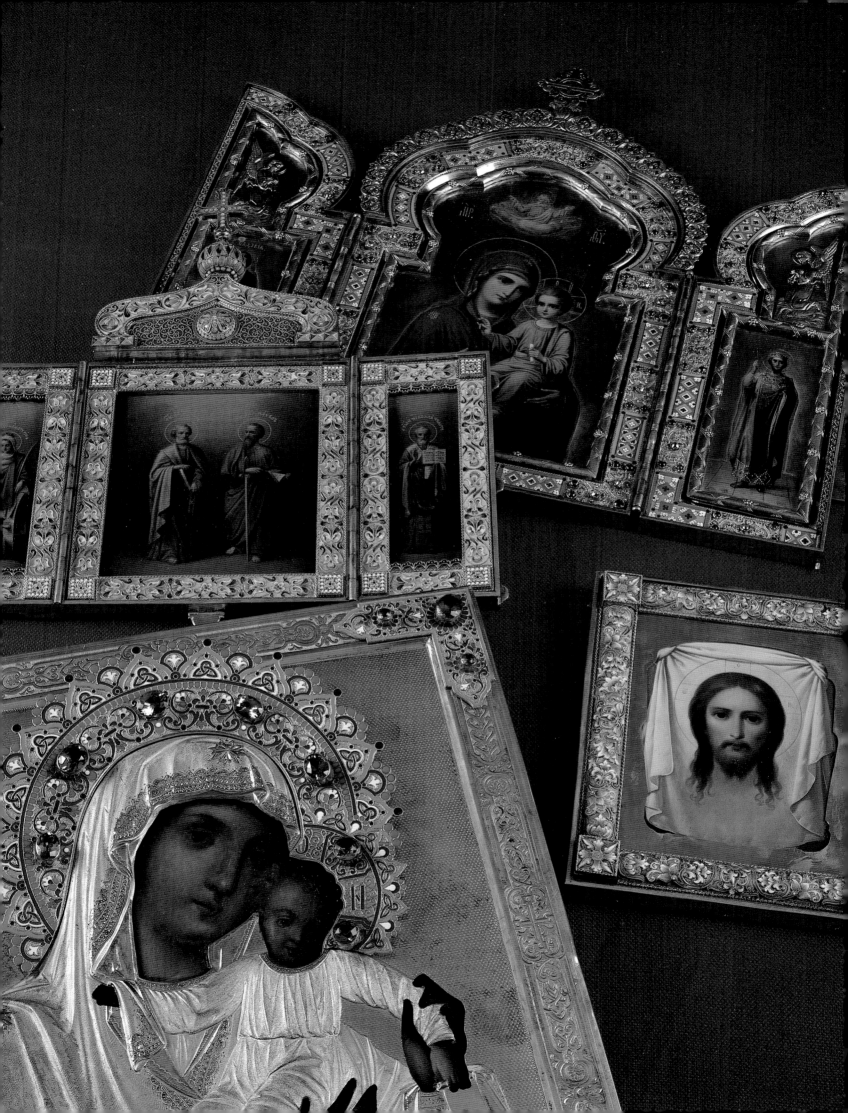

ОБРАЗЪ СВ. МАКАРІЕВЪ, ЕП

ОТД. I.          IMAGE DE St MACAIRE D'EGYPTE ET DE St MACA

world in detail and with utmost precision. Paintings began to show clocks, books, engravings, pictures, combs, and feathers standing out against backgrounds rather than receding into them. Nevertheless, while portraiture and landscape painting evolved, academic training hindered the developement of flower, fruit, and animal painting, using these subjects strictly as compulsory allegorical objects.

Prompted by the increasing interest of Russian artists in the plasticity and texture of the subjects they depicted, the genre of still-life painting finally gained the status of an autonomous art form during the first decade of the twentieth century. Painters such as Ilya Mashkov, Piotr Konchalovsky, and Vasily Rozhdestvensky, who were intrigued with the power of the material world, focused on its vividness and variety of shapes and textures. As the Russian art historian Irina Bolotina describes, they "gained from the vigor of folk experience of Cézanne who taught them to render volume by color. Nonetheless the enchantment of the natural beauty of fragrant fruit and flowers, freshly baked bread, copper samovars and the warm glow of polished wood could be created only by the inspiration of the moment and could not be invented in advance or repeated." With the acceptance and perpetuation of still-life painting, it was only a short step to the evolution of Russian Constructivism, the graphic, abstract style of art that would lend its bold, uncompromising character to the imagery of the Revolution.

*Harvest Festival,* oil on canvas by Boris Mikhailovich Kustodiev (1878–1929).

# CHRONOLOGY OF RUSSIAN RULERS

| | REIGN |
|---|---|
| Peter I (The Great) | 1689–1725 |
| Catherine I | 1725–1727 |
| Peter II | 1727–1730 |
| Anna | 1730–1740 |
| Ivan VI | 1740–1741 |
| Elizabeth | 1741–1762 |
| Peter III | 1762 |
| Catherine II (The Great) | 1762–1796 |
| Paul I | 1796–1801 |
| Alexander I | 1801–1825 |
| Nicholas I | 1825–1855 |
| Alexander II | 1855–1881 |
| Alexander III | 1881–1894 |
| Nicholas II | 1894–1917 |

# PHOTO CREDITS

Courtesy of *Connoisseur* Magazine
  76 (Ken Schles)

Courtesy of The Forbes Magazine Collection, New York
  1 (Larry Stein), 9 (*top left*), 11 (Larry Stein), 48 (Sotheby's),
  54–55 (Stephane Korb), 143

Courtesy of the Hillwood Museum, Washington, D.C.
  8 (*top left*), 26, 34–35, 191

The Image Bank
  12, 74–75

Leslie Jean-Bart
  87, 112–113, 211, 213

Anthony Johnson
  4, 7, 8 (*top center*), 8 (*top right*), 9 (*top center*), 9 (*top
  right*), 32, 40, 44–45, 52–53, 56, 63, 65, 68–69, 80, 82,
  84, 88, 89, 90, 93, 96–97, 99, 100, 103, 104, 132, 133,
  134, 136, 138–139, 141, 144, 145, 146, 147, 148–149,
  152, 153, 154, 155, 156–157, 161, 163, 167, 168–169,
  172, 173, 175, 176, 178–179, 180, 183, 184, 185,
  186–187, 188, 192, 193, 196, 197, 198, 199, 200, 201,
  203, 205, 207, 214, 215, 217

Derry Moore
  20, 129, 130, 209

Neal Slavin
  16–17, 110–111

Courtesy of Sotheby's, Inc., New York
  22–23

Fritz von der Schulenburg
  85, 106, 109, 115, 116, 119, 121, 122, 124, 126, 164,
  195

Superstock
  2–3

# BIBLIOGRAPHY

A La Vieille Russie, Inc. *The Art of the Goldsmith and the Jeweler*, a loan exhibition for the YWCA. New York, 1961.

A La Vieille Russie, Inc. *The Art of Peter Carl Fabergé*, a loan exhibition for the Manhattan School of Music. New York, 1961.

A La Vieille Russie, Inc. A Loan Exhibition of *Russian Icons from the Fourteenth Through the Nineteenth Centuries*, New York, 1962.

A La Vieille Russie, Inc. *Thirty Five Russian Primitives*, Jacques Zolotnitsky's collection. Paris, 1931.

A La Vieille Russie, Inc. *Peter Carl Fabergé*, an Exhibition of His Works. New York, 1949.

A La Vieille Russie, Inc. *The Schaffer Collection of Authentic Imperial Russian Art Treasures*. New York, 1936.

Andrews, Peter. *The Rulers of Russia*. Chicago: Stonehenge Press, 1983.

*The Architecture of Russia, from Old to Modern Times. Vol. I: Churches and Monasteries*. New York: Russian Orthodox Youth Committee, 1973.

*The Architecture of Russia, from Old to Modern Times. Vol. II: Palaces, Manors, and Churches*. New York: Russian Orthodox Youth Committee, 1974.

Billington, James H. "Keeping the Faith in the USSR after a Thousand Years," *Smithsonian*, April 1989, 130–43.

Chenevière, Antoine. *Russian Furniture: The Golden Age, 1780–1840*. New York: Vendome Press, 1988.

Donnert, Erich. *Russia in the Age of Enlightenment*. German Democratic Republic: Edition Leipzig, 1986.

Dragadze, Peter, and Daria Dragadze. "Inside Russia." *House Beautiful*, 131 (May 1989), 41–57.

Froncek, Thomas, ed. *Arts of Russia*. New York: American Heritage Publishing Co., Inc., 1970.

Gibert, Martin. *Atlas of Russian History*. Great Britain: Dorset Press, 1972.

Hamilton, George Heard. *The Art and Architecture of Russia*, rev. ed. New York: Penguin Books, Inc., 1983.

*History of Russian Costume, from the Eleventh to the Twentieth Century*. New York: Metropolitan Museum of Art, 1976.

*History of the Russian Empire*. Russian Orthodox Youth Committee, 1971.

Ivanova, E. *Russian Applied Art, 18th–Early 20th Centuries*. Leningrad: Aurora Art Publishers, 1981.

Korshunova, Tamara. *The Art of Costume in Russia, 18th–20th Centuries*. Leningrad: Aurora Art Publishers, 1979.

Lancere, A. K. *Russian Porcelain: The Art of the First Russian Porcelain Works*. Leningrad: Khudozhnik RSFSR, 1968.

Loukomski, Georges. *Tsarskoe Selo*. England: Thomas Heneage & Co., Ltd., 1987. (Written in 1924.)

Massie, Robert K. *Nicholas and Alexandra*. New York: Dell Publishing, 1985.

Myers, Bernard, and Trewin Copplestone, eds. *Art Treasures in Russia: Monuments, Masterpieces, Commissions and Collections*. New York and Toronto: McGraw-Hill Book Co., 1970.

Onassis, J., ed. *In the Russian Style*. New York: Viking Press, 1976.

Schaffer, Paul. "A Survey of Trends in the Russian Decorative Arts of the First Half of the Nineteenth Century." *Art and Culture in Nineteenth-Century Russia*. Bloomington: Indiana University Press, 1983, 211.

Schaffer, Paul. "A La Vieille Russie's Fabergé." *Masterpieces from the House of Fabergé*. New York: Harry N. Abrams, Inc., 1984.

Snowman, A. Kenneth. *Carl Fabergé, Goldsmith to the Imperial Court of Russia*. New York: Viking Press, 1979.

Sokolova, Natalia, ed. *Selected Works of Russian Art: Architecture, Sculpture, Painting, Graphic Art 11th–Early 20th Century*. Leningrad: Aurora Art Publishers, 1976.

*Soviet Porcelain, The Artistry of the Lomonsov Porcelain Factory*. Leningrad, 1974.

Taylor, Katrina V. H. *Russian Art at Hillwood*. Washington, D.C.: Hillwood Museum, 1988.

# INDEX

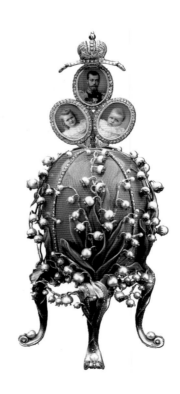